WIND AND WATER

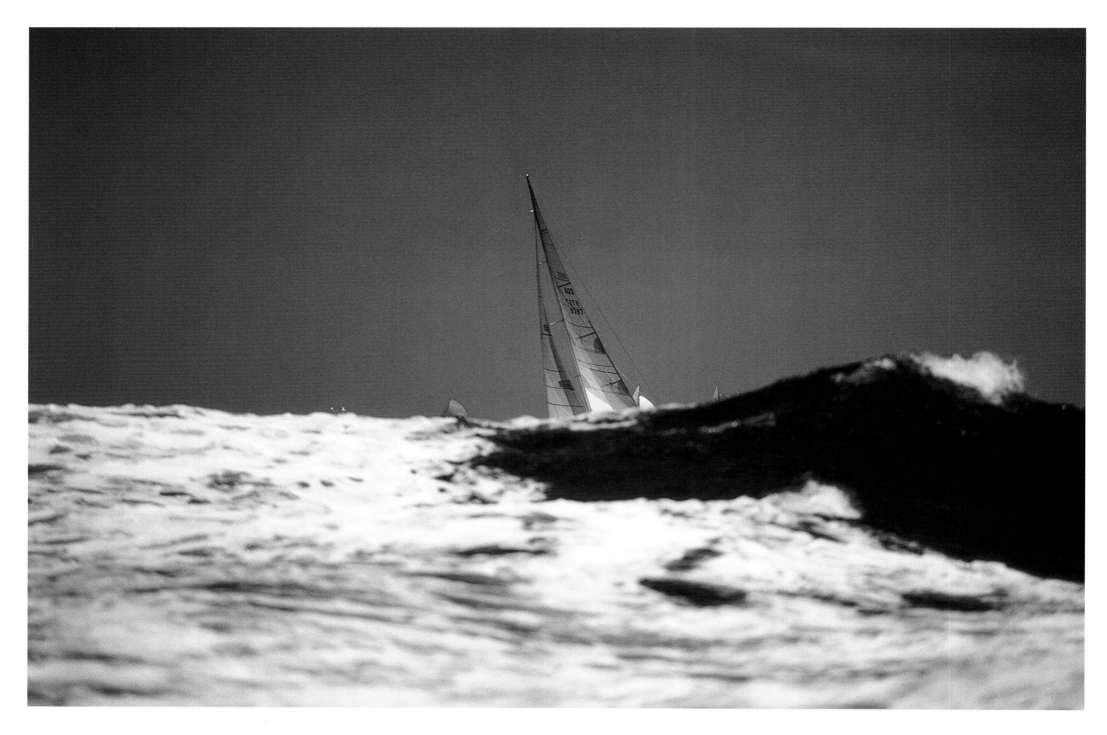

Big breeze and big seas are the nature of the
game as *Ice Fire* heads to the weather mark
during the Kenwood Cup held off Waikiki
Beach, Oahu, Hawaii.

Onne van der Wal

WIND AND WATER

BOATING PHOTOGRAPHS FROM AROUND THE WORLD

Bulfinch Press

NEW YORK | BOSTON | LONDON

Bulfinch Press
Hachette Book Group USA
237 Park Avenue, New York, NY 10017
Visit our Web site at www.bulfinchpress.com

First Edition
Second printing, 2008

LIBRARY OF CONGRESS CATALOGING-IN-PUBLICATION DATA

Van der Wal, Onne.
 Wind and water : boating photographs from around the world /
Onne van der Wal.—1st ed.
 p. cm.
 ISBN 978-0-8212-2844-9
1. Photography of sailing ships. 2. Van der Wal, Onne. I. Title.

TR670.5.V36 2004
779'.97971—dc22 2003023017

Designed by Miko McGinty

Printed in Spain

To my Ma and Pa, thank you for your faith and support

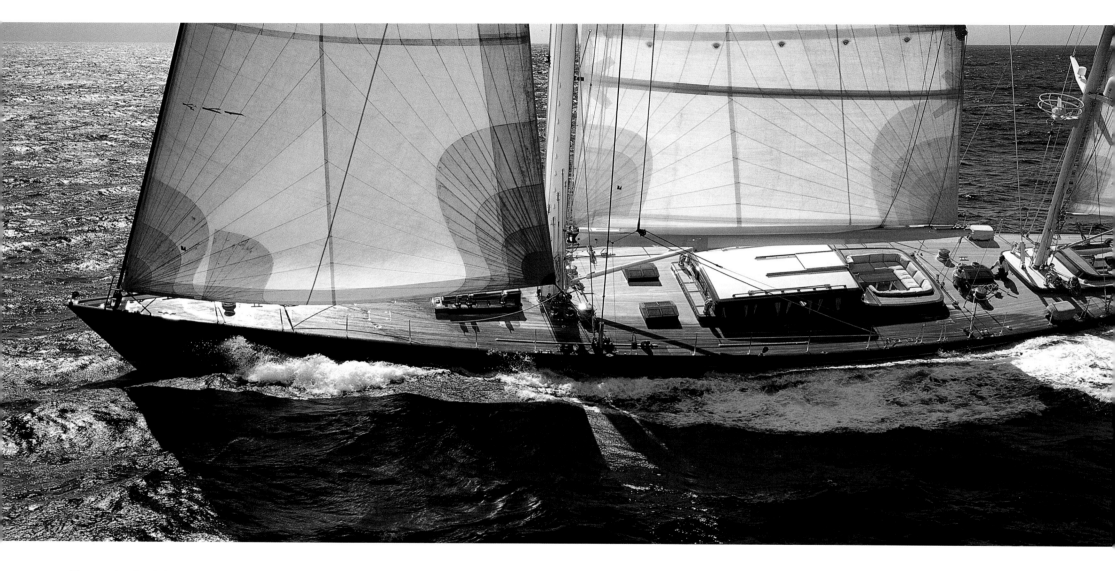

The 140-foot ketch *Rebecca* on a beat off
Antigua, West Indies.

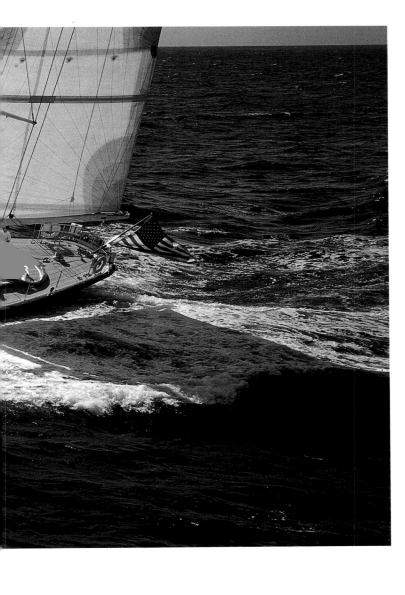

Contents

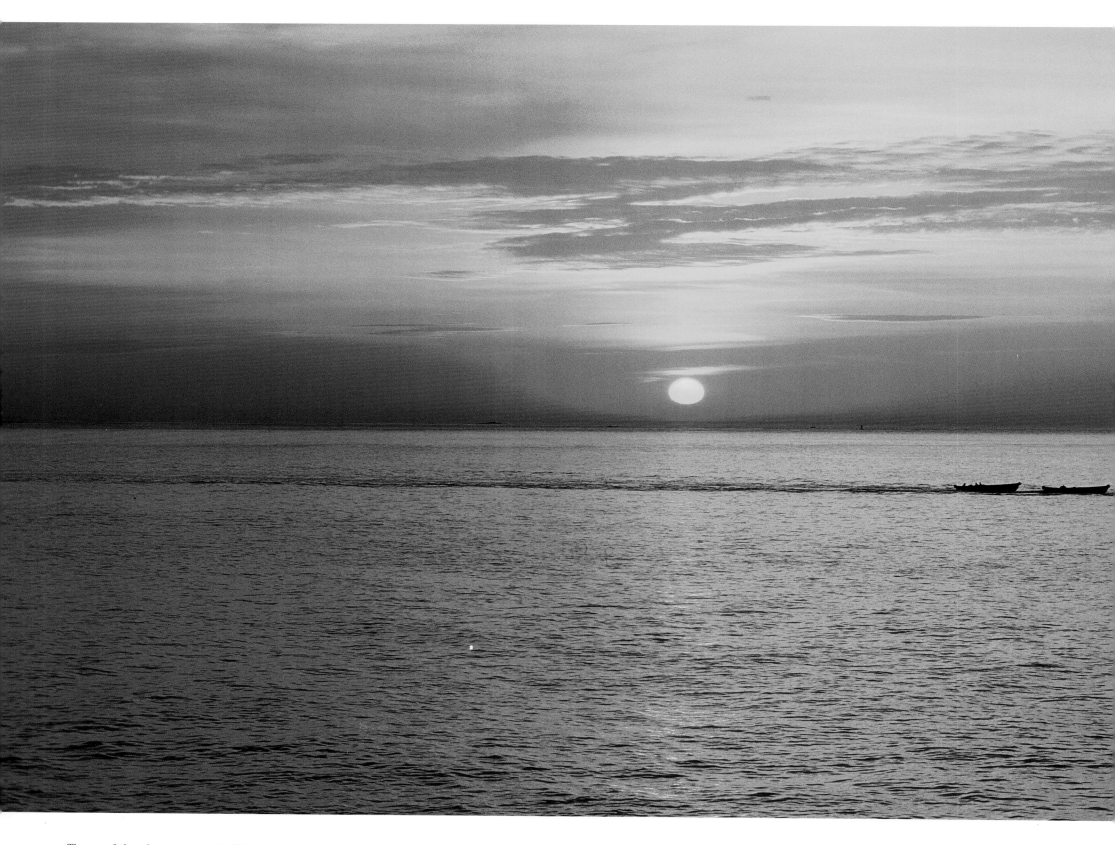

The trap-fishing boats steam to the fishing
grounds at daybreak off Beavertail, Jamestown,
Rhode Island.

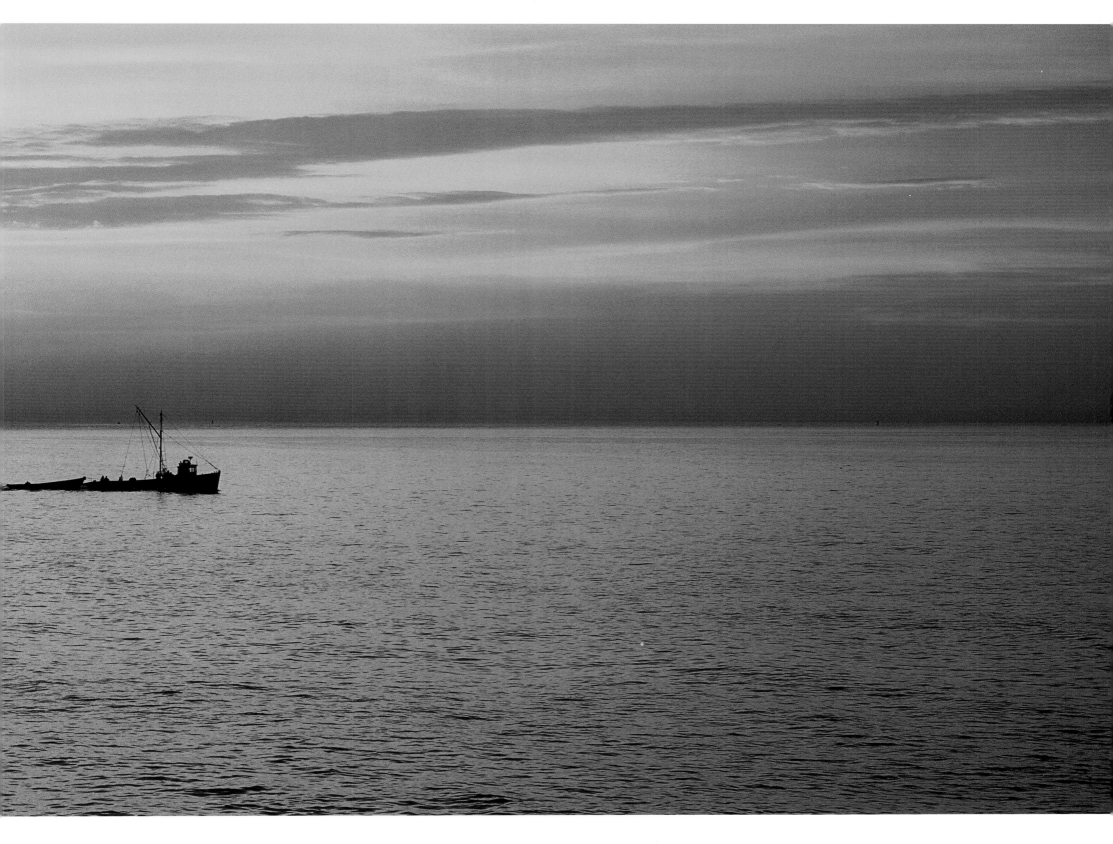

The Maritime Tradition

The Maritime Tradition

A love of the sea has been a part of my life since my earliest days growing up in Holland, and an appreciation of the maritime tradition was in my lineage long before I was born. My family has blood thick with sea salt, as both of my grandfathers were men of the sea. One was a lighthouse keeper on a small island off the south coast of Holland, and the other spent every minute of his leisure time sailing, fishing, and rowing the country's inland canals.

When I was a young boy I moved to South Africa with my family. My father bought us a small boat so we could explore the lakes and ponds and seek adventure in nature. When I turned fourteen, I worked on large commercial fishing boats that docked nearby in the seaport village of Hout Bay. Spending long weekend days on the water with old salts and exploring on our little sailboat furthered the passion for the sea that my grandfathers had ingrained in me. As I grew up I spent as much time as I could helping to maintain other people's boats just so I could spend time listening to their sea tales and stories of racing. At night, I dreamt of sailing across oceans. During this time I learned that the history and traditions of boating were a major part of the experience of being on the water, and I hoped to one day contribute to that tradition.

All sailors have a deep respect for the customs that preceded them. It is something I am teaching my children about now, and it is something I am more and more in awe of. It is easy to see the influence of the maritime tradition when looking at a collection of photographs such as this one. These photographs never lose their relevance, and they hold a certain dignity that speaks to us.

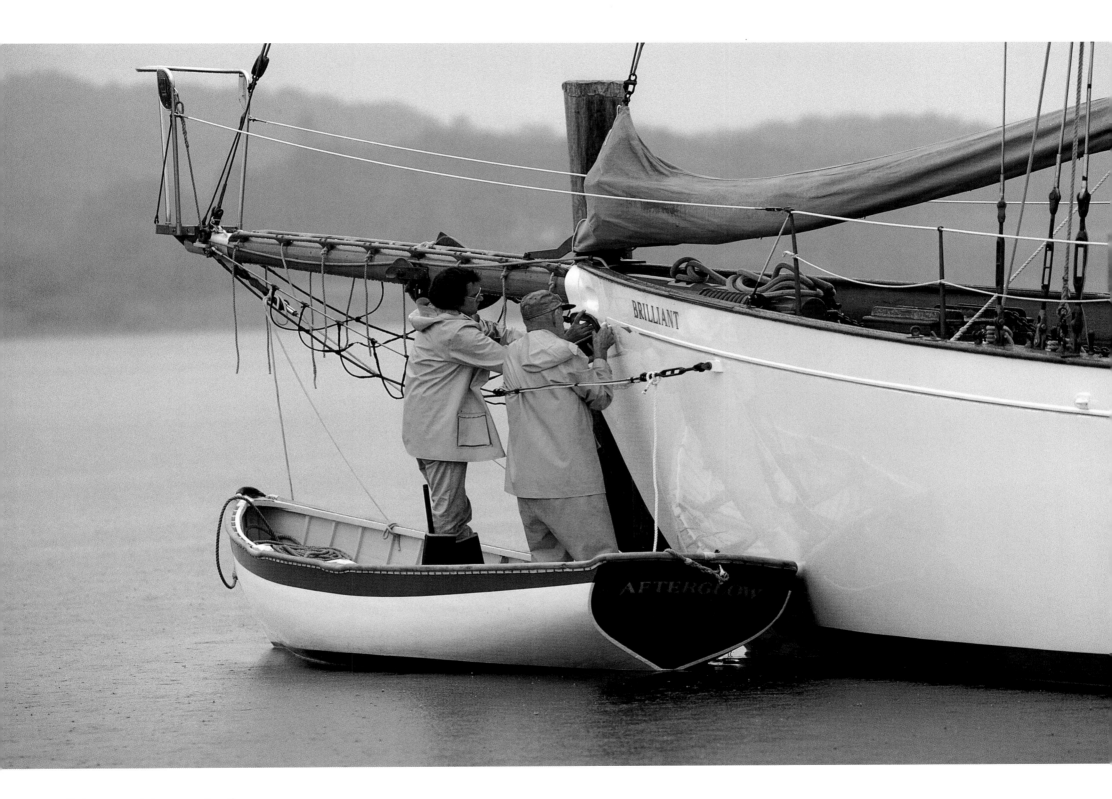

Doing some maintenance work on the
schooner *Brilliant* at Mystic Seaport, Mystic,
Connecticut.

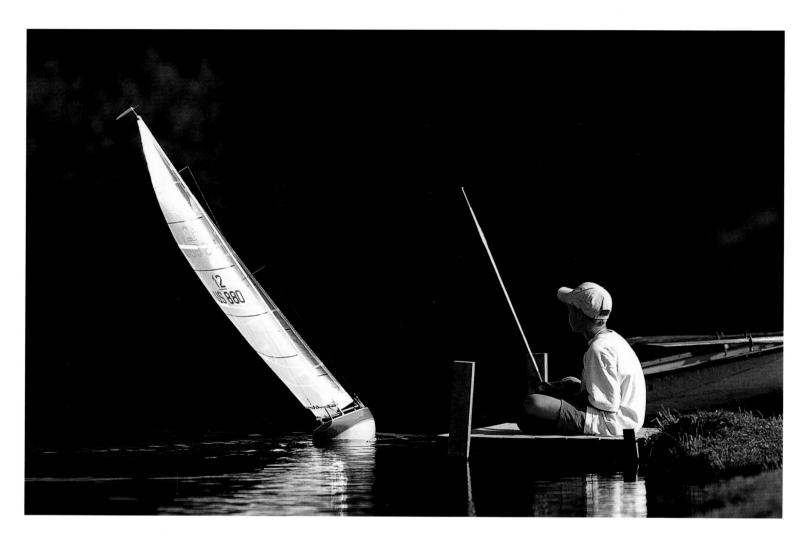

ABOVE

Finally my turn! A young boy gets a chance to sail his father's radio-controlled 12-Meter sailboat on a pond in Stowe, Vermont.

OPPOSITE

The tanker *Skowhegan* enters Narragansett Bay in Rhode Island on a wintry December afternoon.

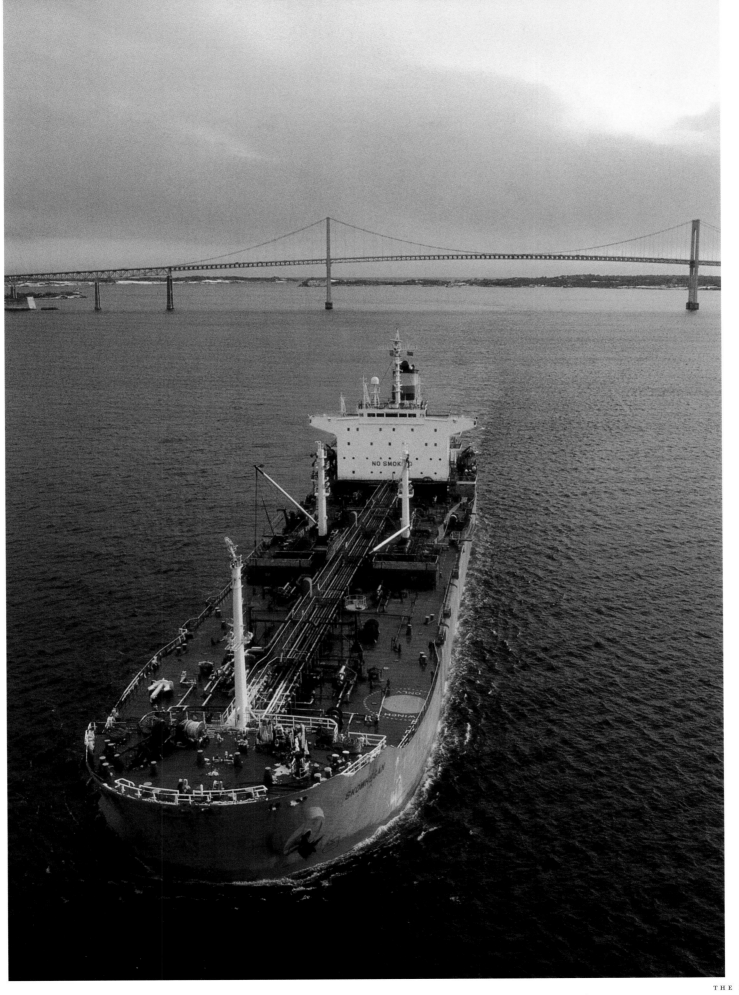

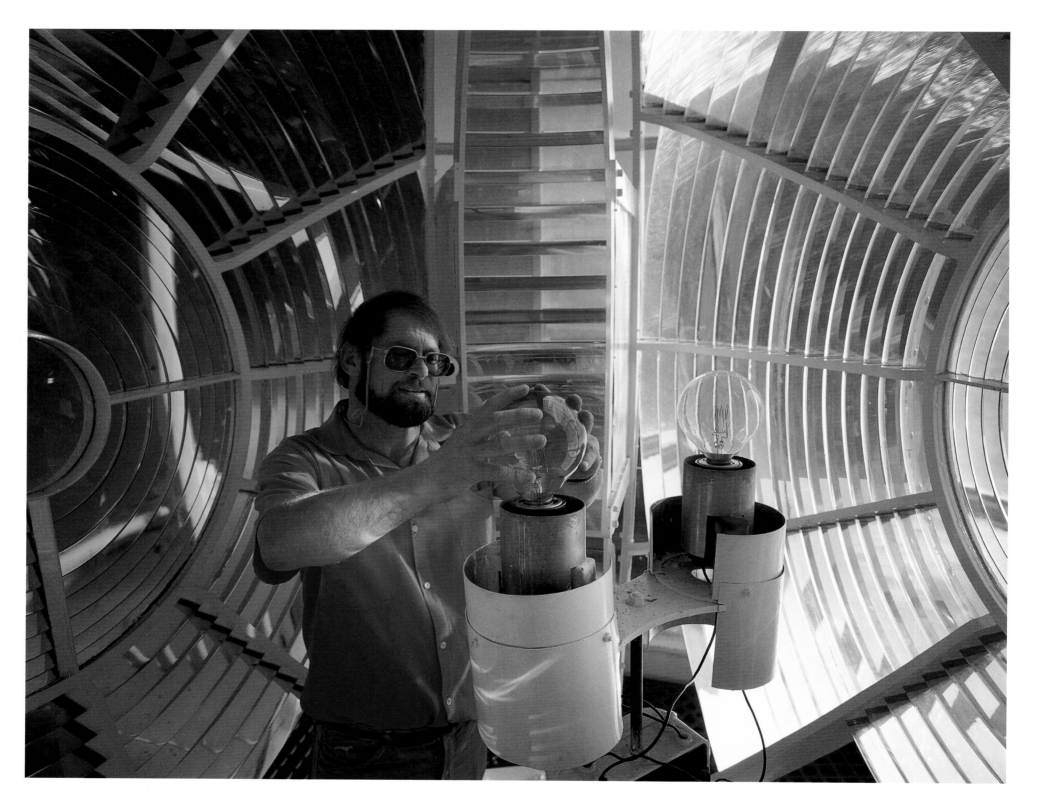

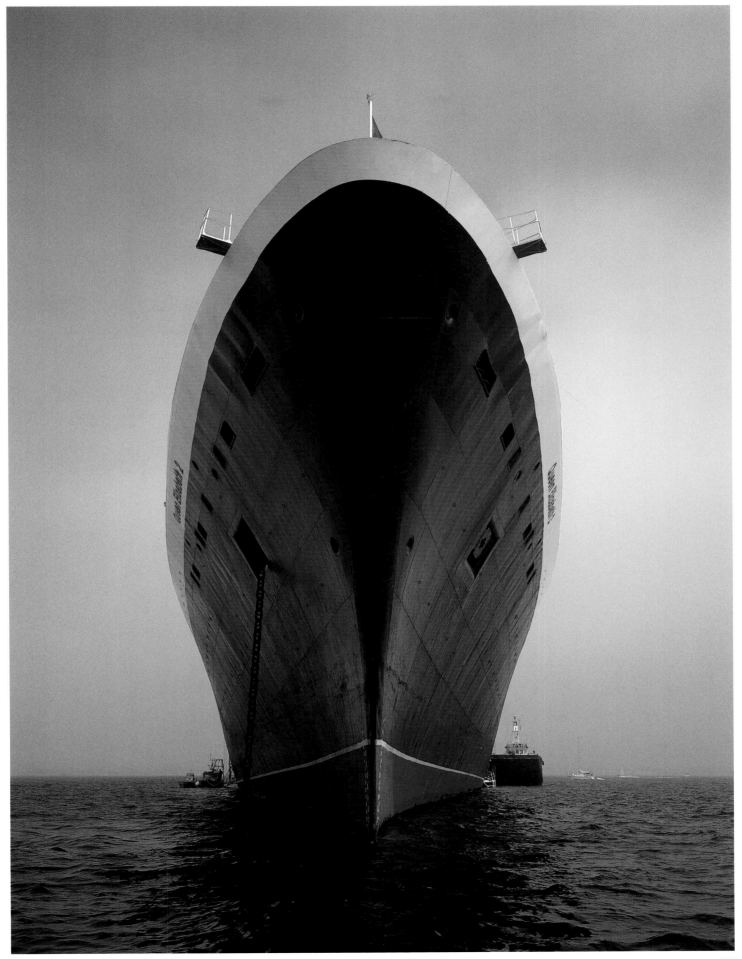

A small Dutch Tjotter in the Friesian town of
Sneek.

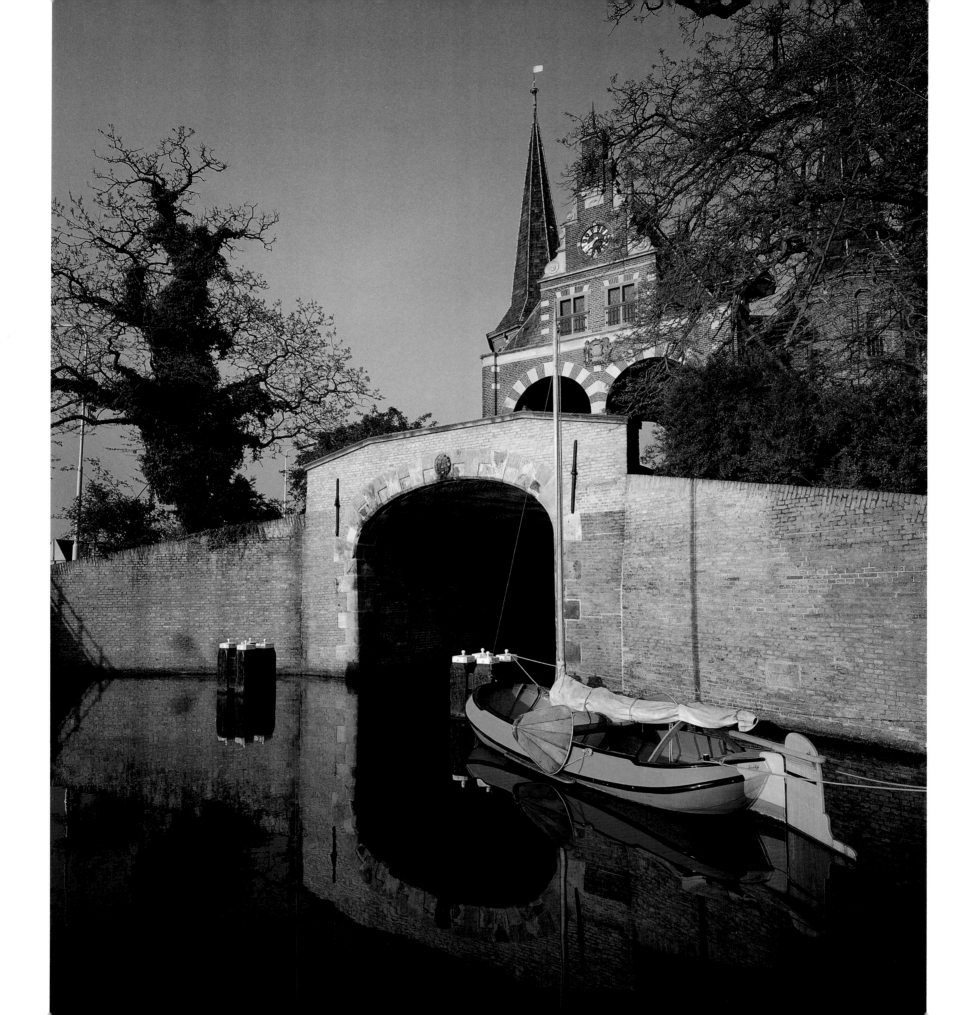

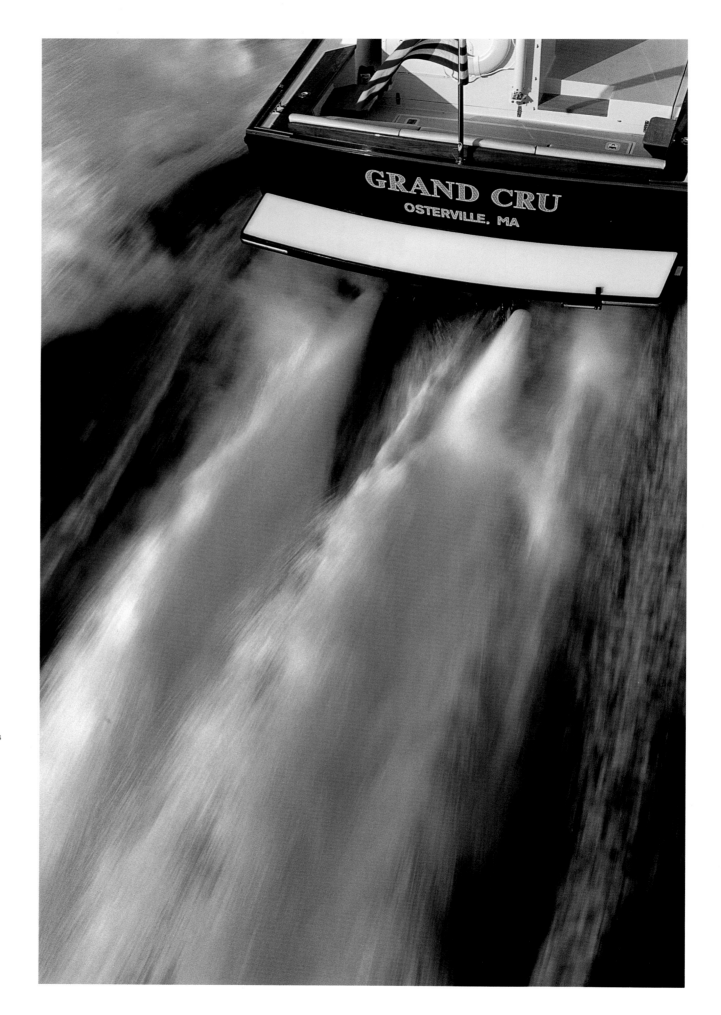

Grand Cru, a Little Harbor Whisper Jet, speeds along, her jets shooting columns of water toward her wake.

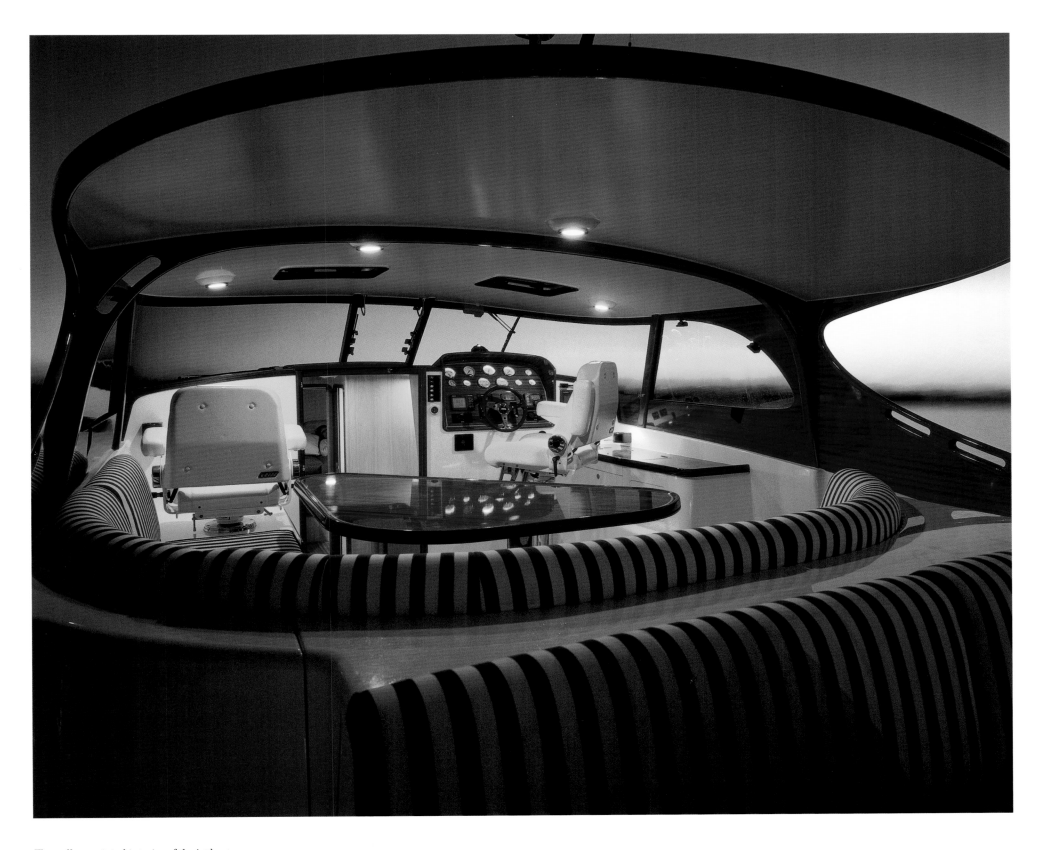

The well-appointed interior of the jet boat
Crazy Horse at sunset.

Wooden motorboat bow detail.

Rudder detail of the Russian tall ship
Kruzenstern at anchor.

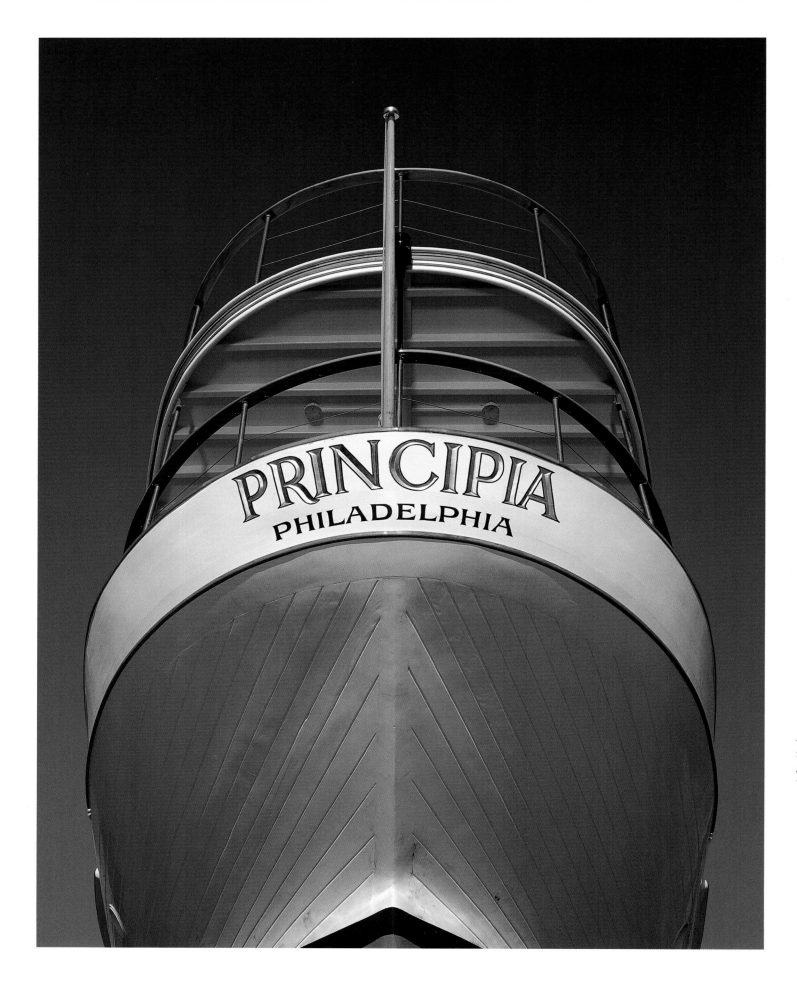

Principia, a classic wooden motorboat ready for a dry-dock spell and some paint after a hard season chartering up and down the U.S. East Coast.

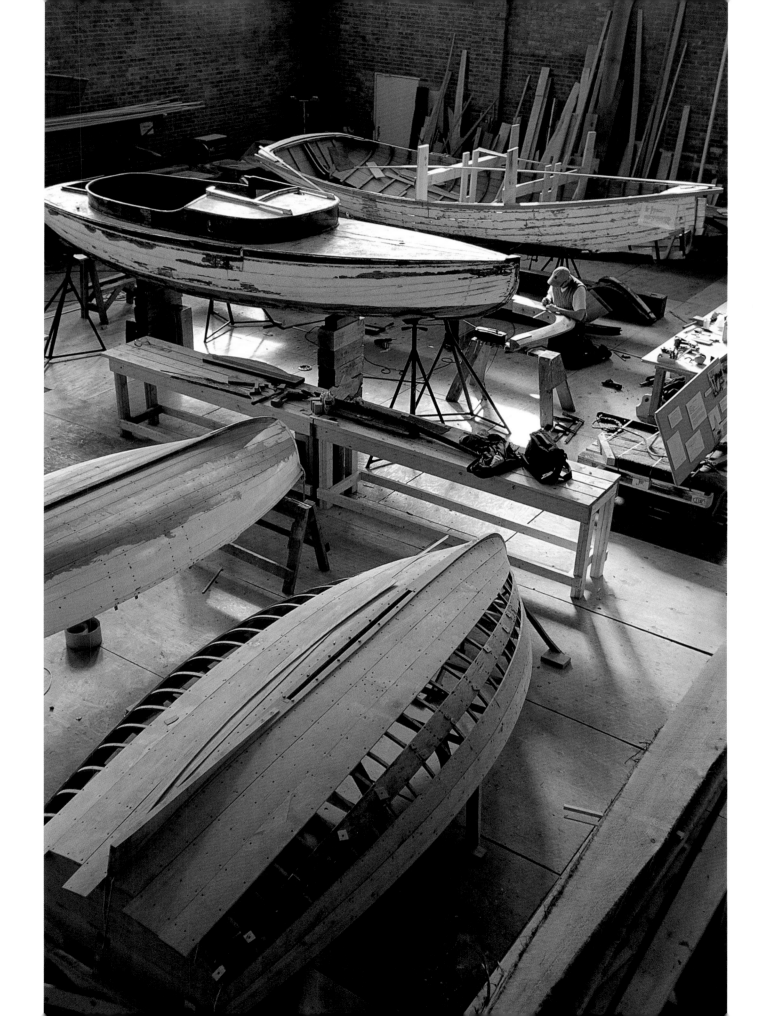

The International Yacht Restoration School
shop in Newport, Rhode Island.

OPPOSITE

A local fishing boat on the beach at Puerto
Montt in Chile.

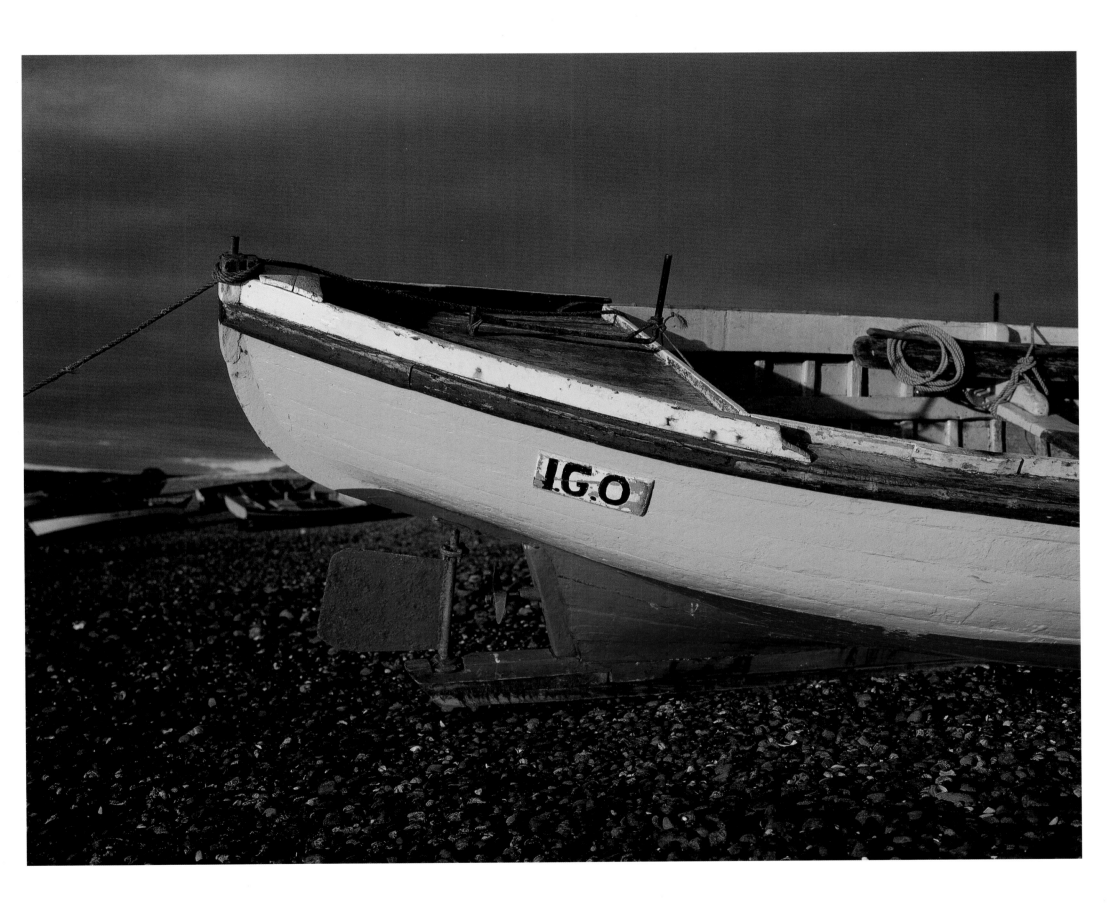

J-24's racing under the Newport Bridge
in Rhode Island during their Thursday
night series.

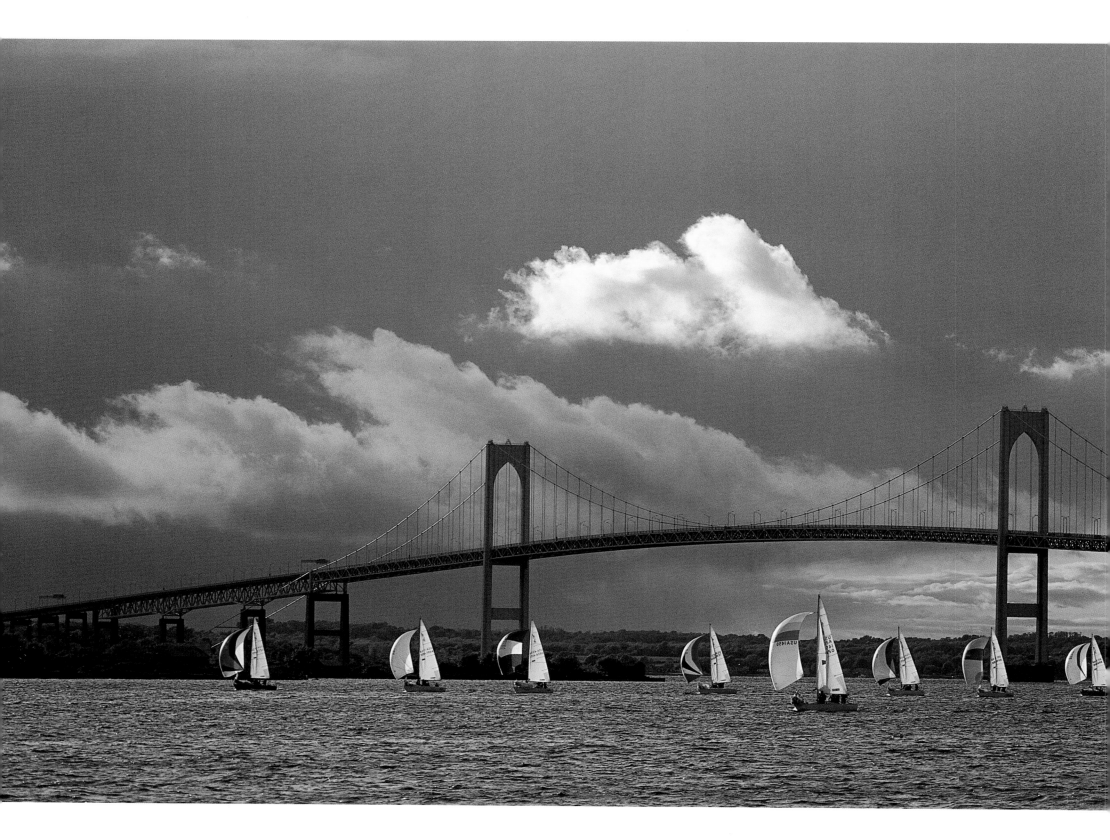

Racing

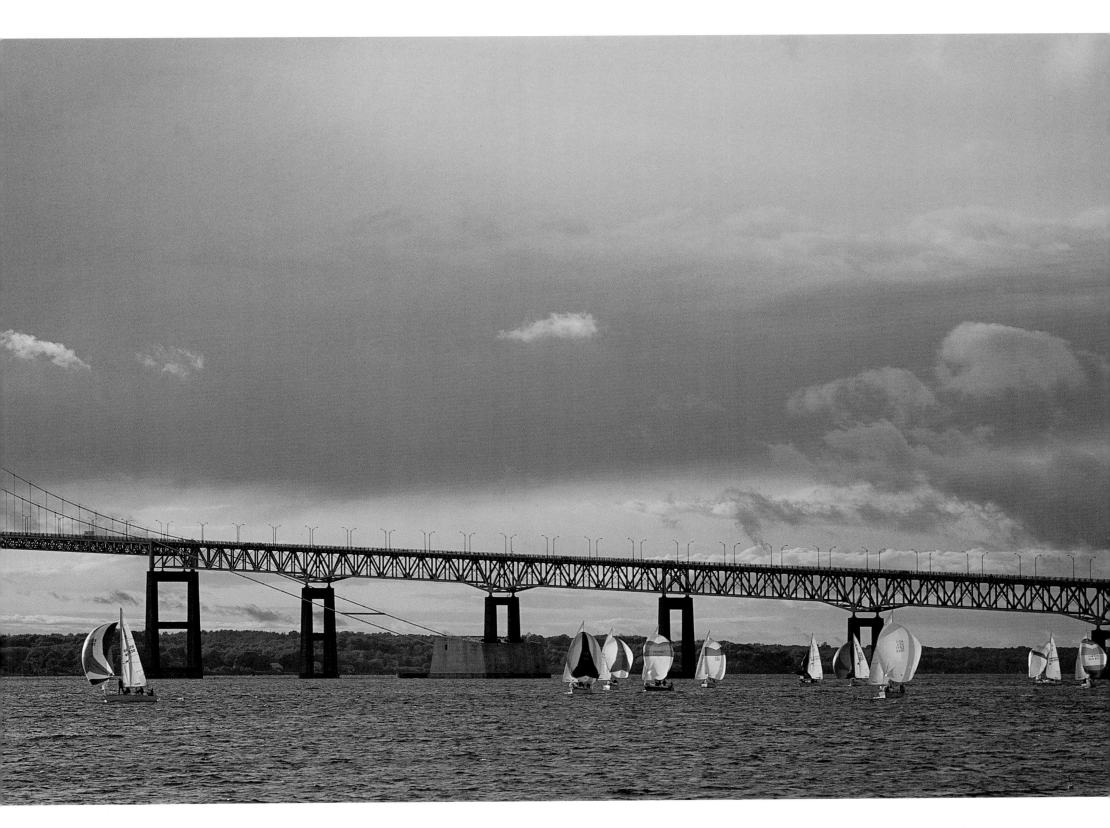

Grand Prix Racing

Grand Prix racing is sailing competition at the highest level. The best sailors in the business are employed and flown all over the world to compete, crews are constantly working to keep their boats on the cutting edge of technology, and owners spare no expense in making their boat the fastest it can possibly be. New boats, keels, rigs, and sails are turned over at an astounding pace to try to keep an edge on the competition and get that extra tenth of a knot of speed to stay ahead. The photographs may lose their timeliness, sometimes even right after an event when a hot new sailcloth comes out, but they never lose the intensity of racing these machines. While qualification rules for Grand Prix racing vary from race to race, the superior level of competition remains the same.

On the day of a race, the dock where the crews prepare the boats is a hive of activity. A few minutes before takeoff time, the best of the best—the rock stars, as they're sometimes known—parade down the dock and strategize with the owners or greet the onlookers and other boat crews. They take a big step onto the racing machine, the lines are let go, and the show begins as the boat motors out to the racecourse.

Very few people get to see the racing up close, but for those privileged ones on the race committee boat, photo boats, or handful of chase boats, it's an action-packed show of carbon and other space-aged materials as the boats duke it out to be first across the line. The view from the photo boat is close and exciting, especially since the competitors sometimes do not welcome the close proximity the photographers like to keep to the action. I always say that if you are not shouted at at least once a day, then you are not close enough to get the real flavor of the race.

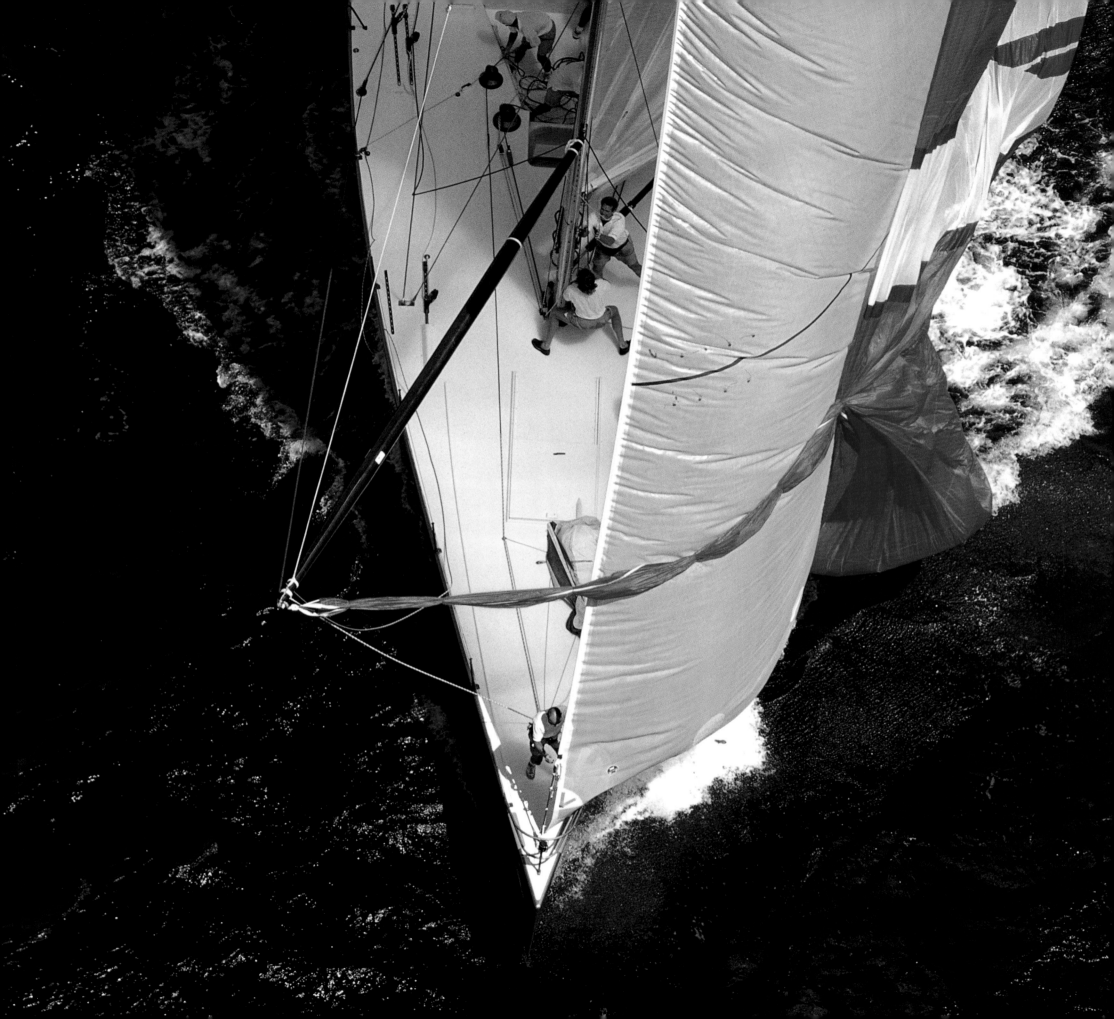

When you are photographing Grand Prix racing, having the right driver and chase boat will make or break your day on the course. In my experience, if you are lucky enough to find a sailor who normally races but is temporarily out of work and is looking to watch the races close up, you are in for a great day of shooting. These guys know the game and can watch the moves of the boats to keep you in the right place. Plus, having two sets of eyes looking for the action and helping to avoid being run down are key.

So much of shooting this type of photography is about timing and a little bit of luck. Being in the right place when the puff hits the fleet or when there is a huge pile-up at the top mark gives you the edge. On a racecourse you do not have the freedom to go where you think the light or the perspective is best; you are strictly kept to certain areas, which makes it much more difficult to get exactly what you want. When weather, technology, and action meet on the course, I am often lucky enough to go back to the dock armed with images of the drama and intensity of the day's competition.

OPPOSITE
Two Australian boats duel during a downwind leg of the Kenwood Cup.

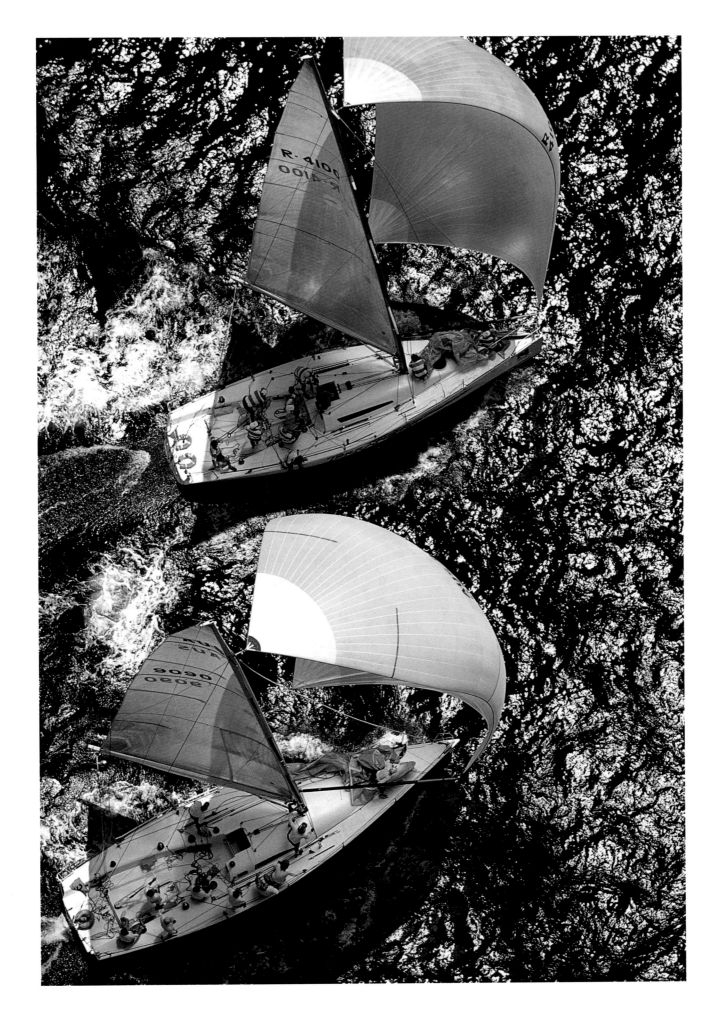

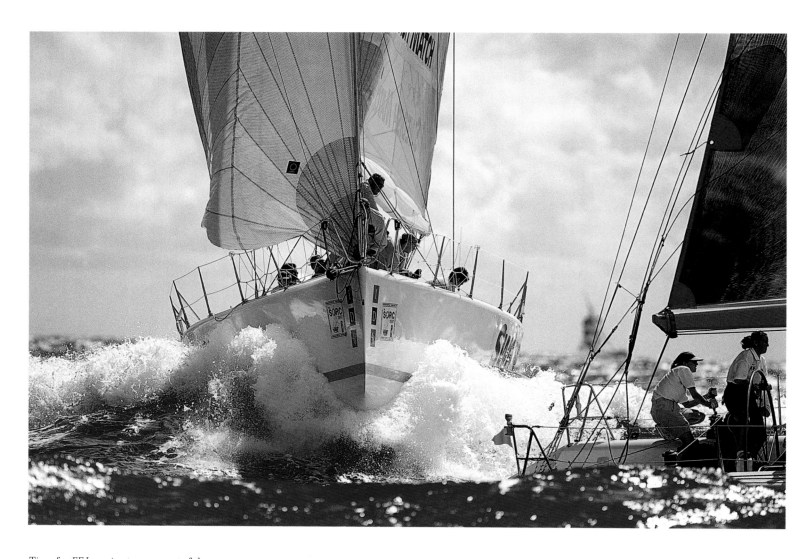

Time for *EF Learning* to move out of the way of 1D 48 *Swedish Match* during the Southern Ocean Racing Conference held off Miami, Florida.

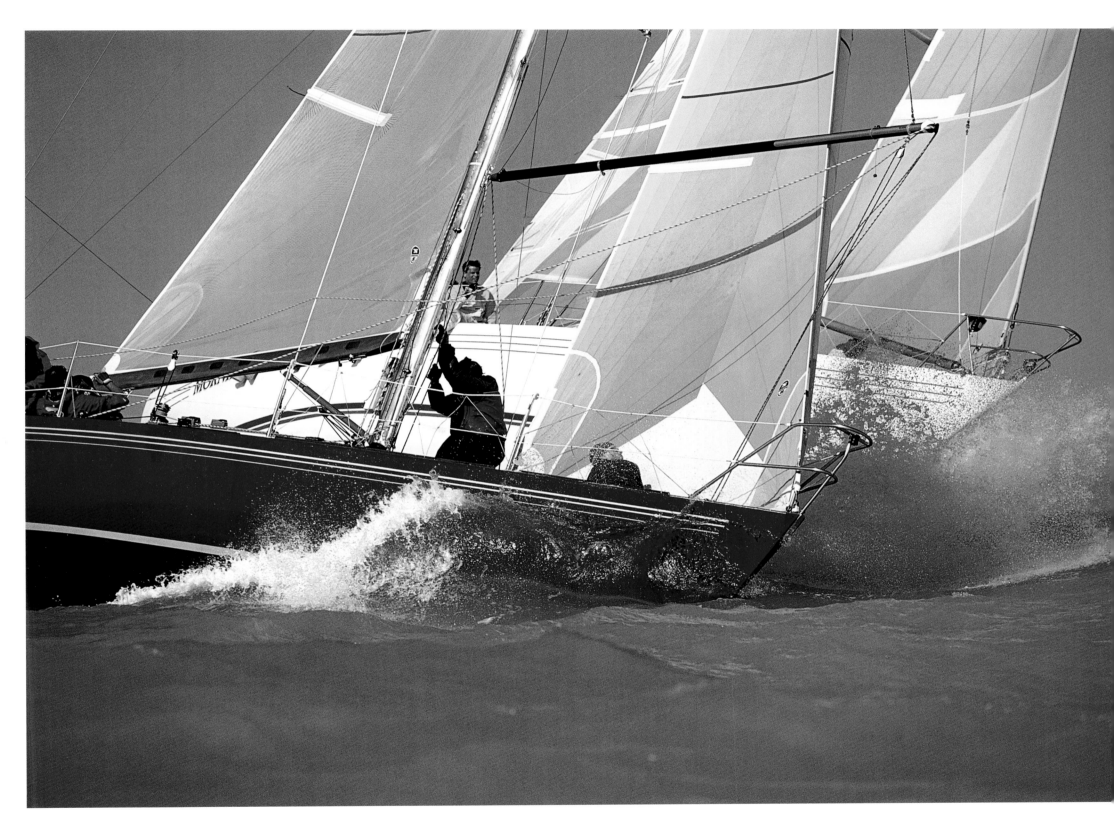

V Max has a good commanding position
going into the weather mark during Key West
Race Week.

Ninety Seven tries to point and gain on her
windward opponent during the Kenwood Cup
off Waikiki Beach, Hawaii.

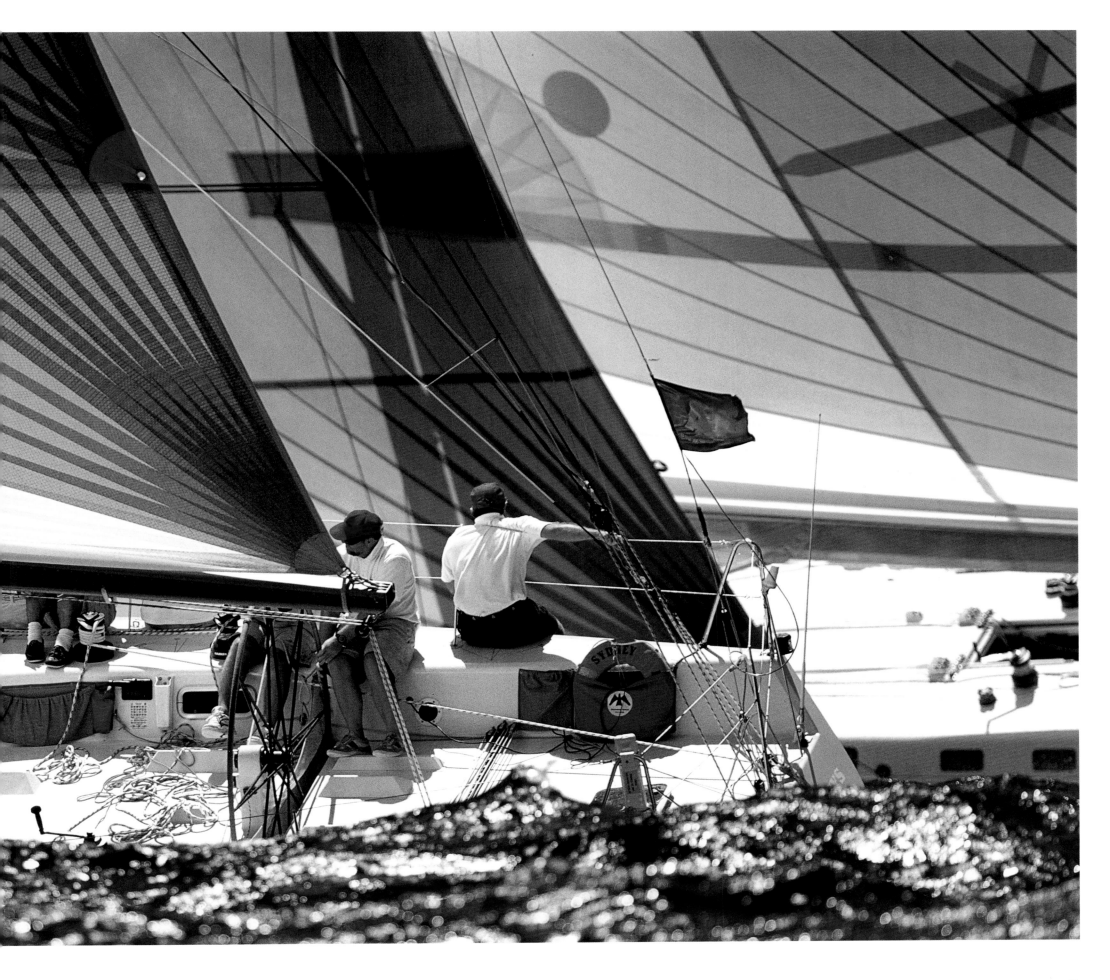

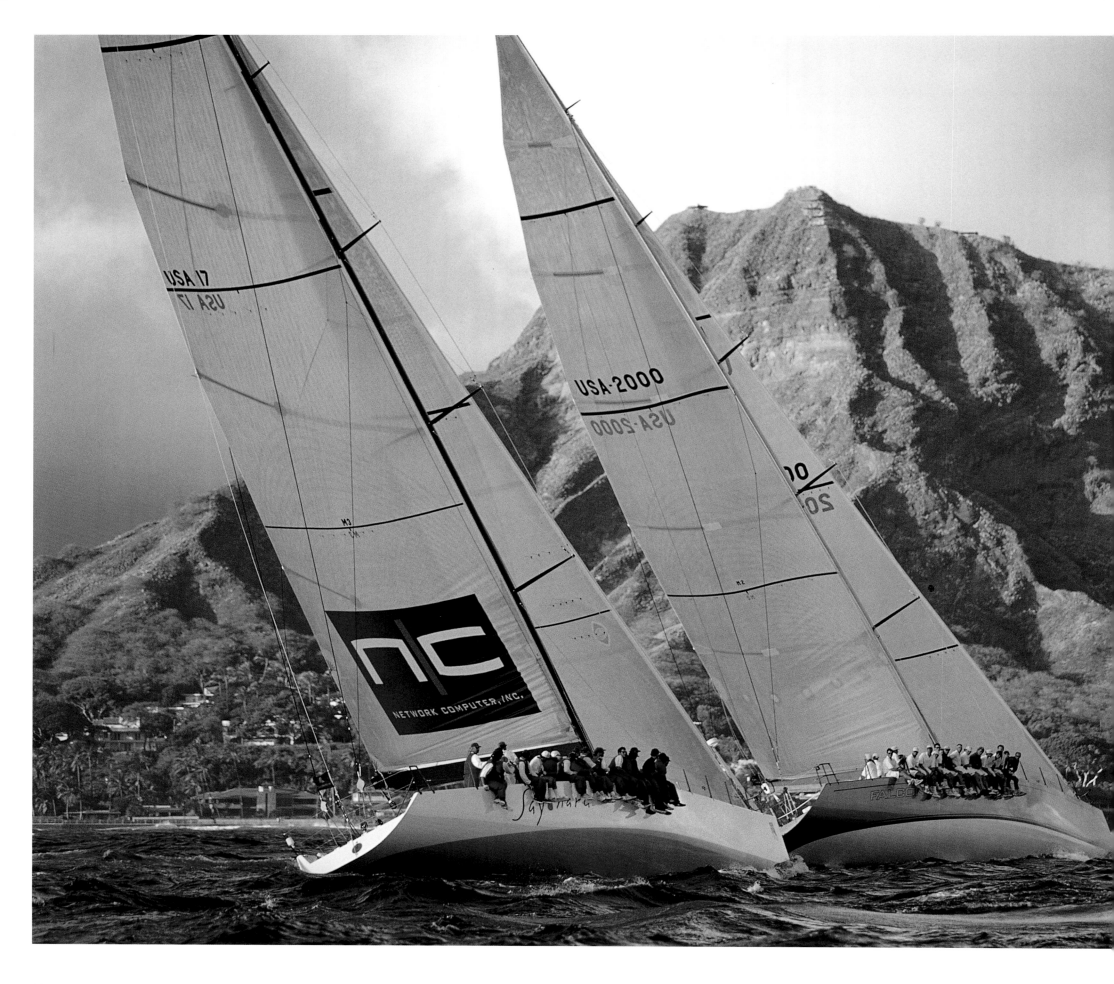

Sayonara and *Falcon 2000* duke it out at the early evening start of the Molokai race during the Kenwood Cup.

Indulgence leads the way around the windward
mark during the Southern Ocean Racing
Conference held off Miami, Florida.

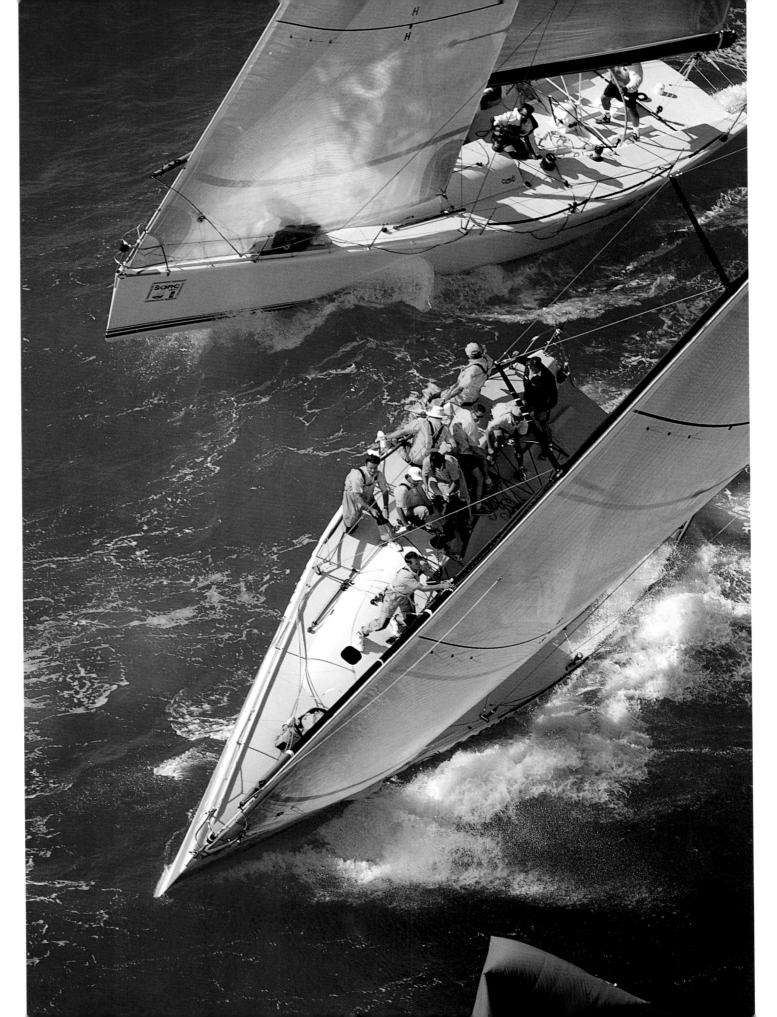

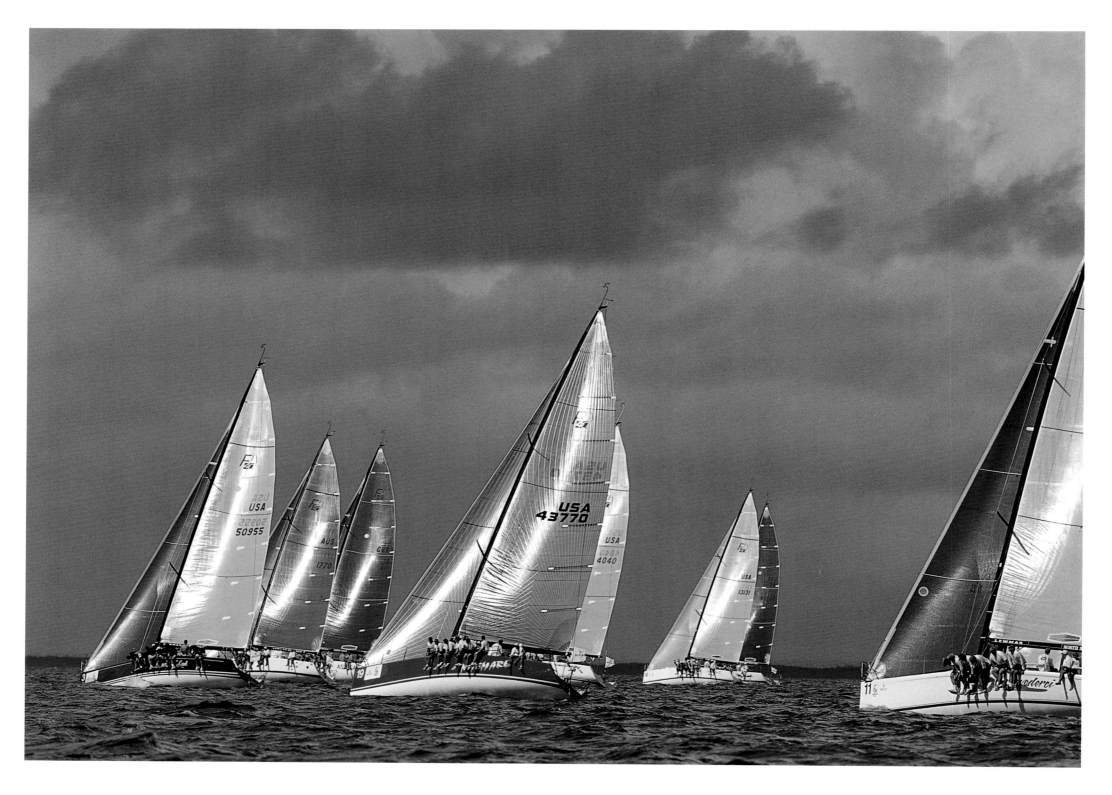

Action during the 2001 Farr 40 World
Championship held off Nassau in the Bahamas.

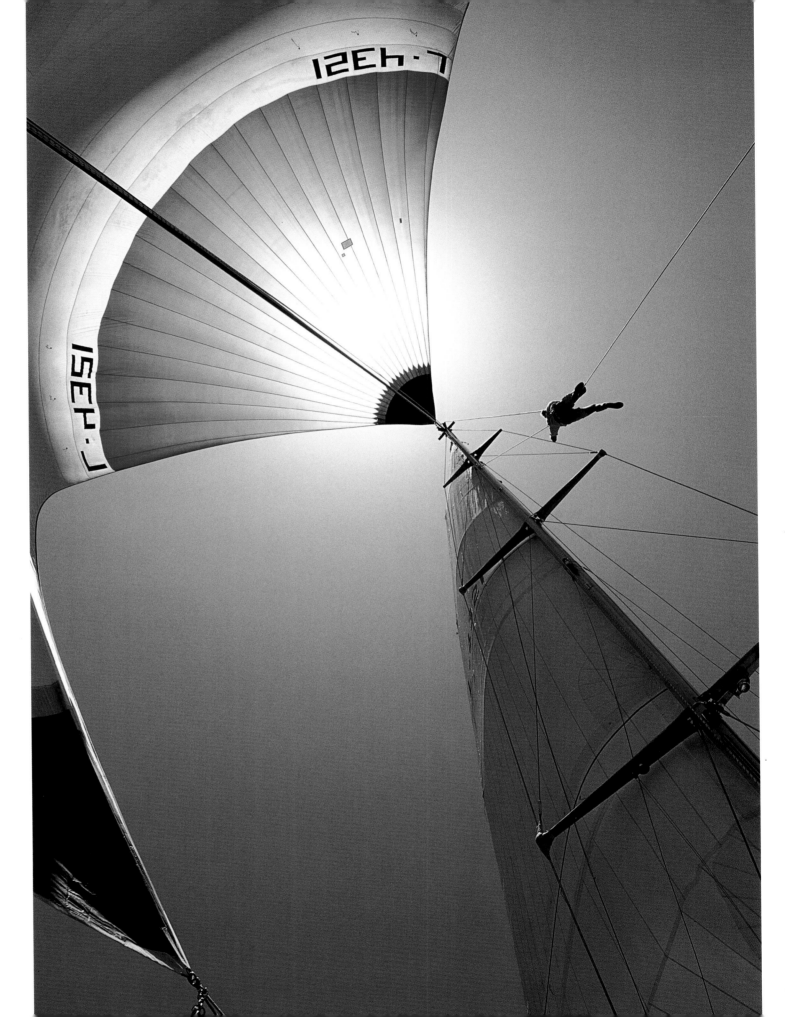

The bowman on *Colt International* goes
aloft to check the spinnaker during Antigua
Race Week.

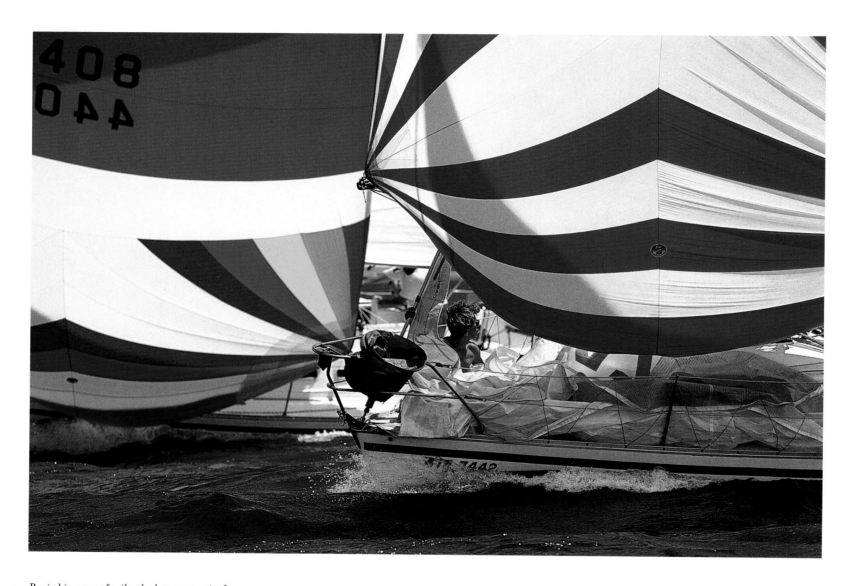

Buried in a sea of sails, the bowman waits for the call from the back of the boat to hoist the headsail during the Youngstown Regatta in Youngstown, Ohio.

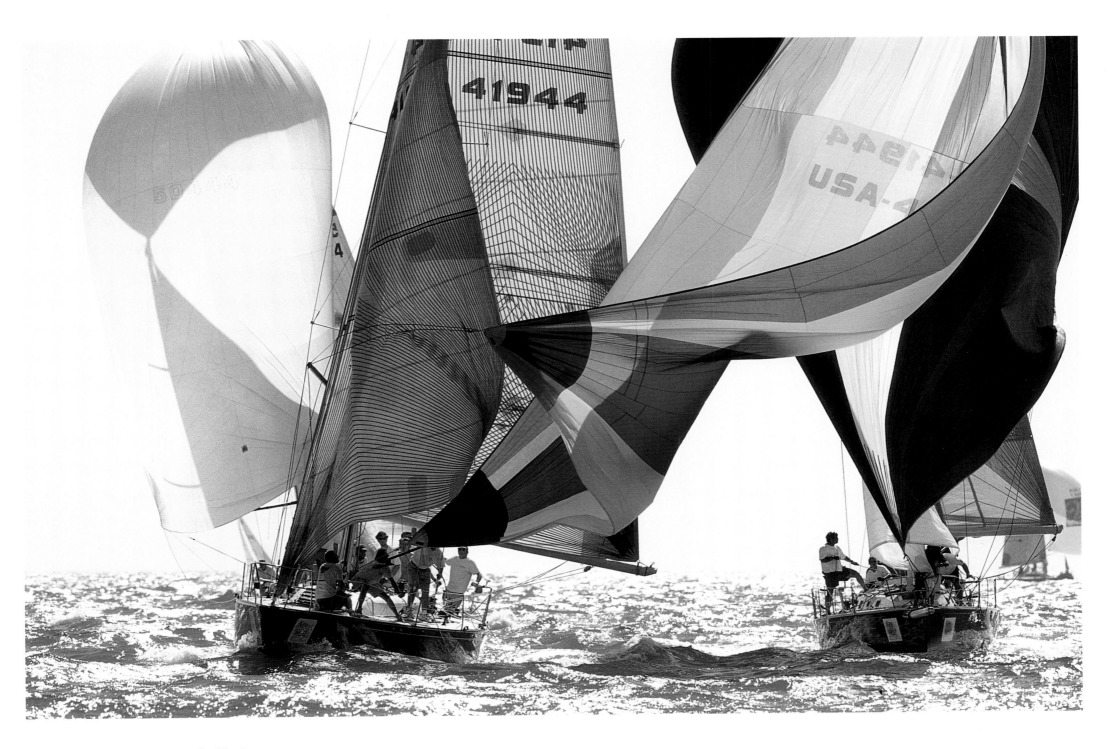

Spinnaker takedown during Key West Race
Week, Florida.

An ominous sky during Key West Race
Week keeps the skippers on their toes as they
approach the leeward mark.

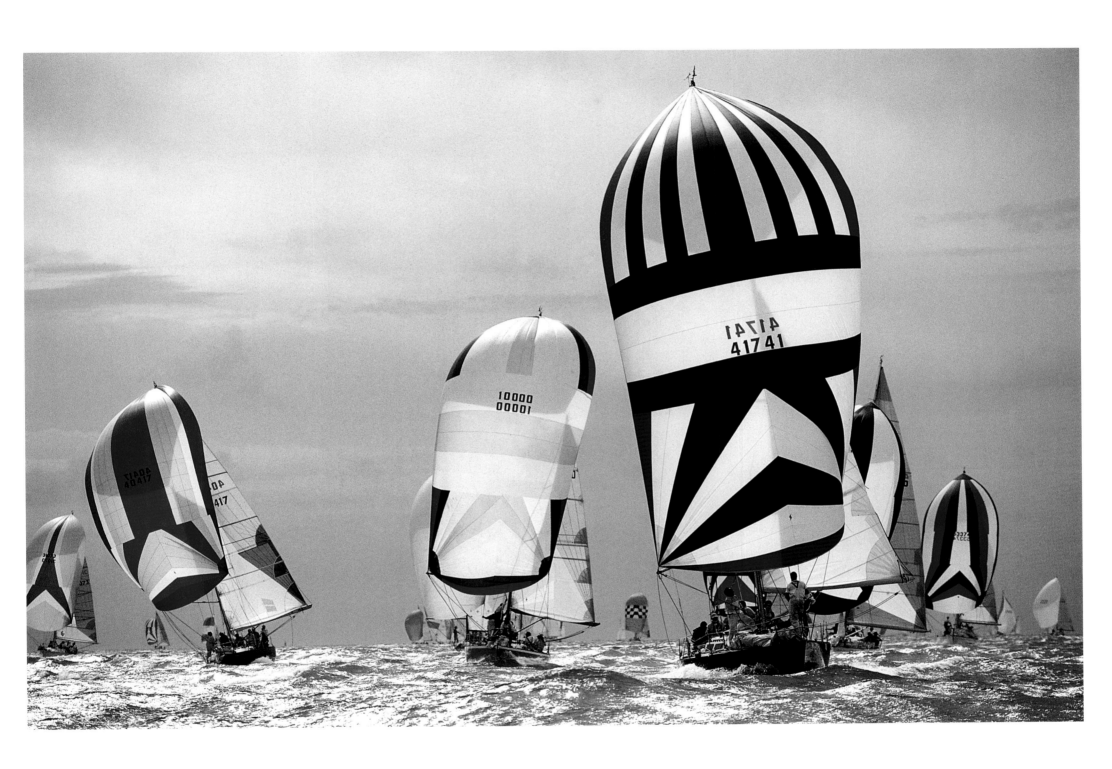

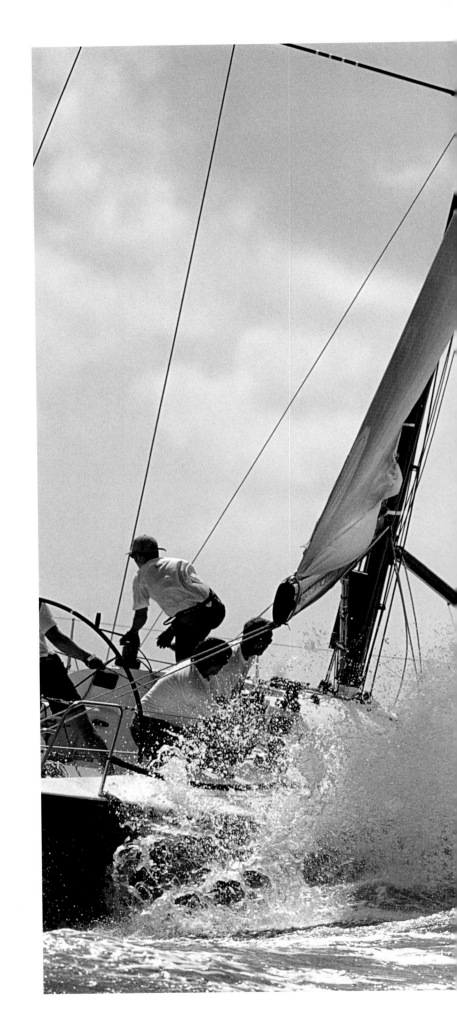

Indulgence in tight quarters during the
Southern Ocean Racing Conference.

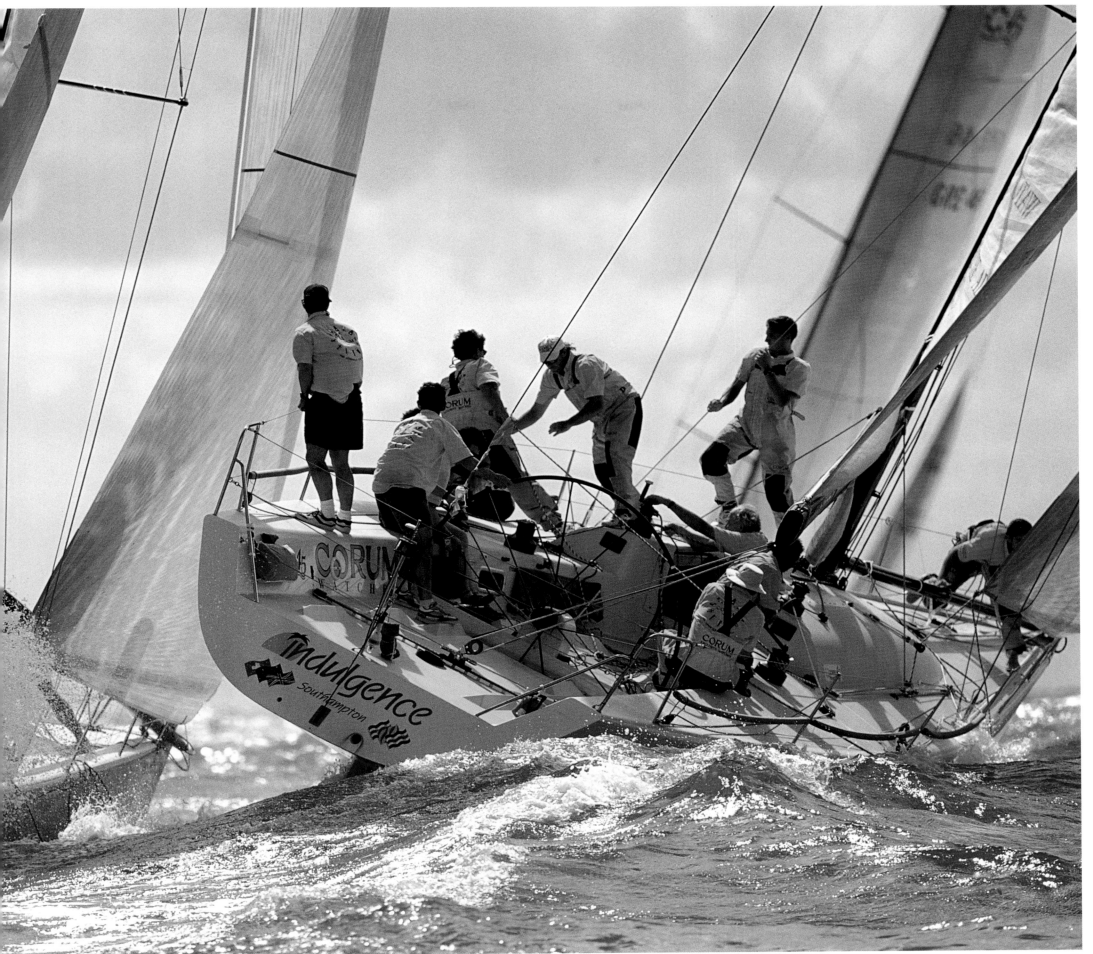

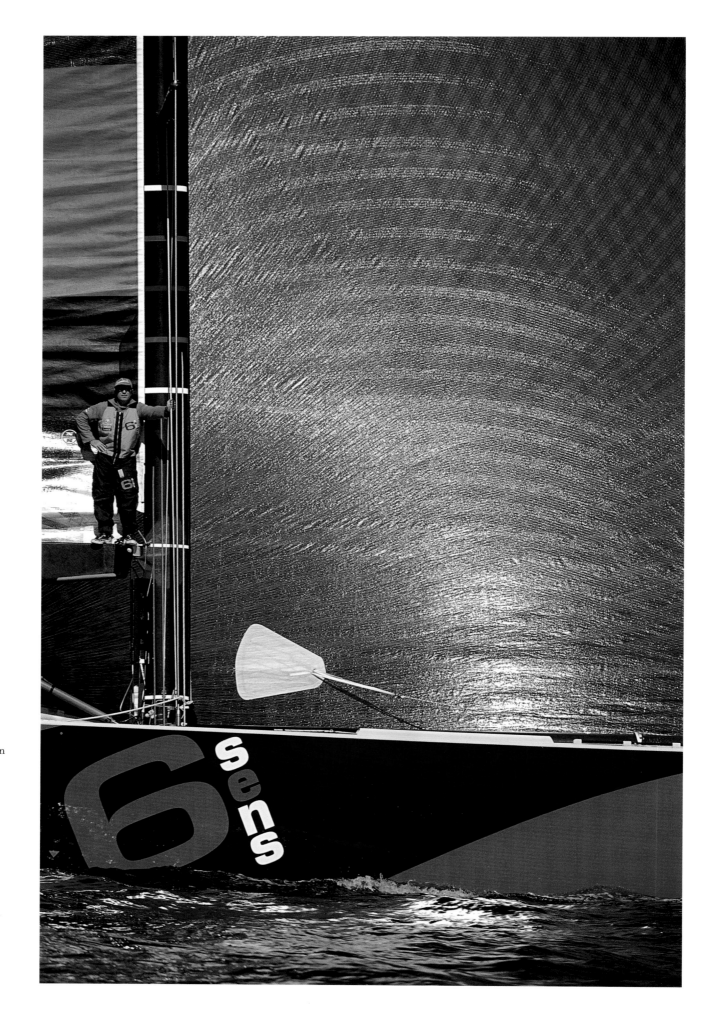

Looking for breeze onboard the French America's Cup entry in the 2000 Louis Vuitton Cup trials held in New Zealand.

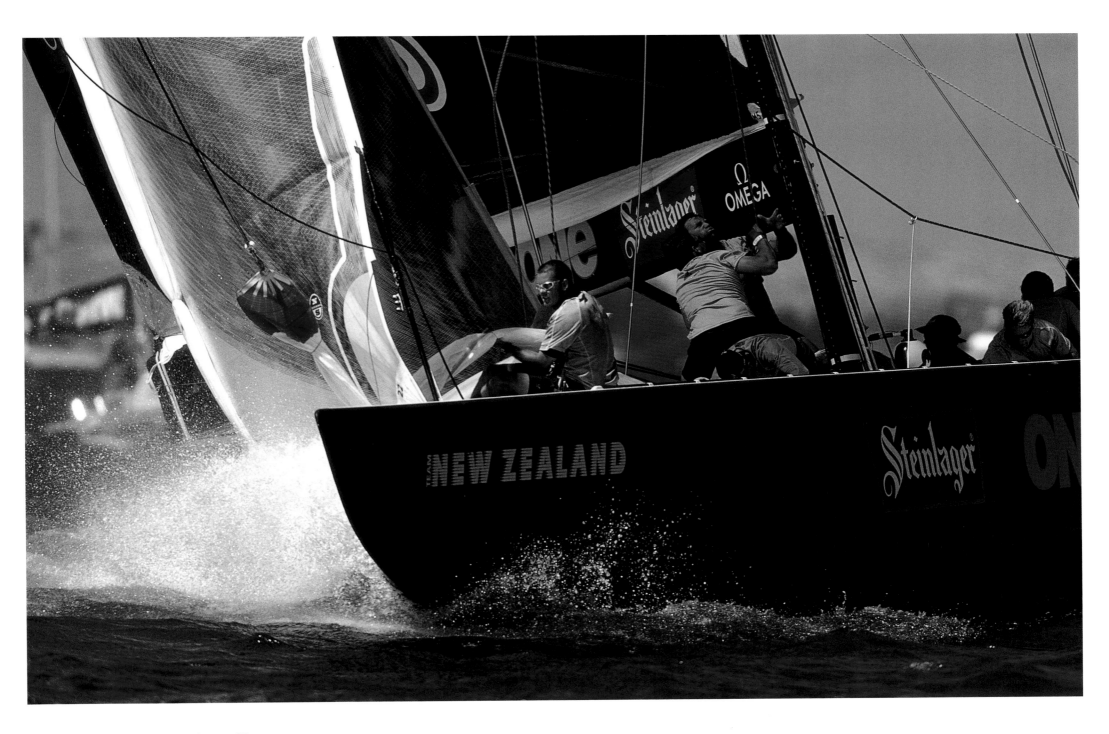

It's all muscle as the foredeck crew of Team
New Zealand hoists the spinnaker during the
2000 America's Cup races.

The Classics

Classic yachts, by definition, almost always have perfectly varnished wood, gleaming teak decks, and brightly varnished spars with acres of good old Dacron sails as a background. Genuine classics are made of wood or steel and were built at the time of or before the Second World War. They creak and groan as they work their way to weather, heaving their bellies over the swells, letting you know they have ridden the waves for longer than you or your father or grandfather have been alive. And the toughest classics are none the worse for the wear—the more salt on the decks the better.

Modern classics have either a new design with an old look or a new build to an old design. Both, however, have generous amounts of varnish and sails that look like they were built for the ark. Today's classic sailmakers use modern fabrics that look like canvas or old yellowed Dacron. The deck hardware is copied from the old look in bronze, but inside the winch and below the deck you'll find contemporary technology in use.

Classic boats are owned and raced by people who love their boats with a passion. These sailors spend time and money to maintain their boats so that they can keep them for a lifetime. It is always worth the investment, as the boats never go out of fashion, but they do turn heads and send curious sailors to her side to inquire, "Who designed her?" and "What year was she built?"

I have sailed onboard and photographed some of the largest classics, like the J-class yachts, which once ruled the Cup races, and also the smallest classics, such as the tiny Herreshoff 12½ boats; both large and small are steeped in history, beauty, and a great deal of owner love and appreciation. Photographers are always welcomed aboard by proud owners who extend sailing invitations and who chatter about her many years of racing and cruising. They are willing to share their stories and their yacht in hopes of acquiring a magical shot of their classic pounding through the waves, soaking her crew in salt spray, and burying her rail.

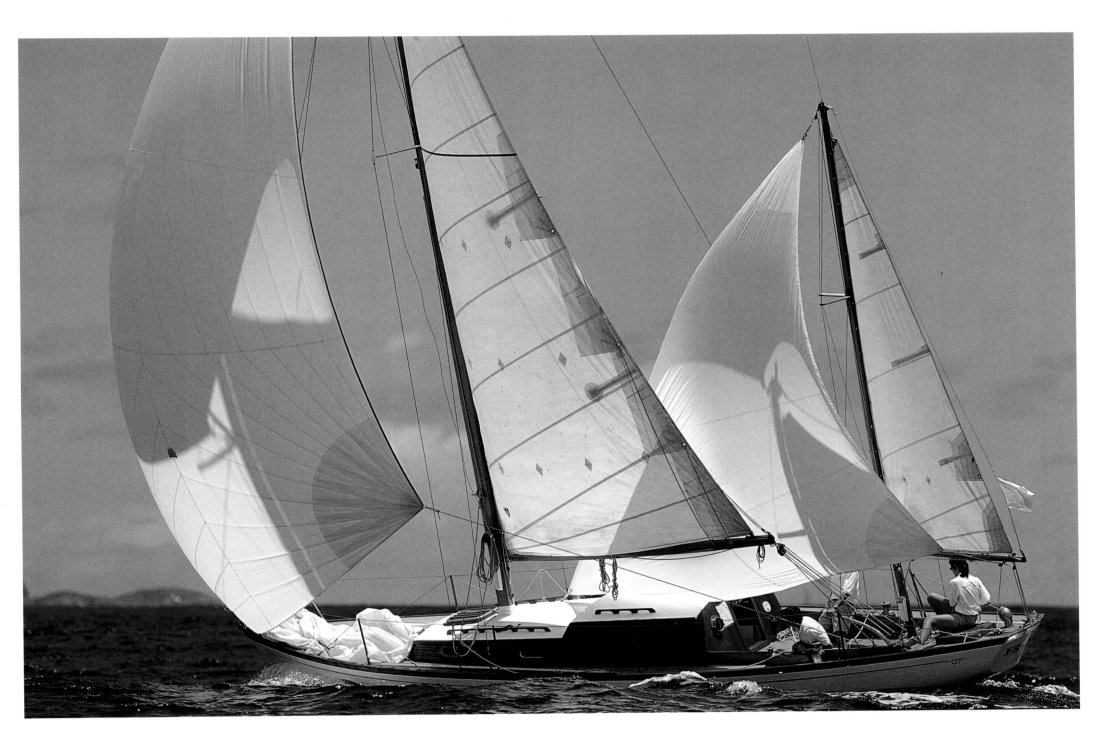

The Hinckley yawl *Fresia* has everything
flying as she close reaches to the finish during
Antigua's Classic Yacht Regatta.

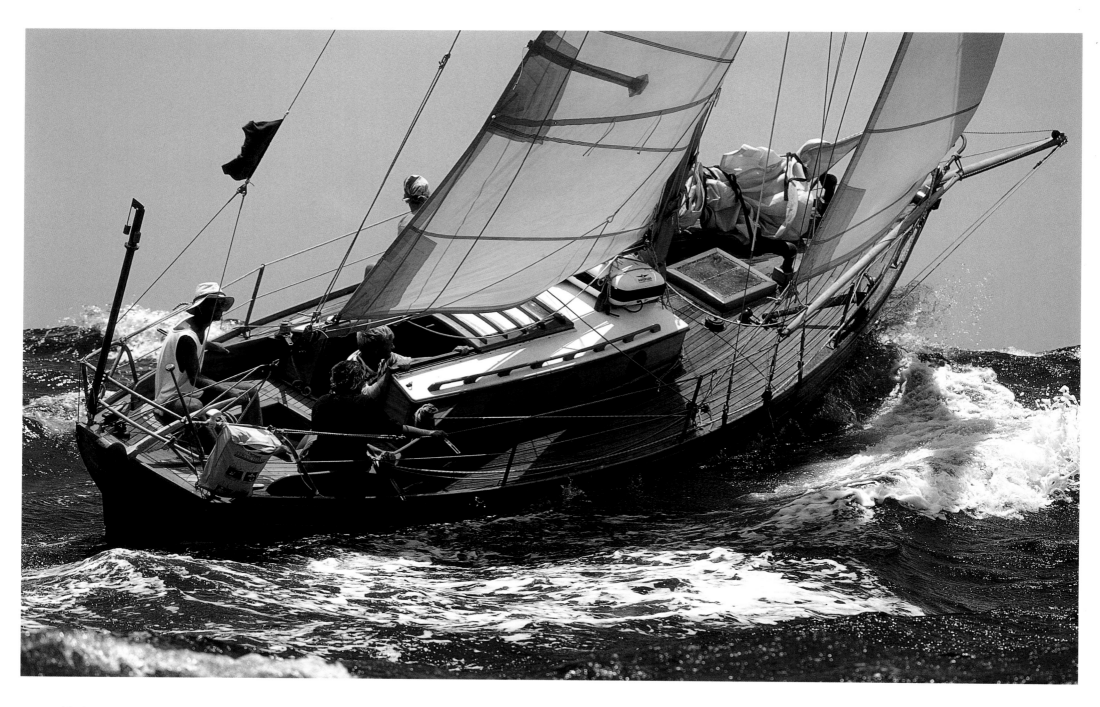

A little wooden sloop rides over a large Atlantic
swell during the Antigua Classic Yacht Regatta.

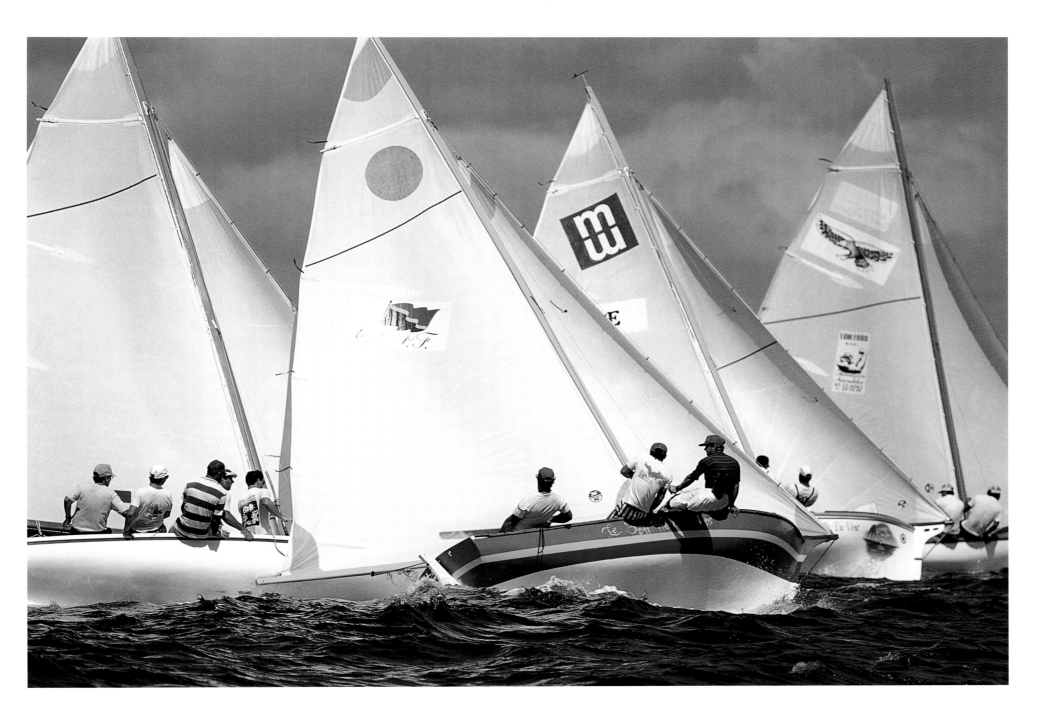

Canot Saintois racers take a chance at the start of this Saturday afternoon race off the town of Gustavia, St. Barths, in the French West Indies.

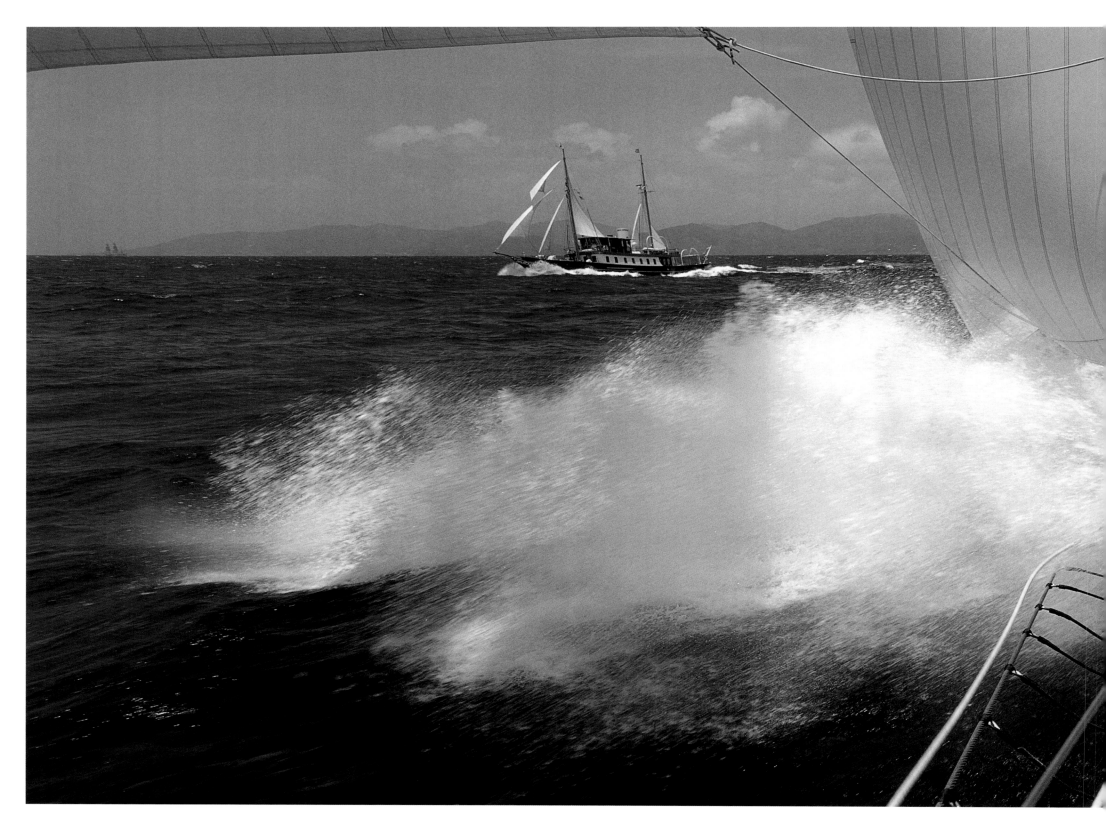

The 1918 Herreshoff schooner *Mariette*, watched
by her tender *Atlantide*, slams along a tight reach
during the Antigua Classic Yacht Regatta.

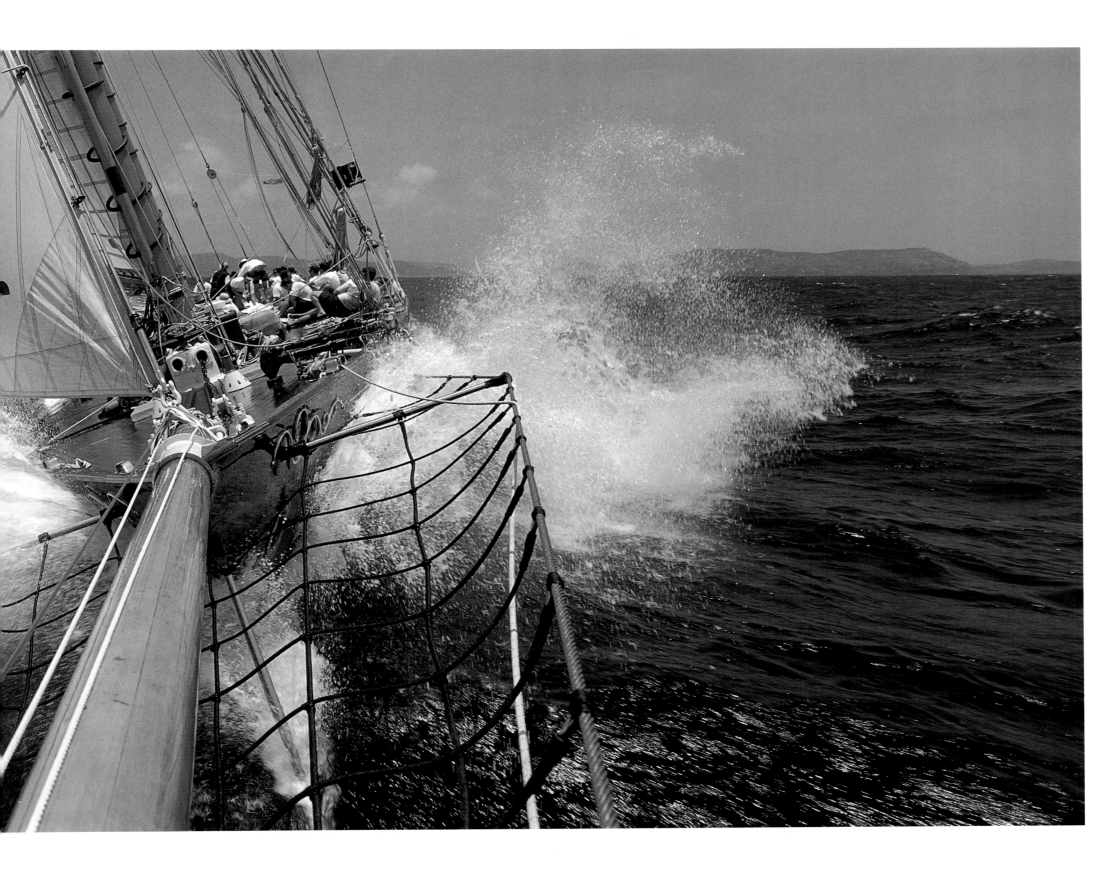

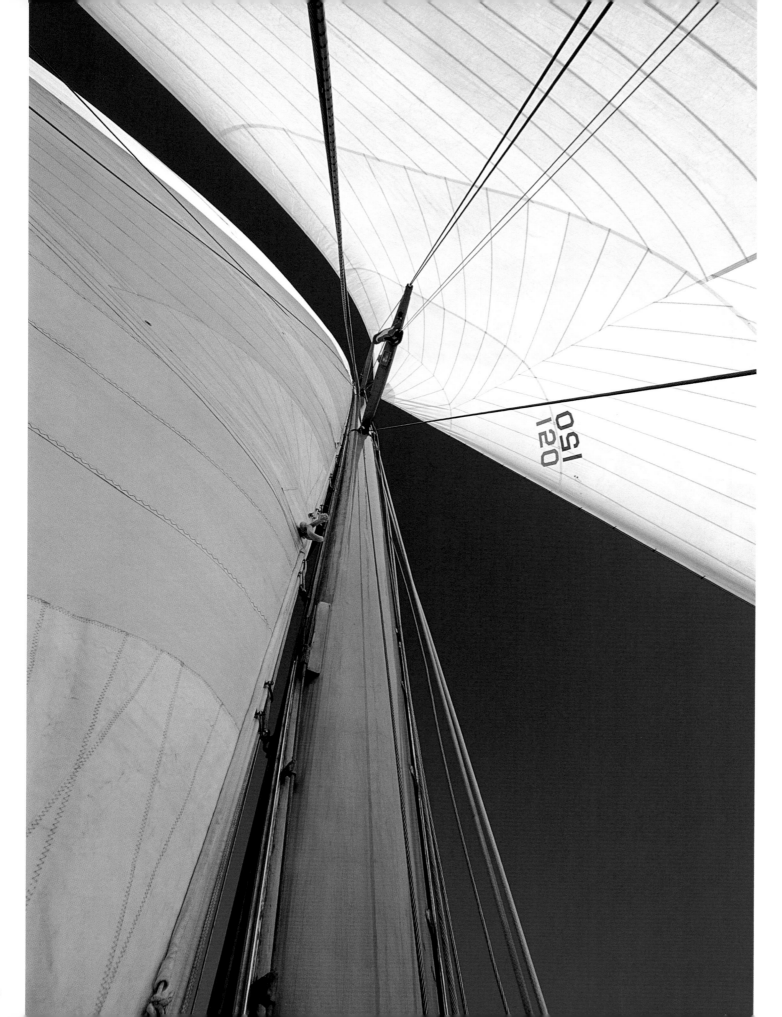

LEFT
Looking up the rig of *Nirvana*, a sixty-five-foot Hinckley sloop designed by Alden.

OPPOSITE
Nirvana hauls along off Antigua's south shore.

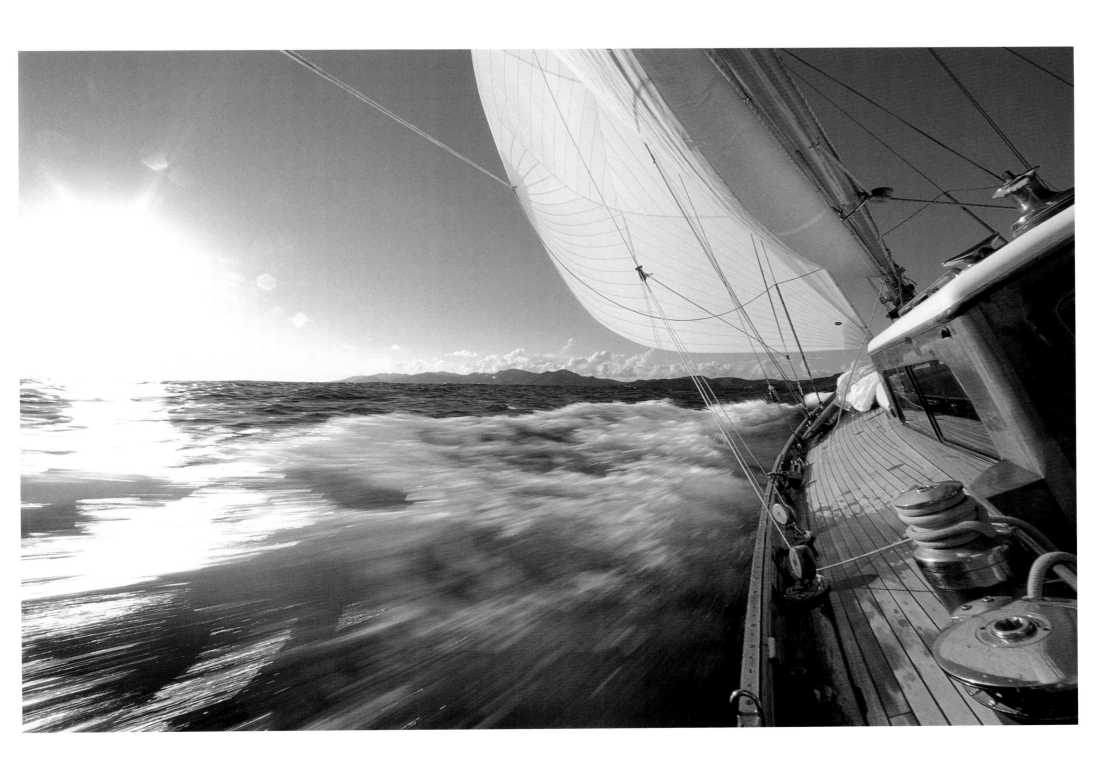

Adix powers over a swell during La Niolargue, the classic yacht regatta held off St. Tropez in the south of France.

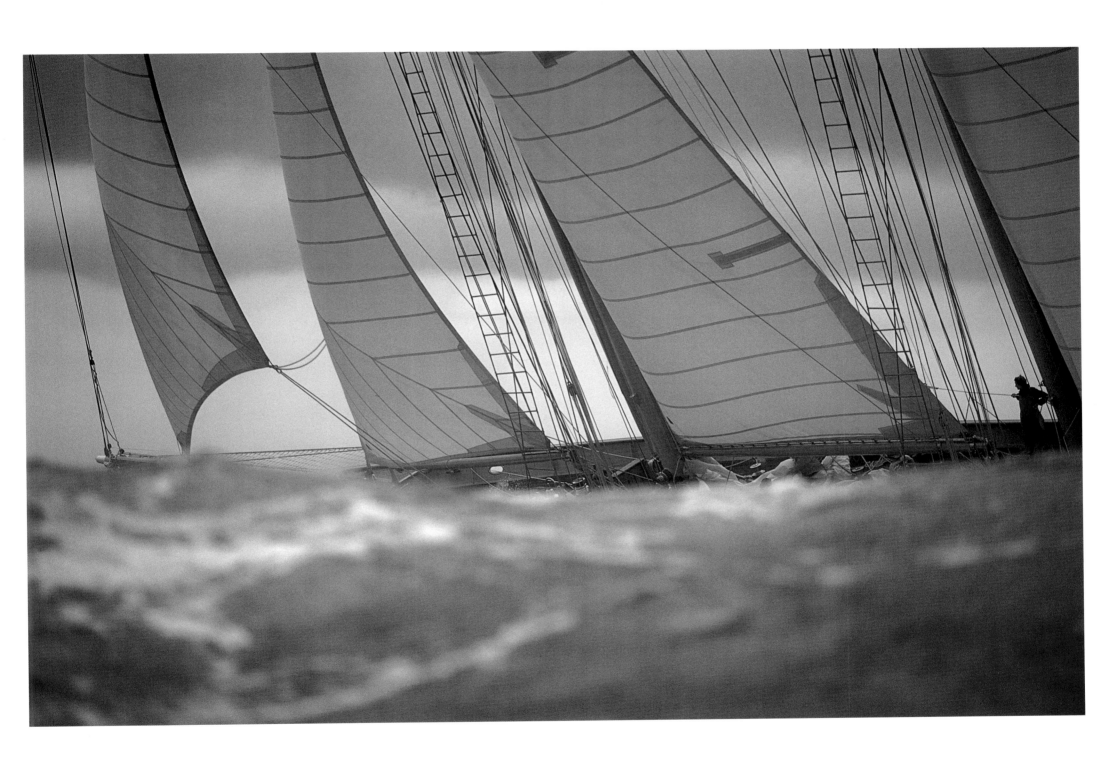

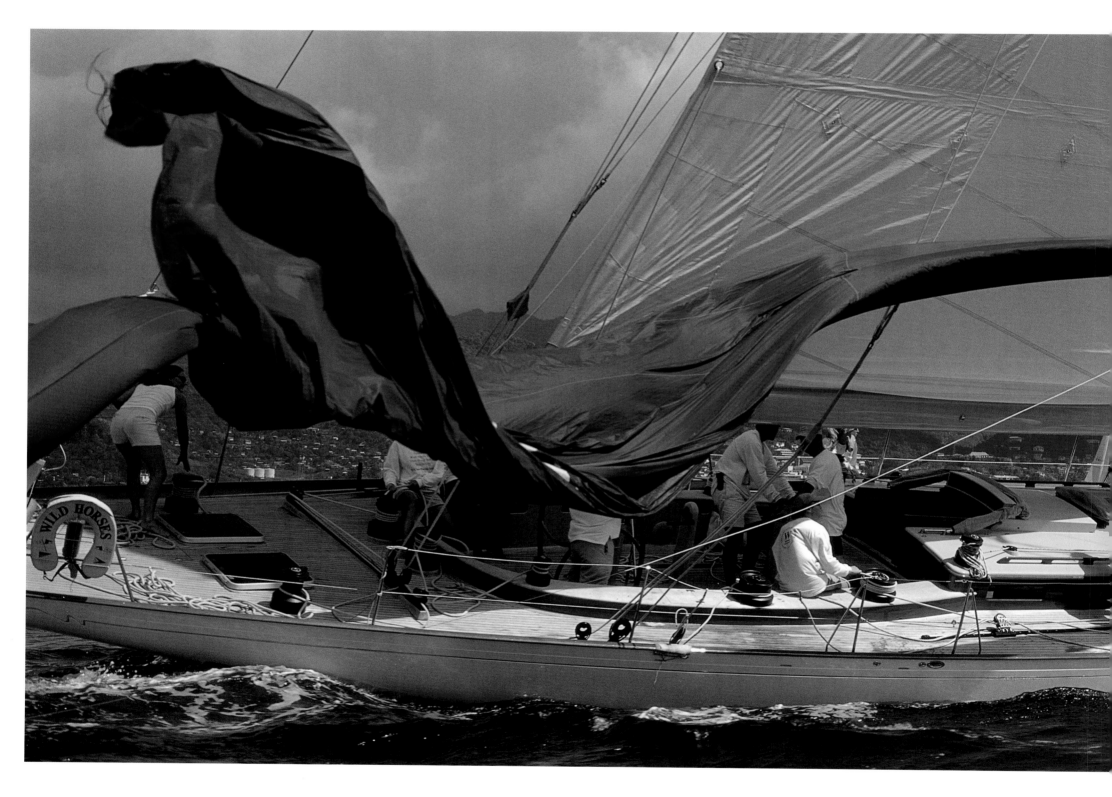

The W60-class *Wild Horses* has a problem
getting the spinnaker down in one piece while
racing in the Grenada Sailing Festival.

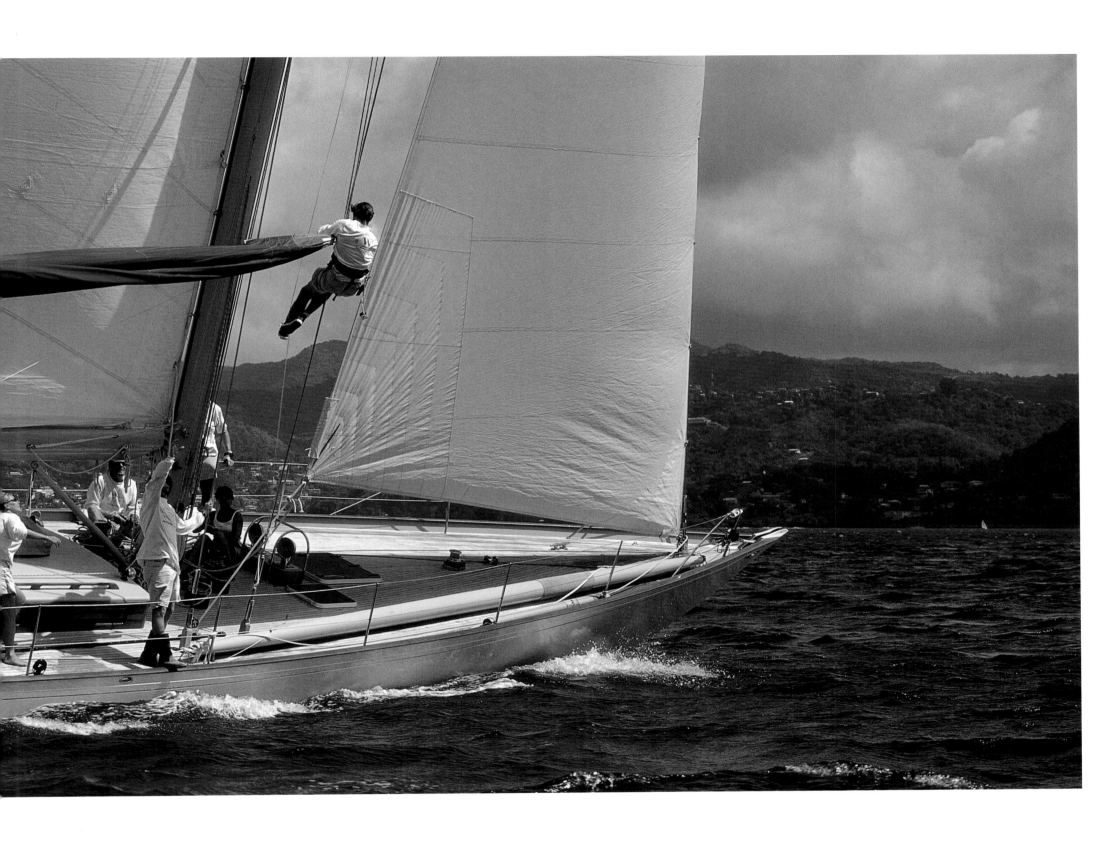

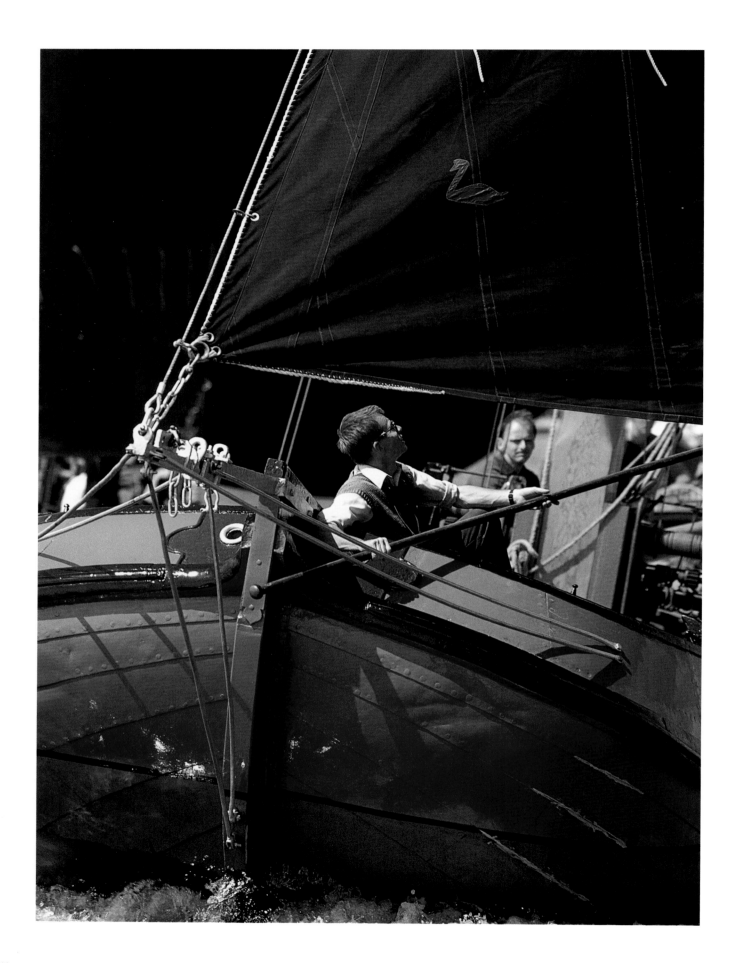

Poling out the headsail on this Dutch Skutje during the annual regatta held in the northern province of Friesland in Holland.

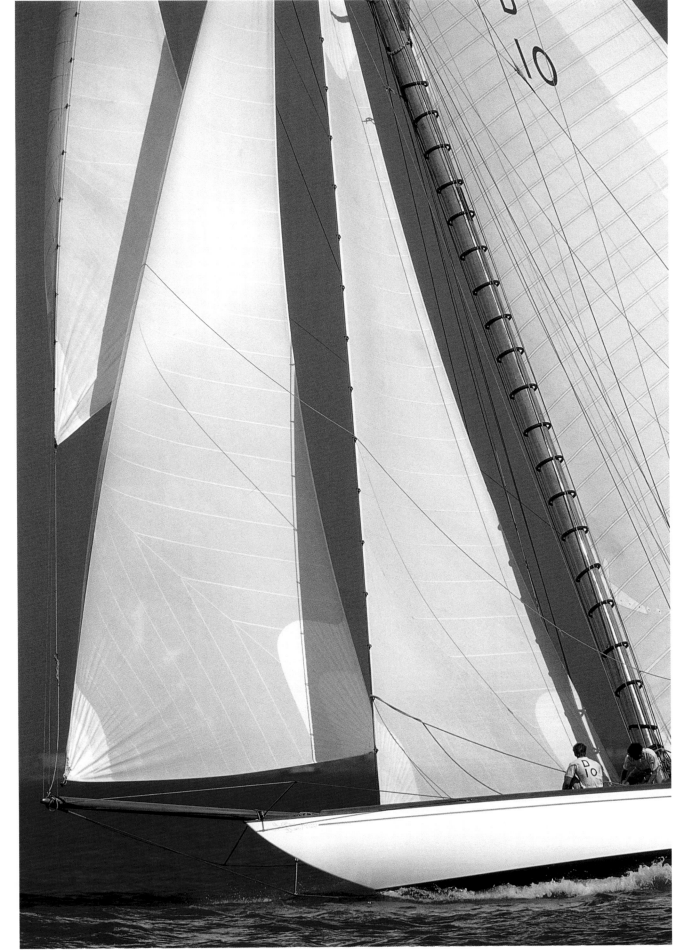

The Fife *The Lady Anne* on the wind in the western Solent during the America's Cup Jubilee off Cowes, England, in 2001.

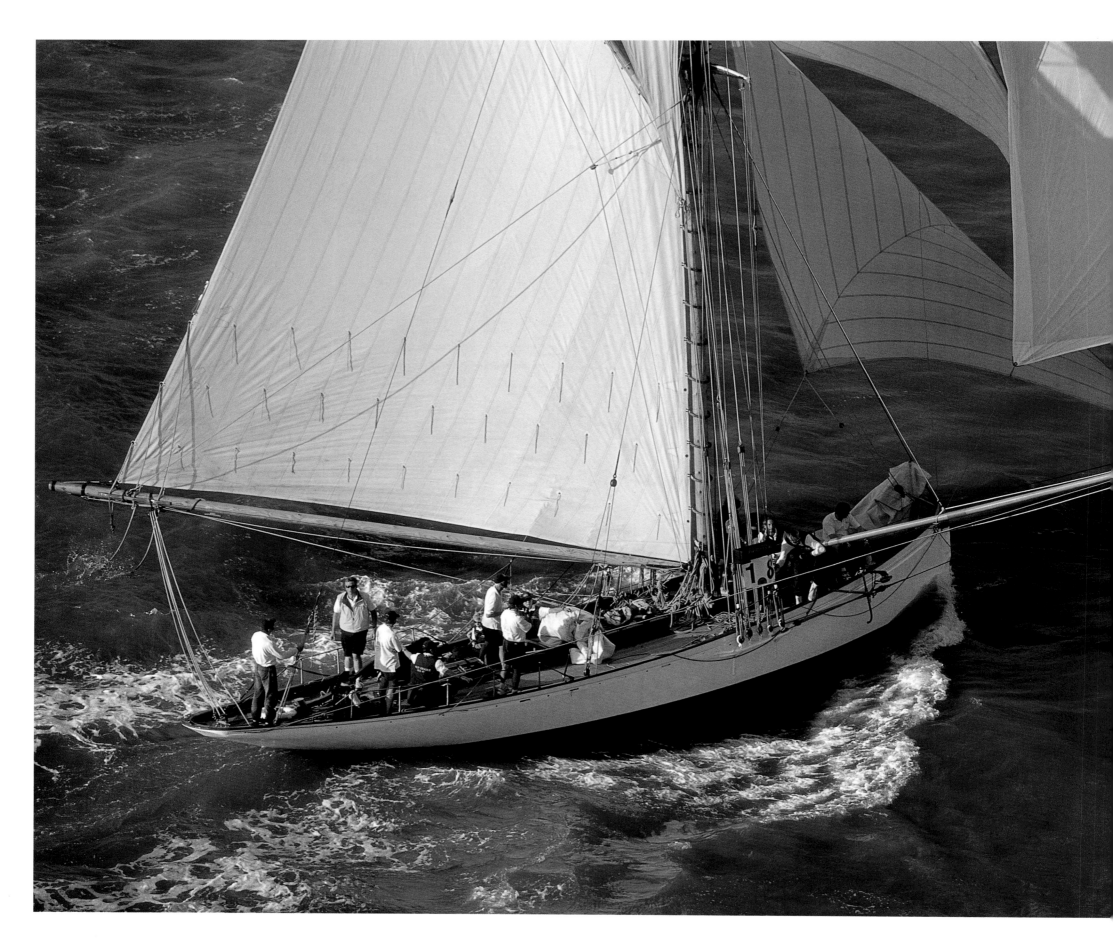

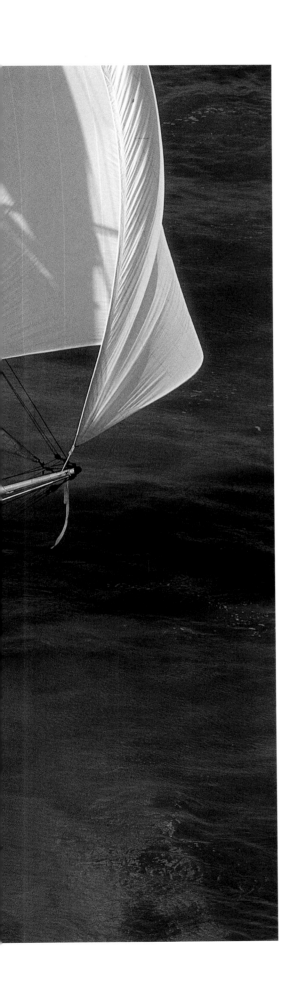

Partridge sails down the western Solent during the America's Cup Jubilee Round the Island Race.

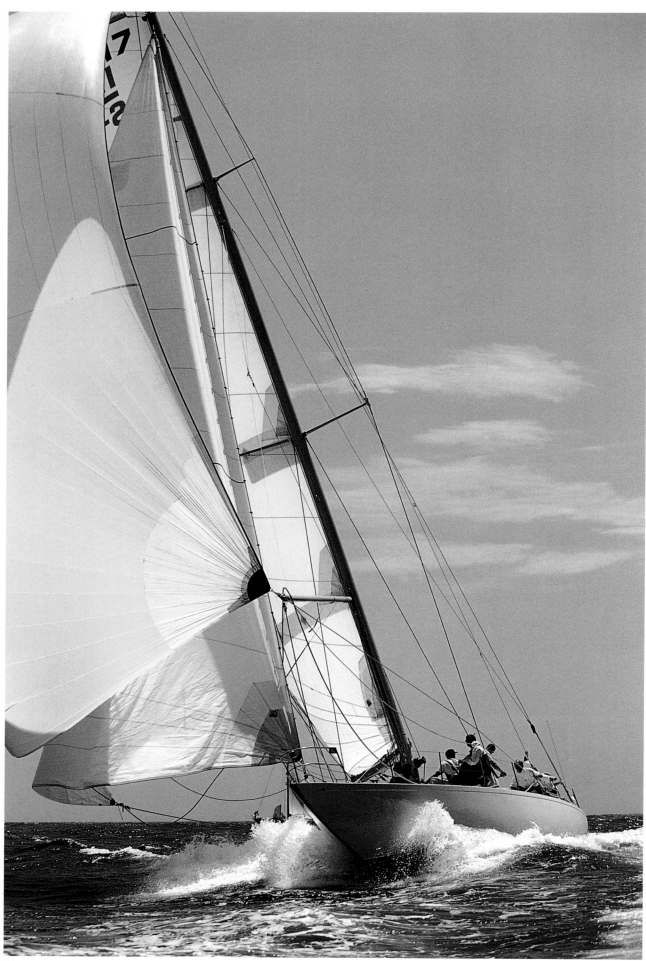

The 12-Meter *Weatherly* surfs on a large wave as she approaches the leeward mark during the New York Yacht Club Sesquicentennial regatta held off Newport, Rhode Island, in 1994.

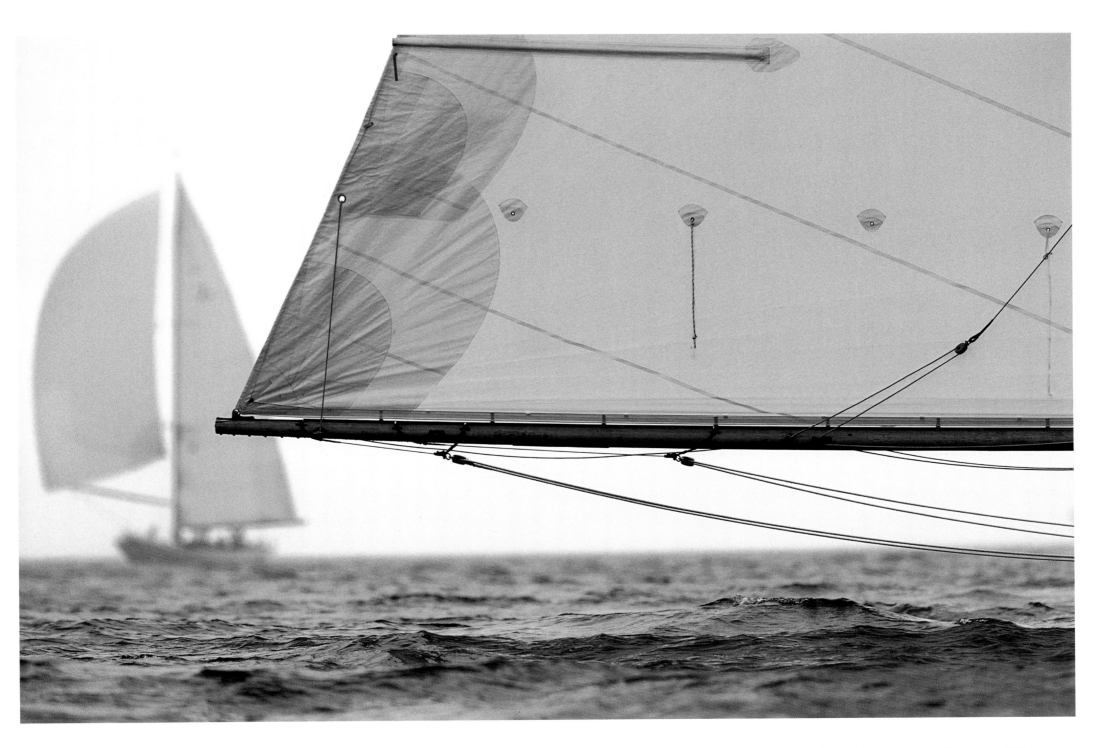

Amorita's boom frames the distant view of *Wild Horses* during the Museum of Yachting's annual Classic Yacht Regatta held off Newport, Rhode Island.

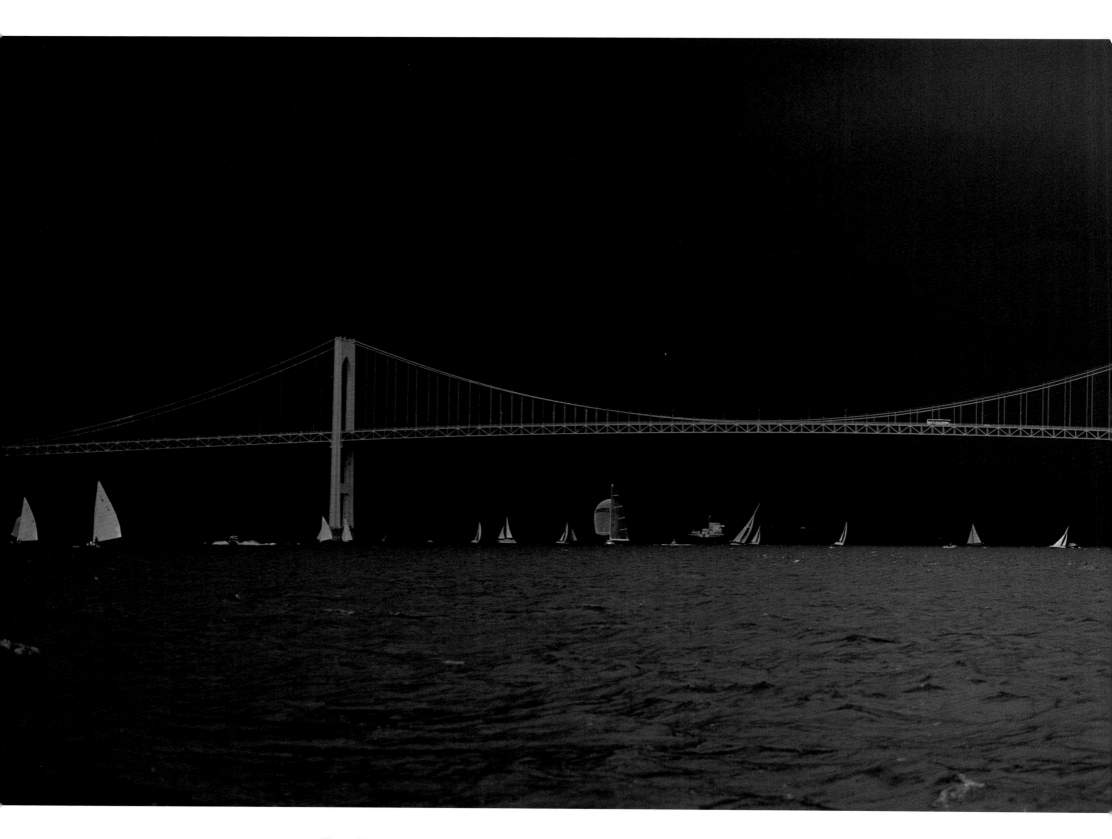

The 12-Meter *Columbia* tries to outpace the
fast-approaching squall during the Museum of
Yachting's annual regatta.

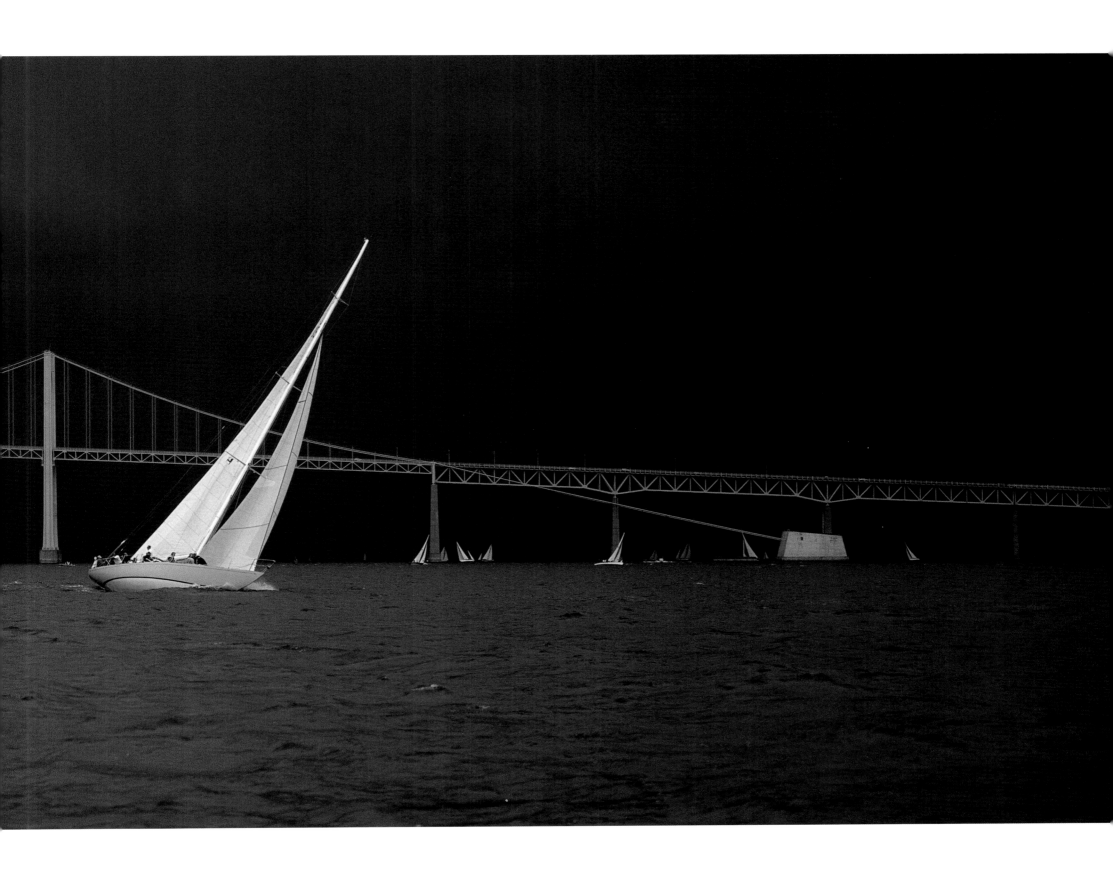

Small Boats

Small sailboats, or dinghies, are normally sailed by just a handful of crew, and unlike larger boats, they rely solely on the crew's body weight to keep the boat the right way up. Without lead in the keel to act as ballast, dinghy sailing is tippy, physically demanding, and exhilarating. If you don't work hard at hiking out to keep the boat flat and upright, you will eventually end up swimming in the tide. Because of the ballast factor, small boat sailing, and especially racing, is for the fit and not so faint of heart.

Some of my most memorable experiences shooting small boats have been covering the Olympics. For the sailors at the Olympic trials, the outcome of a single leg of a race may mean going on to represent their country in the Olympic games or going home after four years of hard work and devotion. During the games in Savannah, Georgia, I remember being in the only boat other than the committee boat at the finish line of the Finn class when a sailor from Holland medaled. I went over to congratulate him, and he asked if he could borrow my cell phone to call his family to tell them of his remarkable feat. Seeing the excitement and glow of this sailor is something I will never forget. The group of us there knew that he would remember that moment for the rest of his life and speak of it many times over. At the same

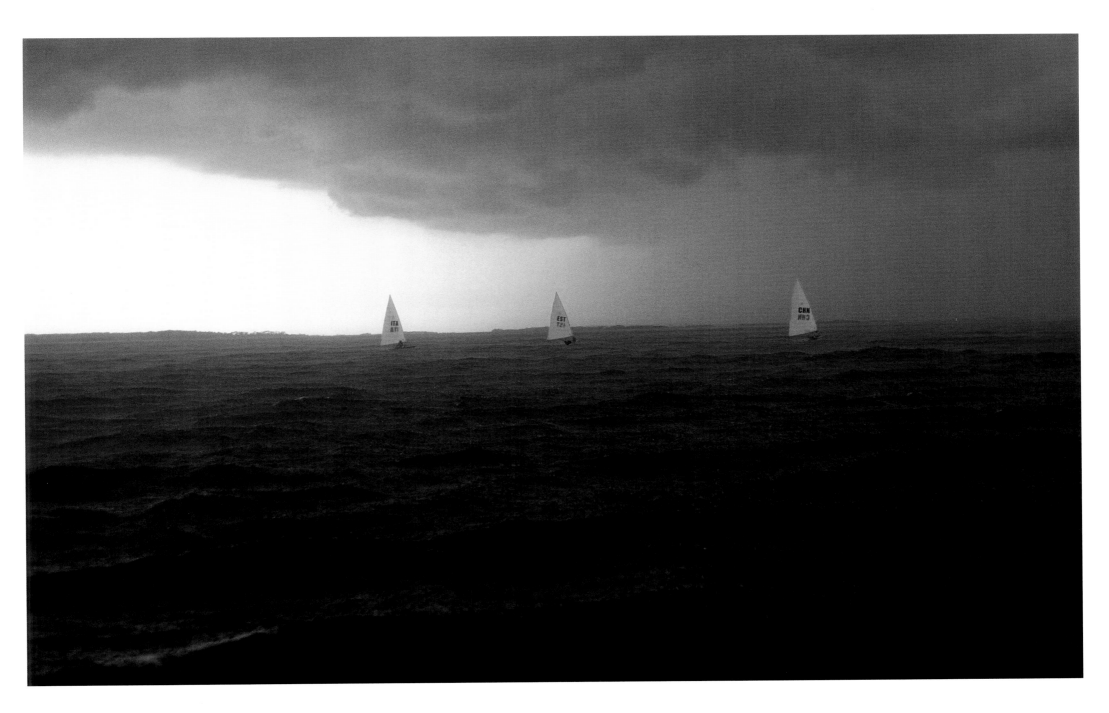

The Laser class during a vicious-looking squall during the 1996 Olympic Games off Savannah, Georgia.

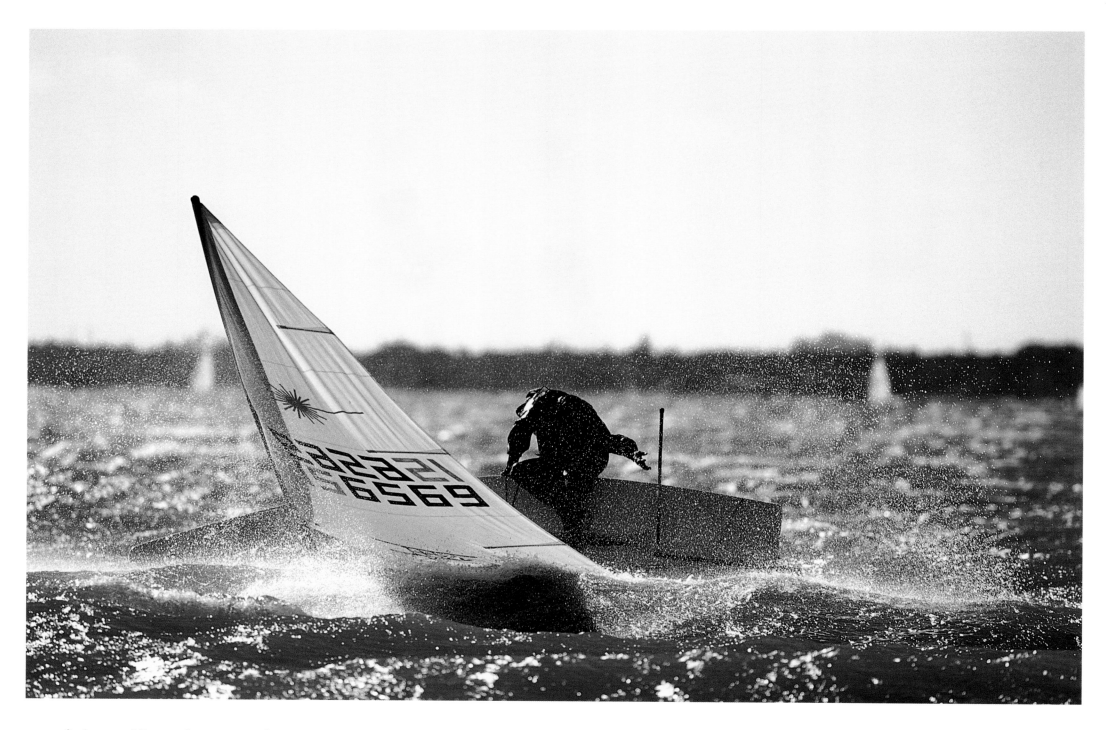

On the verge of disaster, a Laser spins out of
control during the Miami Olympic Classes
Regatta.

race, however, I witnessed the fourth-place finisher cross the line to miss a medal by just three seconds. The intensity of these races is merciless, and the winner is often just a fraction of a second ahead of the rest.

The flip side of small boat racing takes place in the Caribbean, where the locals race fishing sloops that they built on the beach by hand. The sails are made from whatever fabric is available. Oftentimes sails are handed down from one-design classes, who are constantly upgrading to newer, faster sails, sending their seemingly old rags to these island racers. The spars are shaped from the straightest tree found in their island jungle. When it comes to the paint scheme, caution is thrown to the wind and the wilder the colors are, the better. At the end of the day, the competition is just as fierce as it is among the Olympic hopefuls, and the winner, whether sailing from a beach in the Caribbean or going for the Olympic Gold, becomes the village hero for another year.

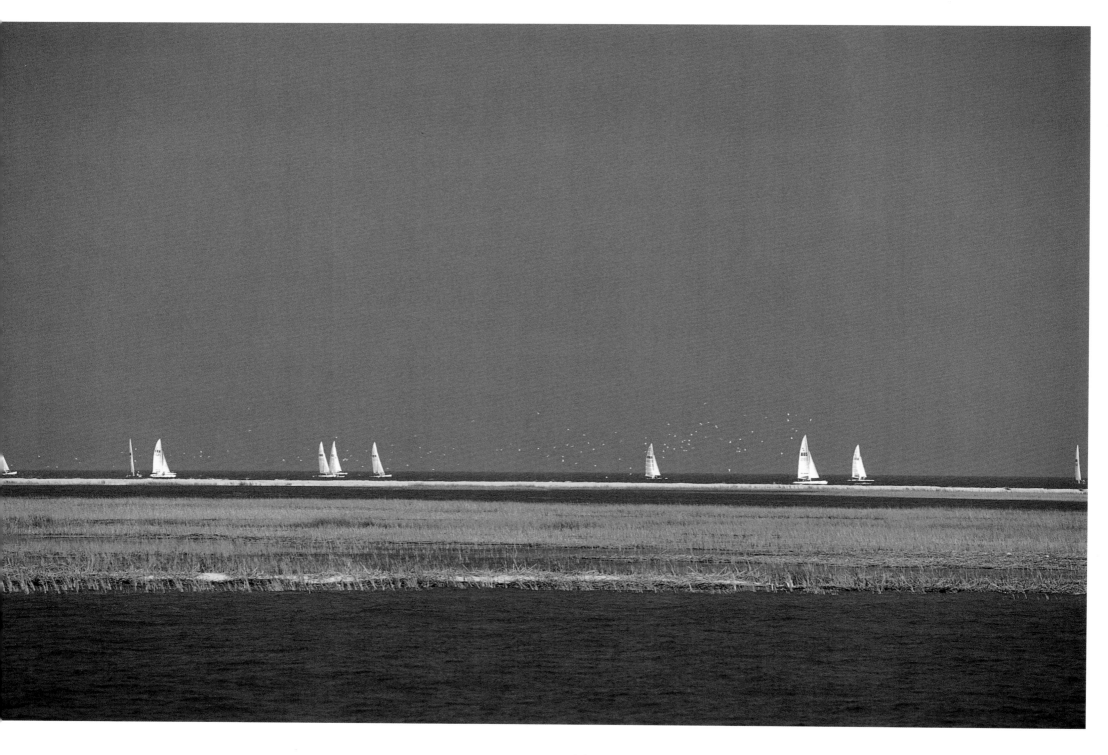

A fleet of Tornados heads home from racing
during the 1996 Atlanta Olympic Games held
off Savannah, Georgia.

An English team of 505 sailors work hard to stay flat during the 1998 World Championships held off Hyannis, Massachusetts.

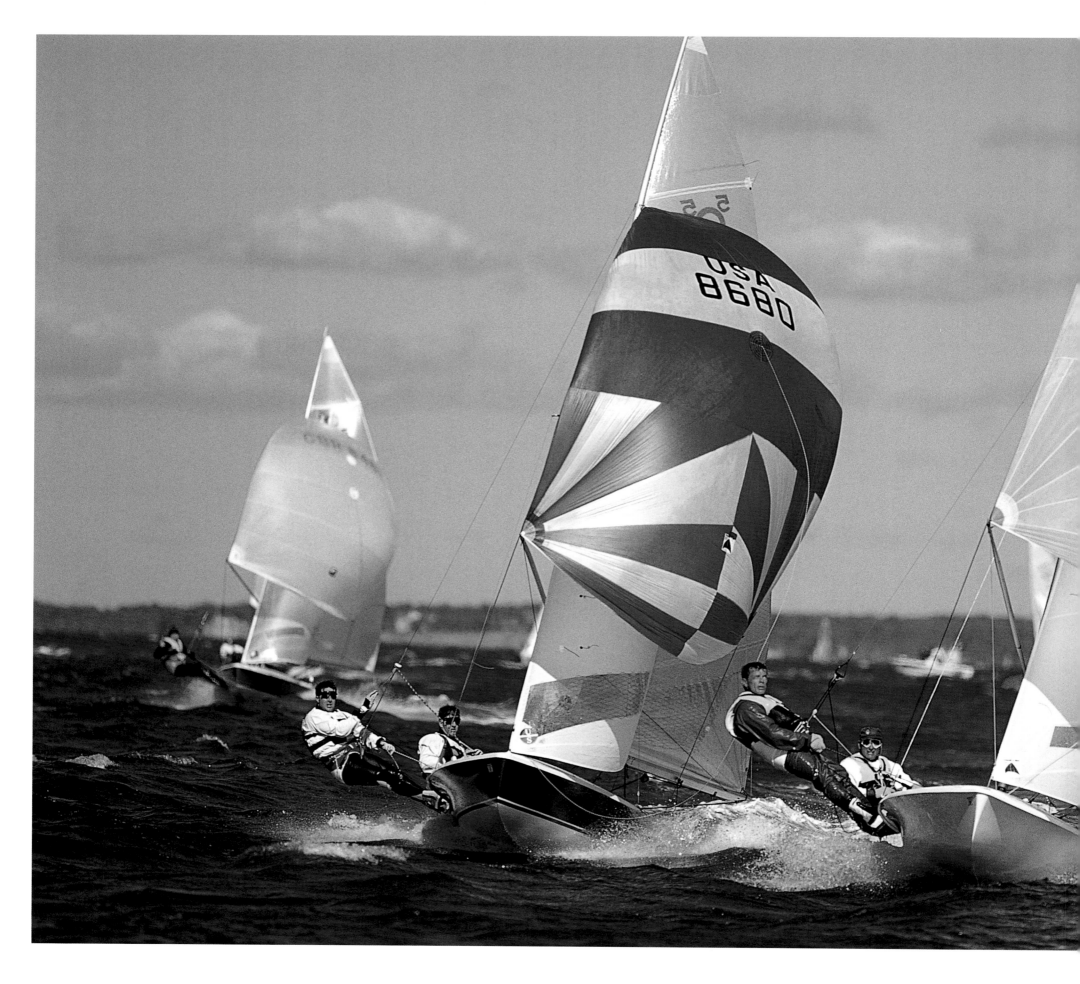

A wild downwind leg during the blustery
505 Worlds.

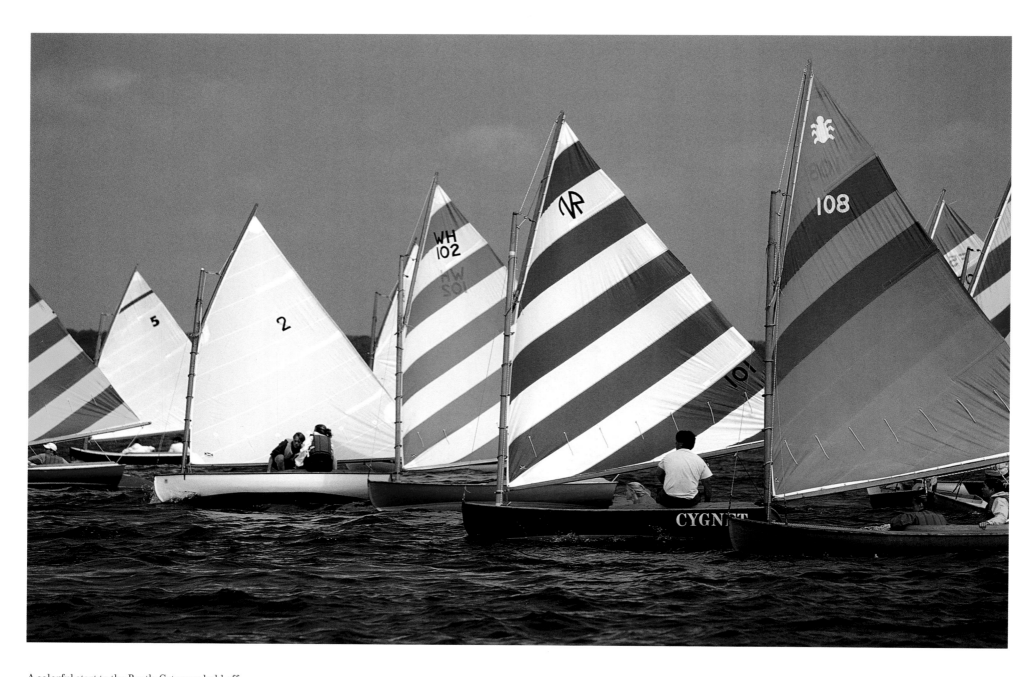

A colorful start to the Beetle Cat races held off
Padanaram, Massachusetts.

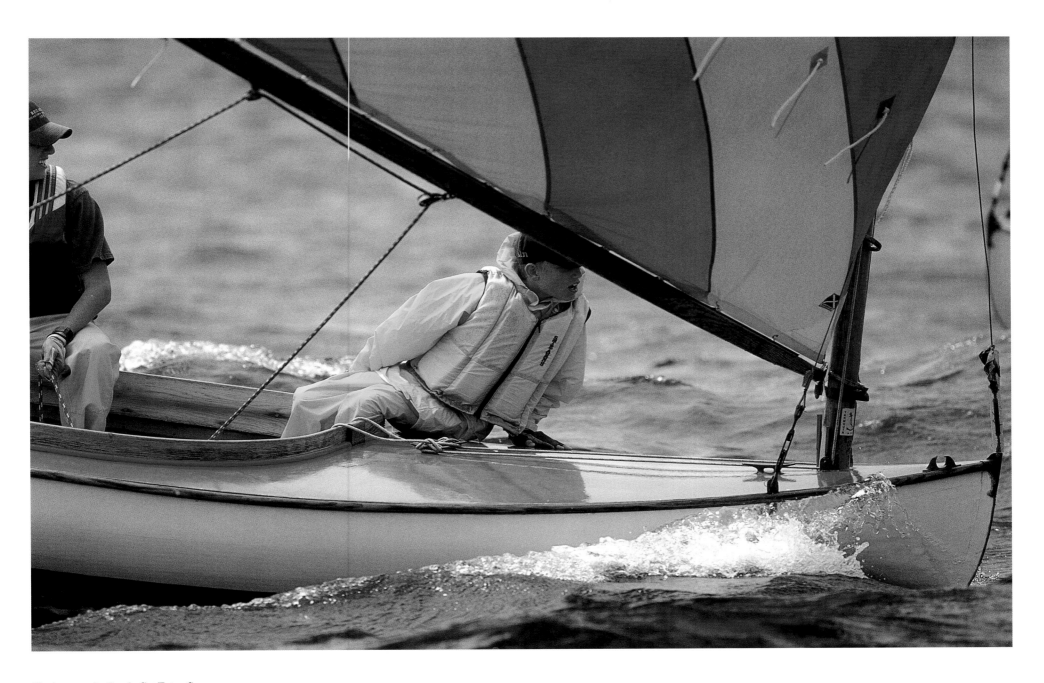

The boys on the Beetle Cat *Flying Goose* work their weight forward to gain on the downwind leg.

The workboats on the beach during the
Grenada Sailing Festival take a break
between races.

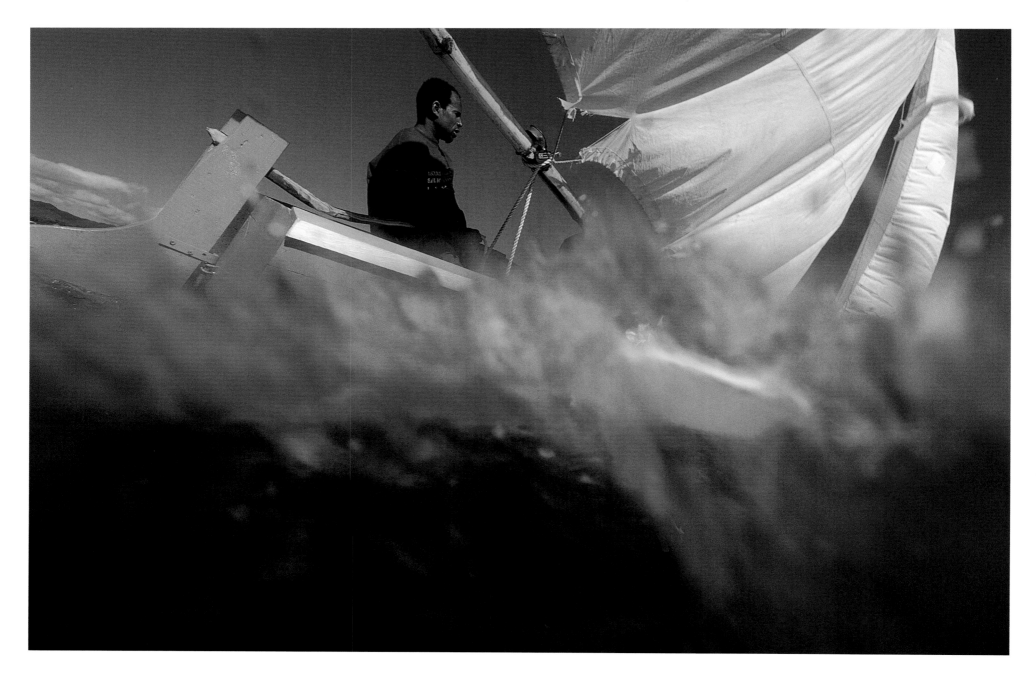

A little rip in the mainsail does not stop this sailor from leading his fleet during the Grenada Sailing Festival.

Bowsprit detail on a Grenada Sailing Festival competitor.

Rasta Goat, a local sailboat competing in the
Grenada Sailing Festival.

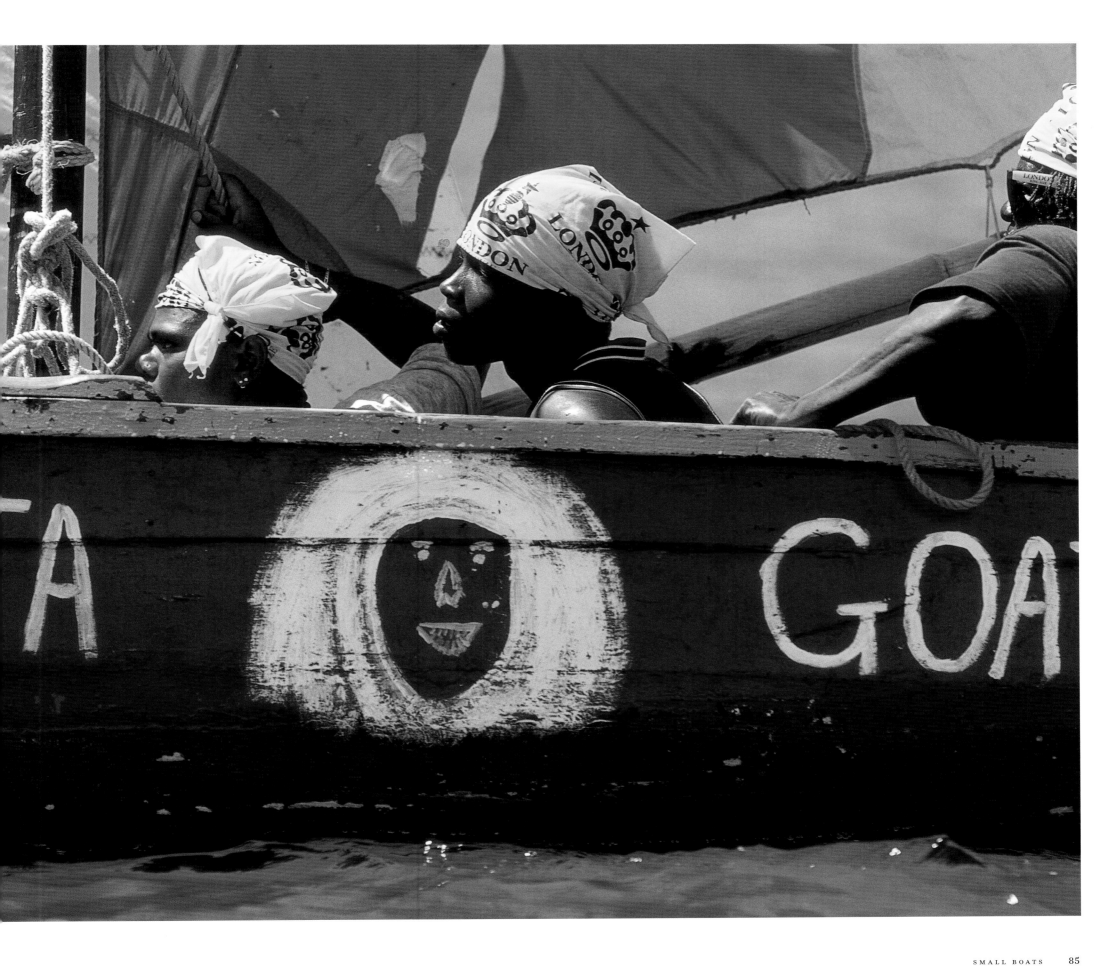

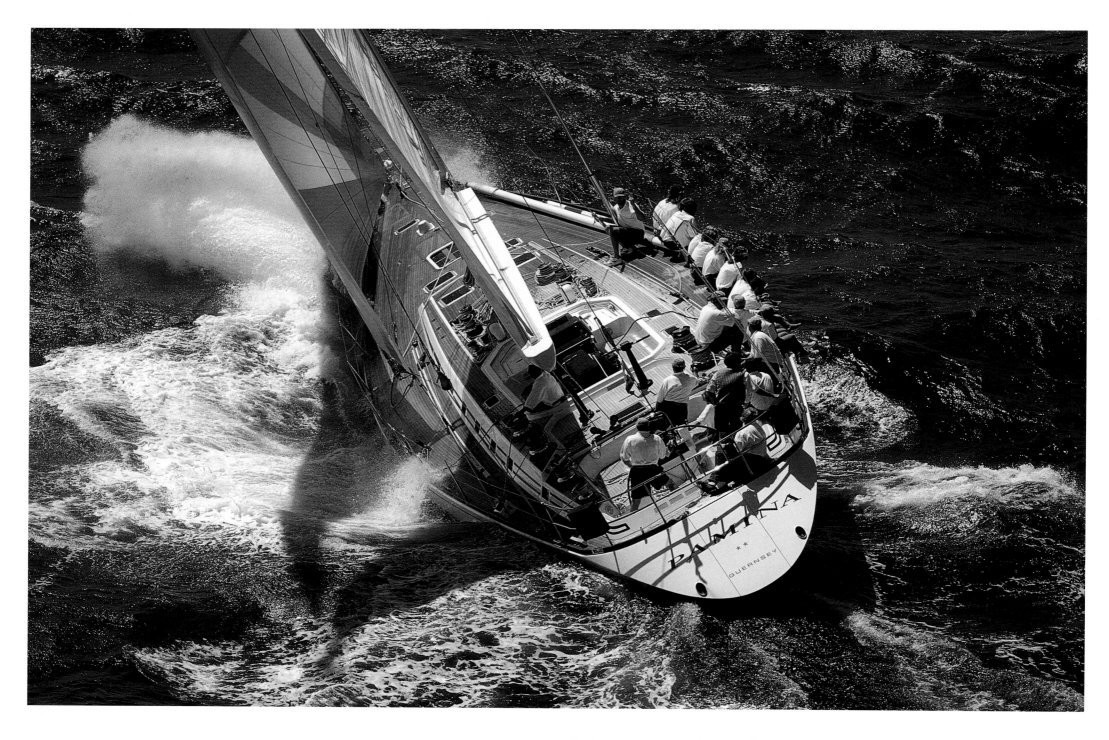

Pamina, a Swan 77, slams into a wave off
Beavertail, Jamestown, Rhode Island, during
the Swan Rendezvous.

Racing Far and Near

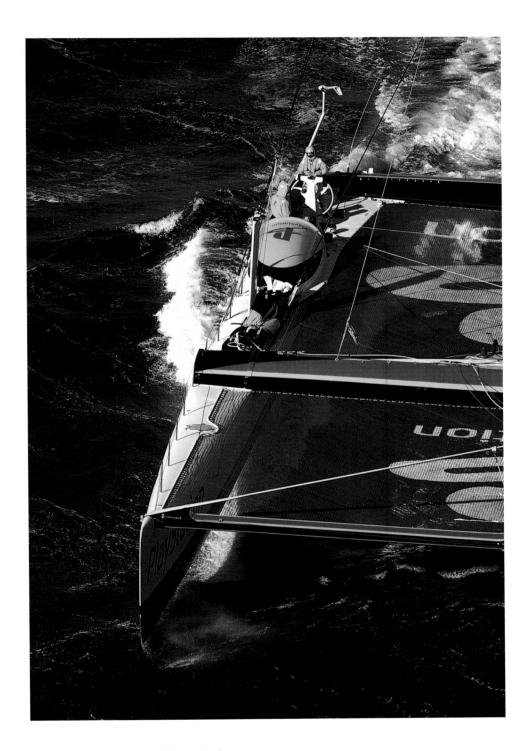

Steve Fossett's maxi-cat *PlayStation* heading for Bermuda on a record-breaking run from Newport, Rhode Island.

The selection of images in this chapter needs its own category, as it is a mix of racing photographs old and new and from far and near. I have included two images from the 1981–82 Whitbread Round the World Race, which essentially launched my career as a photographer. I was an avid competitive sailor at the time and was the bowman as well as the dangling photographer on board the seventy-six-foot Dutch sloop *Flyer*. After a seven-month-long, 32,000-mile adventure, *Flyer* won the race and set a circumnavigation record that stood for four years. When the photographs were published, we were able to show the world how we raced across the vast, dangerous stretches of the deserted Southern Ocean from our own vantage point.

Then there are shots taken during the America's Cup Jubilee in Cowes, England, in 2001—on the very same waters on which I first raced during the 1979 Cowes Week and Fastnet races. The Solent off Cowes must rank as one of the top places for yacht racing in the world, and no place was better suited to host the 150th anniversary celebration of the America's Cup. Boats were shipped over and sailed in from the far corners of the world to participate. The 12-Meter class had thirty-seven entries, and it was a gathering that that class will probably never see again. The three J-class sloops were such a draw that you had to wait for the other photo boats to move away in order to get a spot to shoot from. There were also the classics, from Fife to Herreshoff, the new generation of Cup boats, the cruisers, and the local yacht club entries. This was an event that was not to be missed, and everyone knew it. It was a week of sailing that

needed three weeks to properly document photographically; it was wall-to-wall eye candy for the sailing photographer.

Similarly, on a fine January day I was sitting at my desk overlooking Newport Harbor when a gale blew up and knocked on my window. Across the way, a frenzy of yellow and red foulies busily prepared to make the most of this blow as they readied themselves and their hundred-foot catamaran for a record-setting run to Bermuda. I called my favorite helicopter pilot, grabbed my bag of layers and cameras, and off we went to capture the shot of Steve Fossett's *PlayStation,* screaming off to Bermuda in forty knots of breeze.

Other moments of simply awe-inspiring racing have crossed my lens and made an impression on my racing world. These images are important to include because, while they might not celebrate an anniversary or ride on the edge of a gnarly gale, they symbolize the spirit of what keeps all racers at it for years and years. Watching Steve Pettengill disappearing behind a large South Atlantic swell as he finished the first leg of the Around Alone Race in Cape Town or watching the six 12 Meters parading for me on a sunset photo shoot on my home waters of Narragansett Bay make this collection of images as unique as the boats and the sailors who sail them.

OPPOSITE
A fleet of Frers 33s under spinnakers racing on Narragansett Bay.

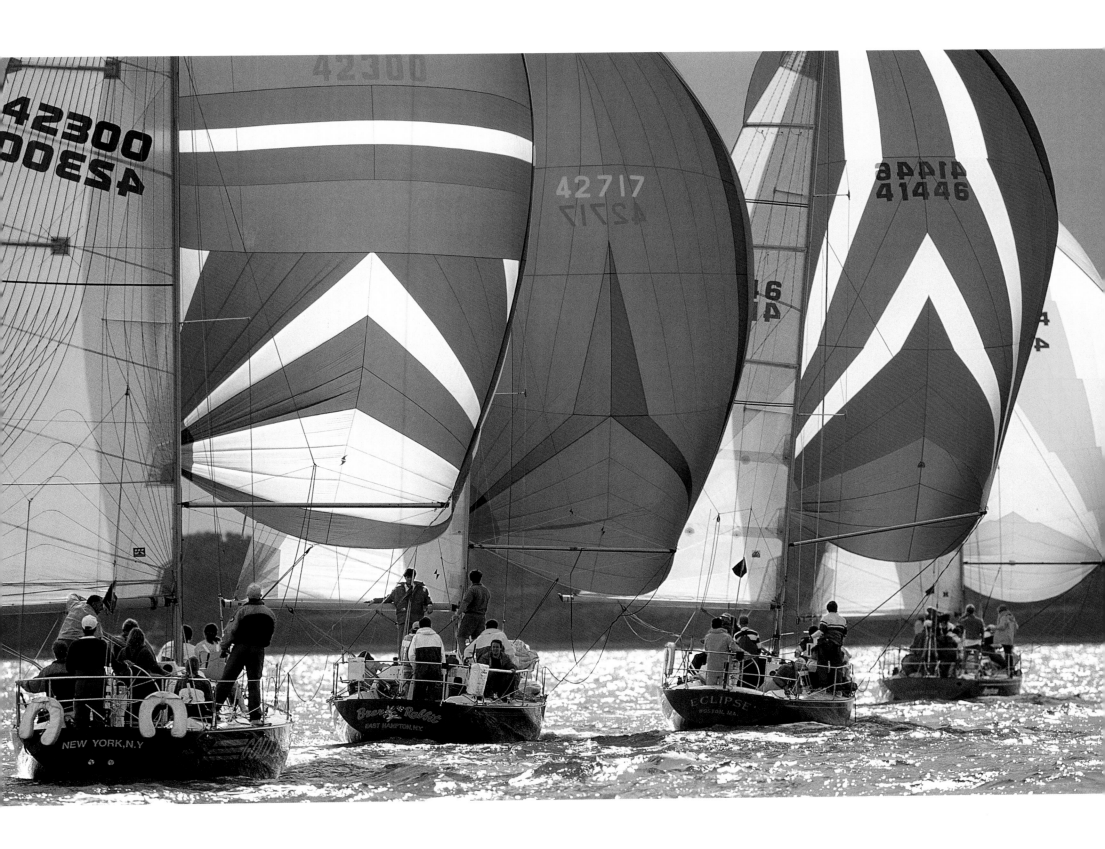

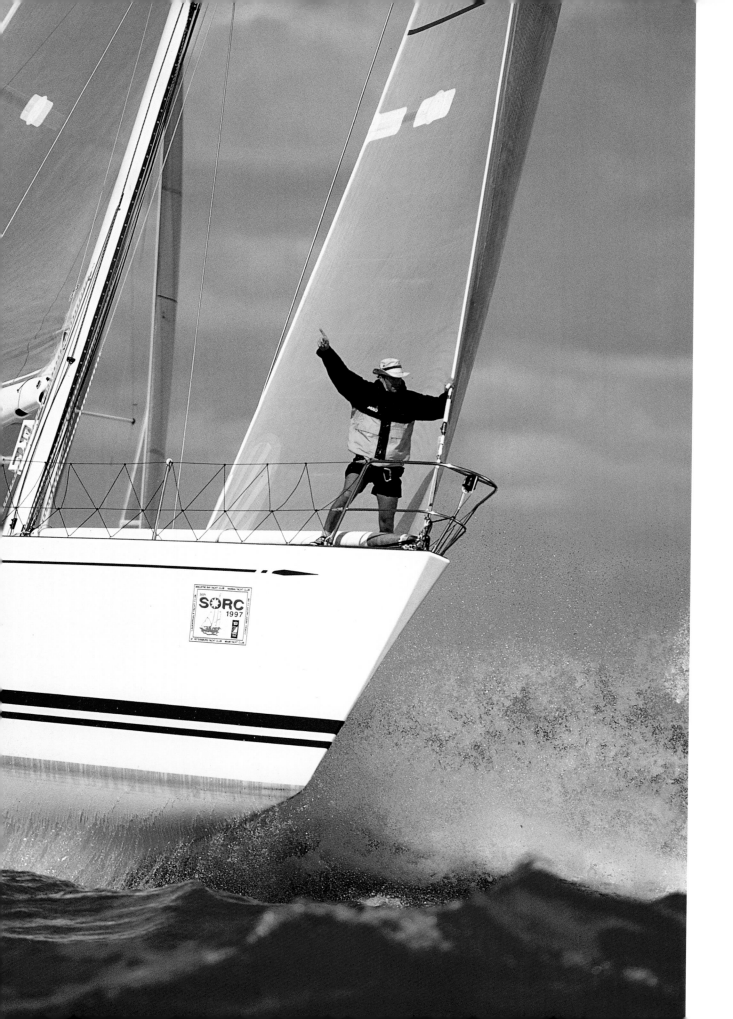

The bowman on the Swan *Highland Fling* calls
the distance to the starting line during the 1997
Southern Ocean Racing Conference (SORC)
held off Miami, Florida.

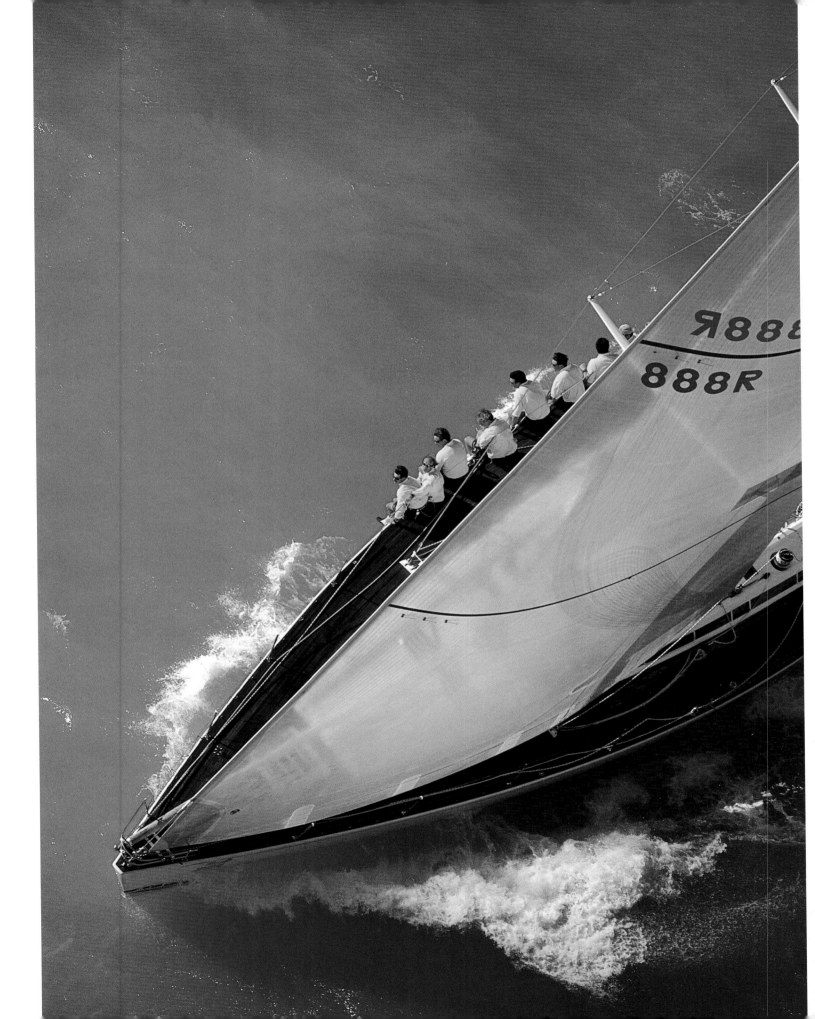

Highland Fling has the crew neatly lined up on
the rail during a weather leg of the SORC.

OPPOSITE

Six 12-Meter-class yachts compete as the sun
sets on Narragansett Bay, Rhode Island.

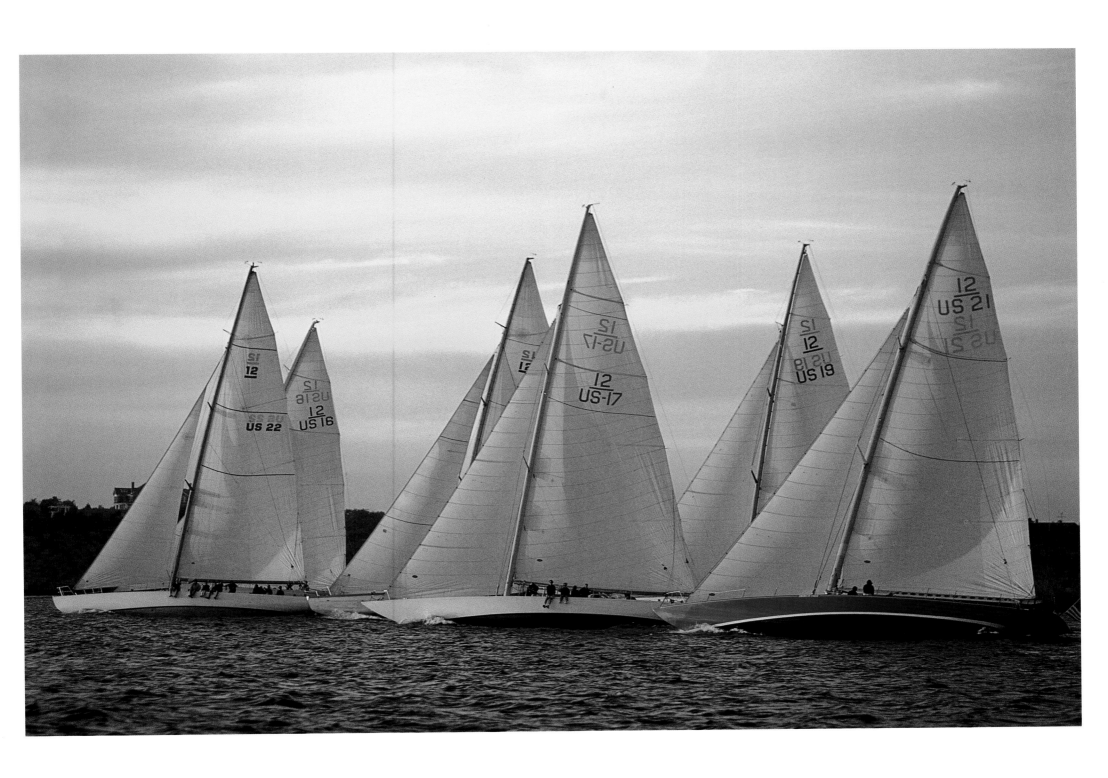

Hunter's Child sailed by Steve Pettengill deals with light air and a large swell as he completes leg one of the BOC Around Alone race off Cape Town, South Africa.

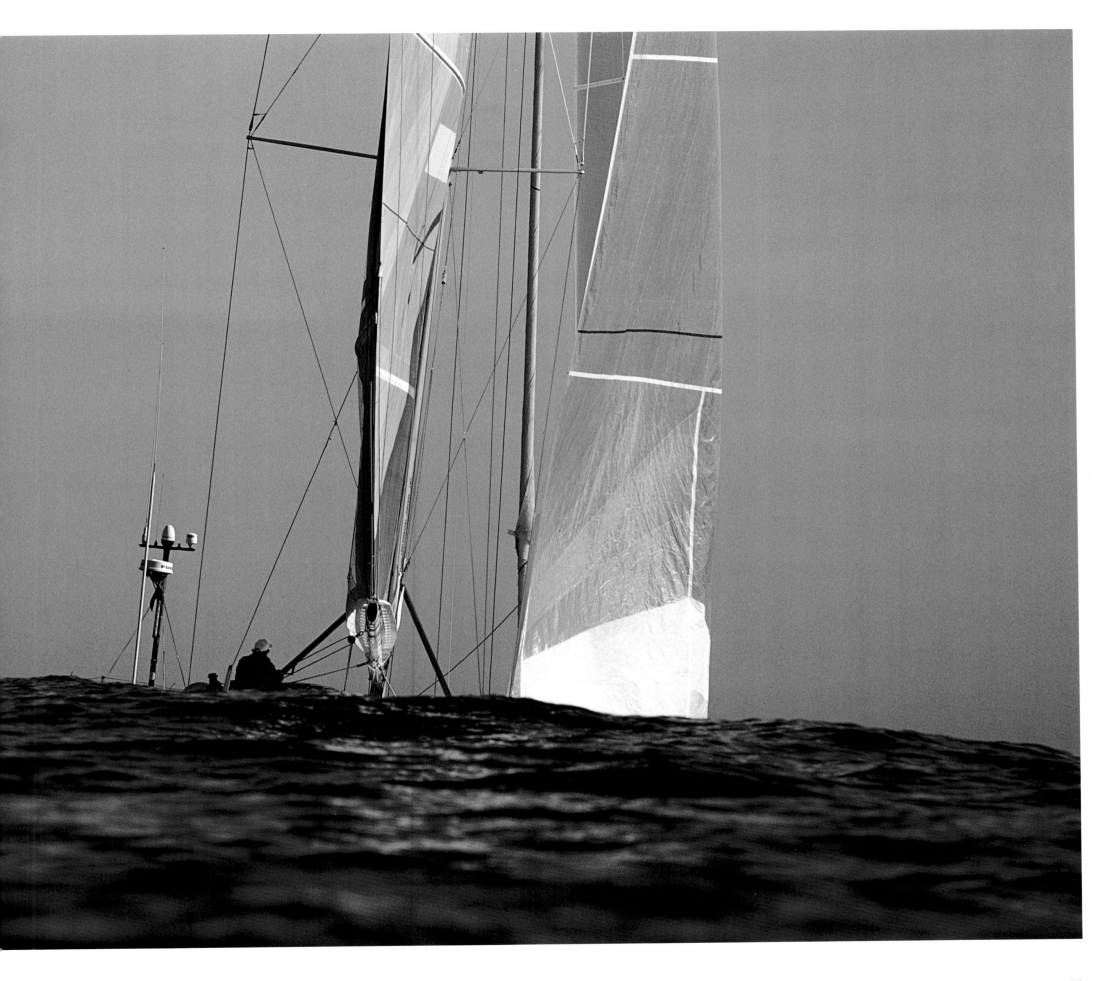

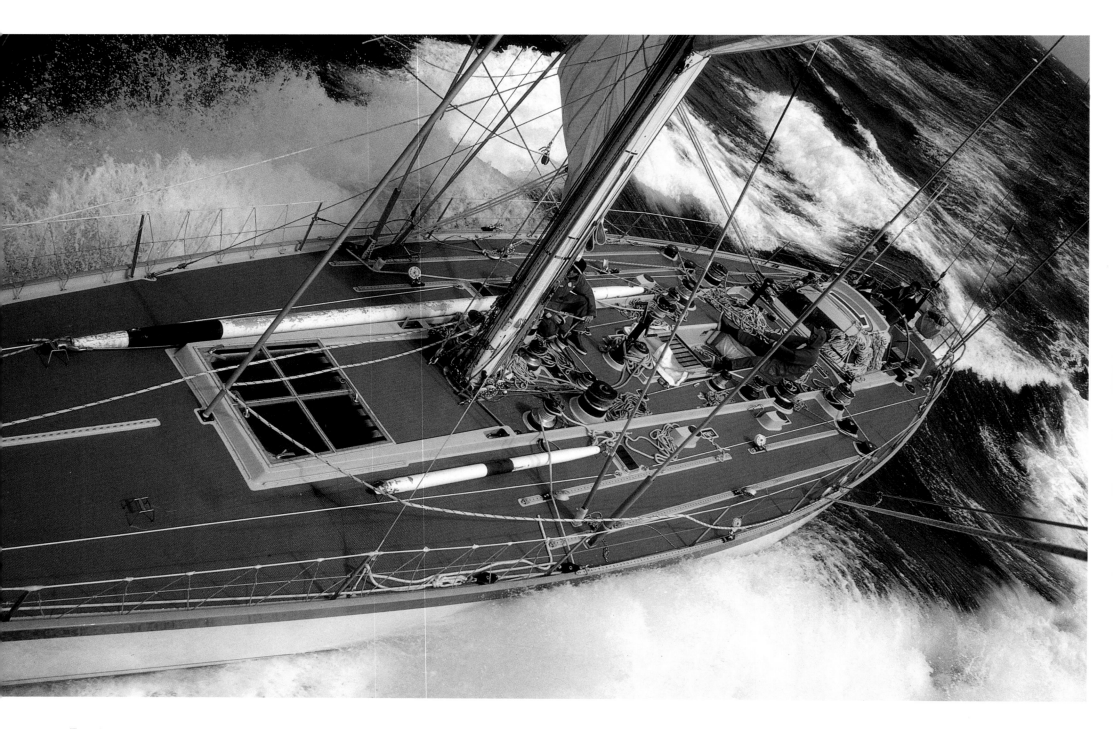

Flyer, the seventy-six-foot sloop and winner of the 1981–82 Whitbread Round the World Race, shot from the spinnaker pole, in the Southern Ocean leg between Cape Town, South Africa, and Auckland, New Zealand.

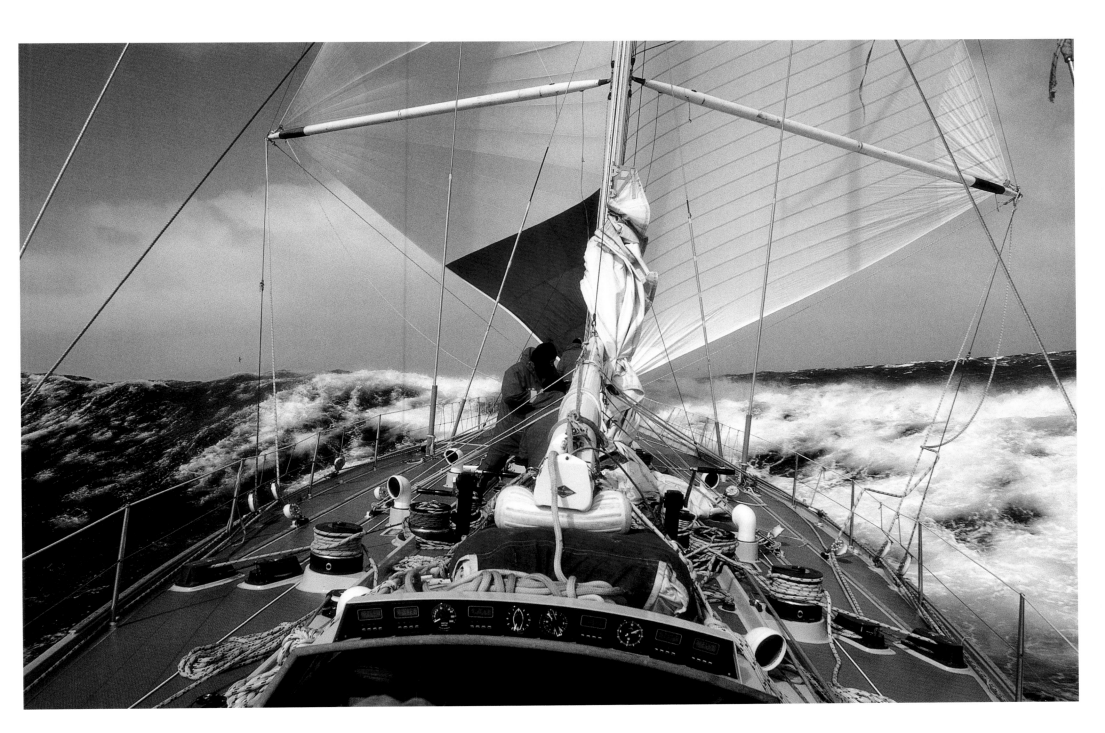

Flyer seen here repairing a broken boom in the Southern Ocean.

OPPOSITE

The 146-foot ketch *Mari-Cha III* during the
America's Cup Jubilee held in the Solent off
Cowes, England.

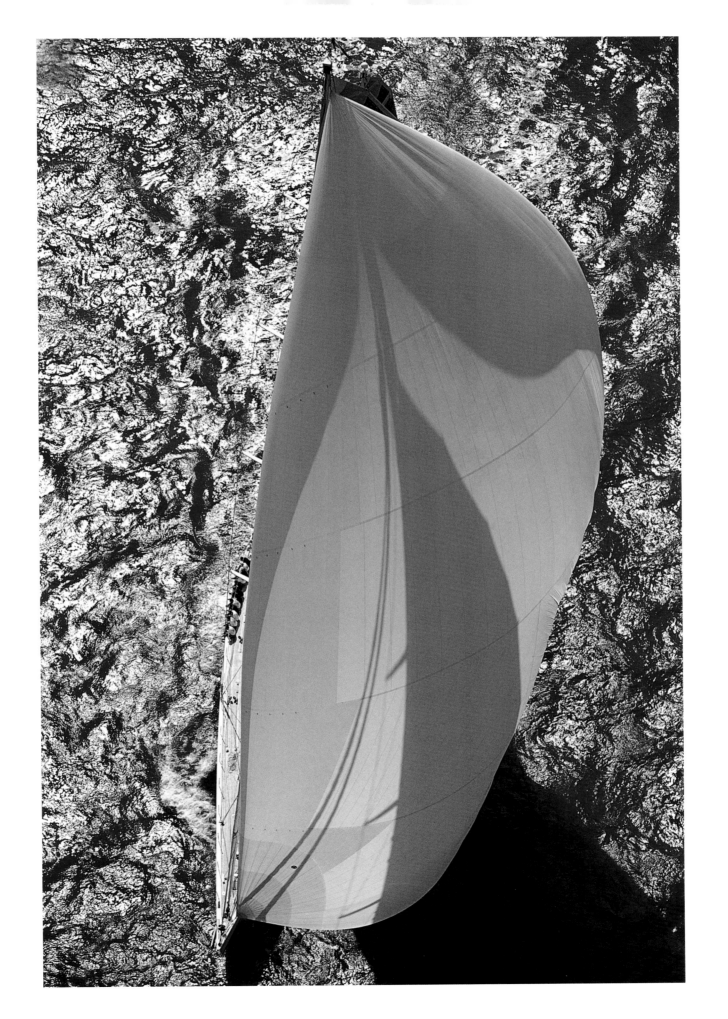

A never-before sight of the fleet of 12 Meters
starting the Round the Island race during the
America's Cup Jubilee.

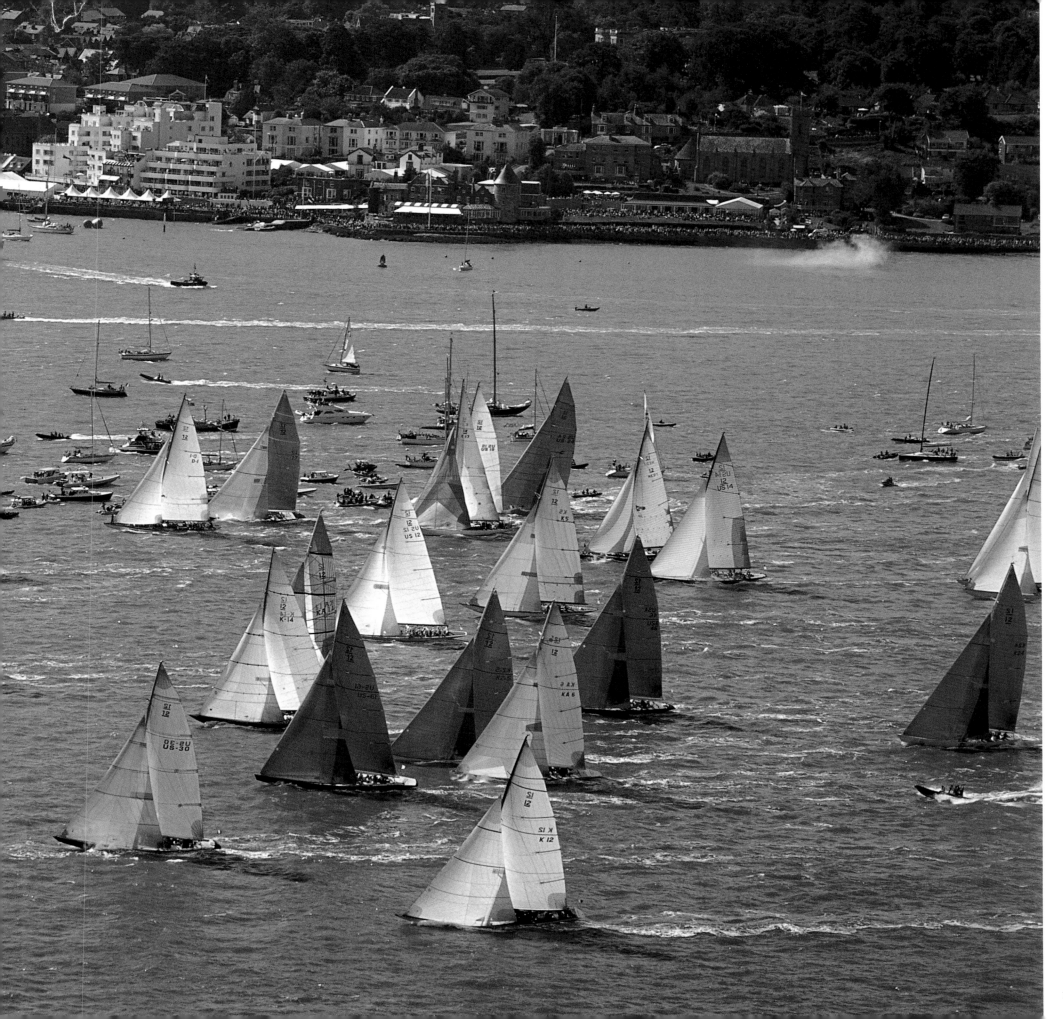

Onlookers feel as if they are onboard a competing yacht during the America's Cup Jubilee as she sails close to the shore to get out of the raging tides in the western Solent.

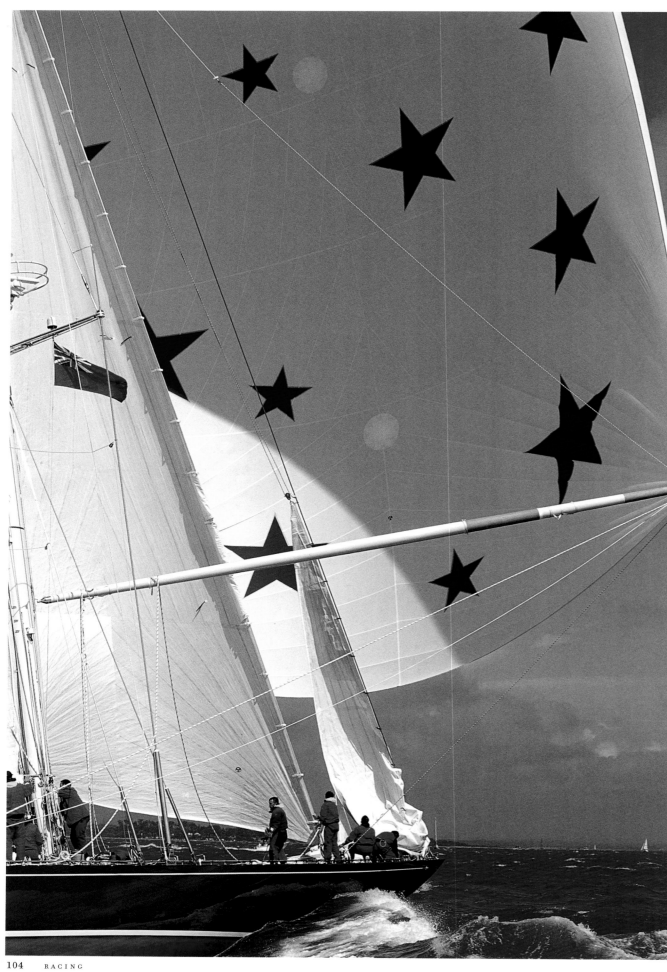

The J-class sloop *Endeavour* prepares to douse
her tennis court–sized spinnaker during the
America's Cup Jubilee.

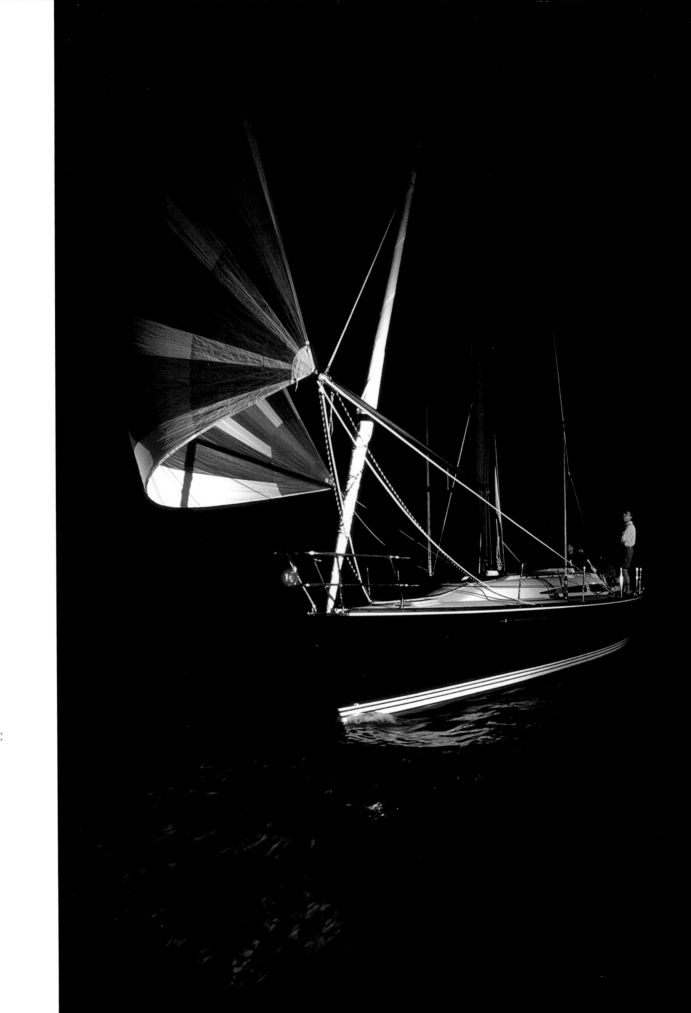

Trimming the spinnaker at night on a C&C while heading for Chicago on Lake Erie.

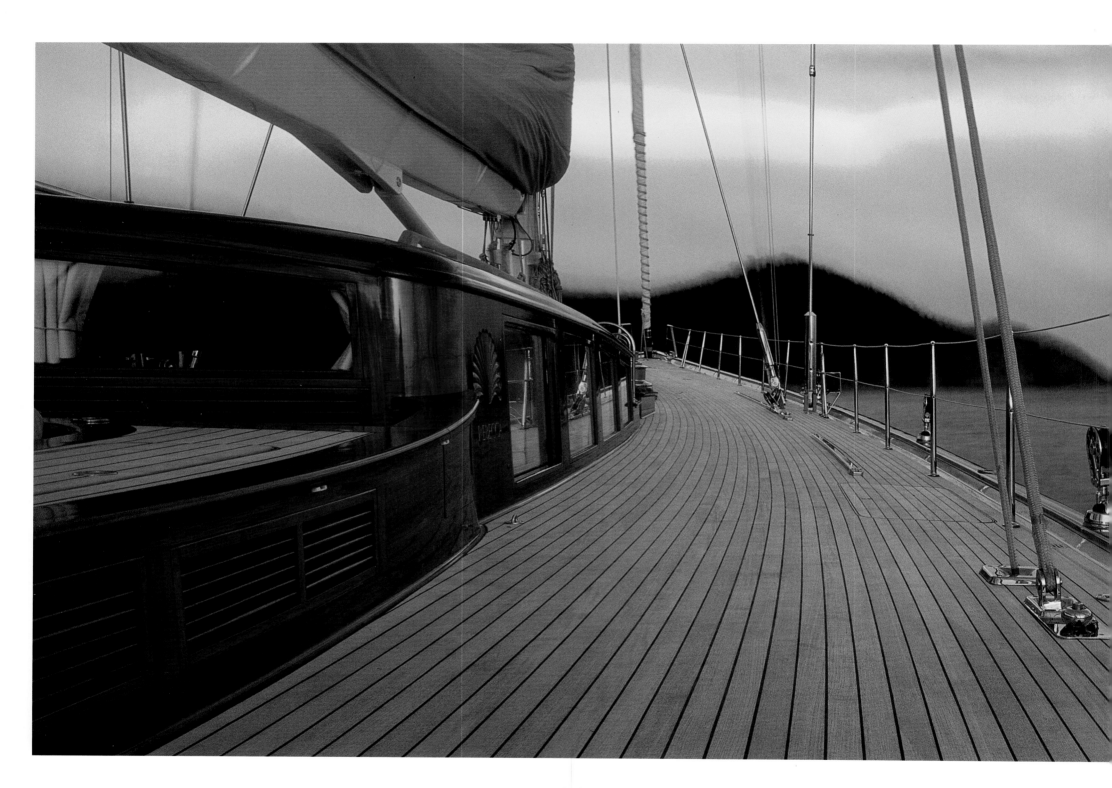

A tranquil sunset onboard the yacht *Rebecca*
while anchored off Antigua, West Indies.

Cruising and Destinations

Sailing in the Tropics

On cold winter days, I dream of the warm breezes, palm trees, and white beaches that define the tropics. One's boat is the perfect means by which to enjoy the laid-back island lifestyle. The never-ending trade winds that push through the tropics from east to west prove highly reliable, so sailors can easily travel from island to island. It is hard to find anything better than anchoring in the lee of a tropical island and watching as the anchor settles on the sandy ocean floor with the chain hanging in crystal-clear water. Dive off the stern, feel the warm water cool off your hot body, and see the boat floating in the turquoise sea. To me, this is heaven.

A tee shirt, shorts, and a pair of walking shoes is about all that is needed to experience this part of the mudball we live on. One of the most impressive tropical cruising grounds I have visited was in the Kingdom of Tonga in the South Pacific. There, I spent a lot of time exploring above and below the surface. I have a waterproof housing for my camera that enables me to take it underwater and capture oceanic life. Being able to jump over the side and have several hundred feet of visibility with the ink-blue ocean around you feels like you are floating in space. The boundless world of sea life and colored fish, so busy feeding and swaying with the current, is something I could watch forever.

OPPOSITE
Manawa Nui catching the last rays of the day's sun off St. Maarten, West Indies.

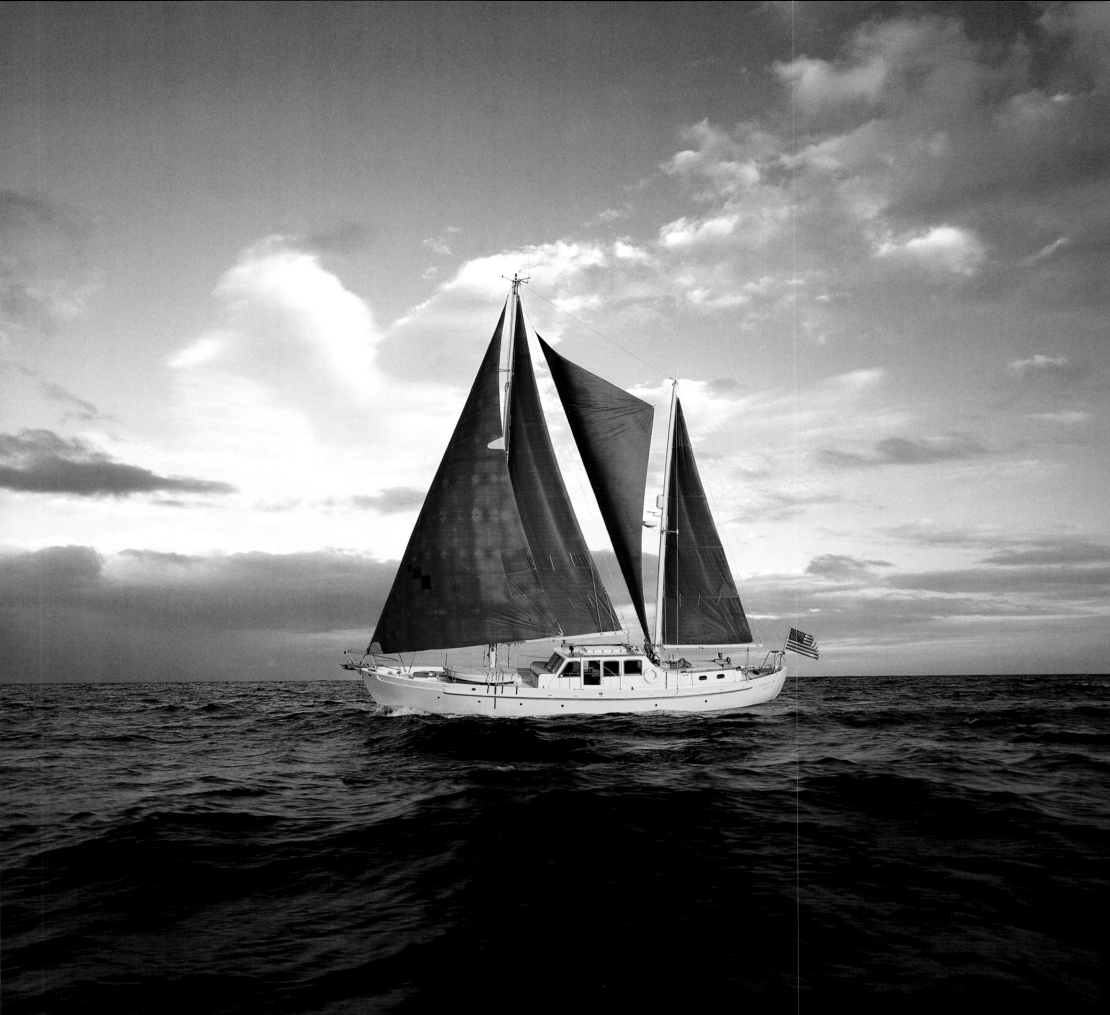

When the sun is high and causes too much contrasted light for photographs, I take to wandering the tight streets of the small villages. I always try to explore the less touristy, more native nooks and crannies of tropical islands during the hot afternoons as I wait for the sun to lower and the chance to shoot again. It gives a glimpse into the local culture—and then there is always the surprise of what I might find when ducking into the neighbor-hood establishments to have a taste of the cold local beer of choice. If I get hungry, an exotic dish I have never heard of awaits me from a scribbled menu on a chalkboard. Getting to know the local side of tropical culture is most important and makes the photographs I take that much richer and more interesting. I relish the opportunity to shoot the village fishermen at work or the shopkeeper stocking the banana supply. This type of exploration shows the unsurpassed beauty and vitality of the tropics.

At play on a hand-built Kayuka off Panama's
San Blas Islands.

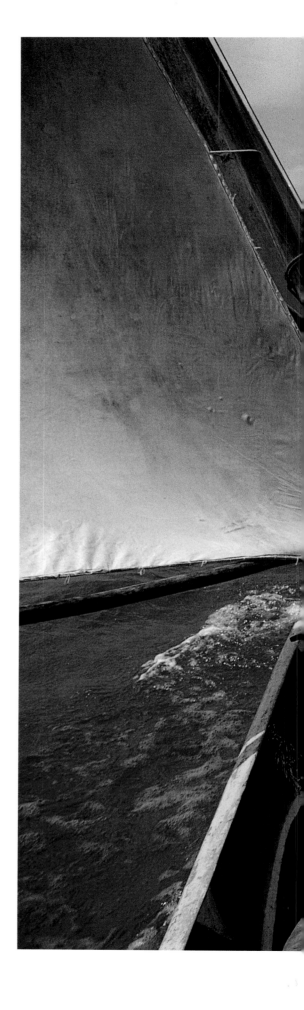

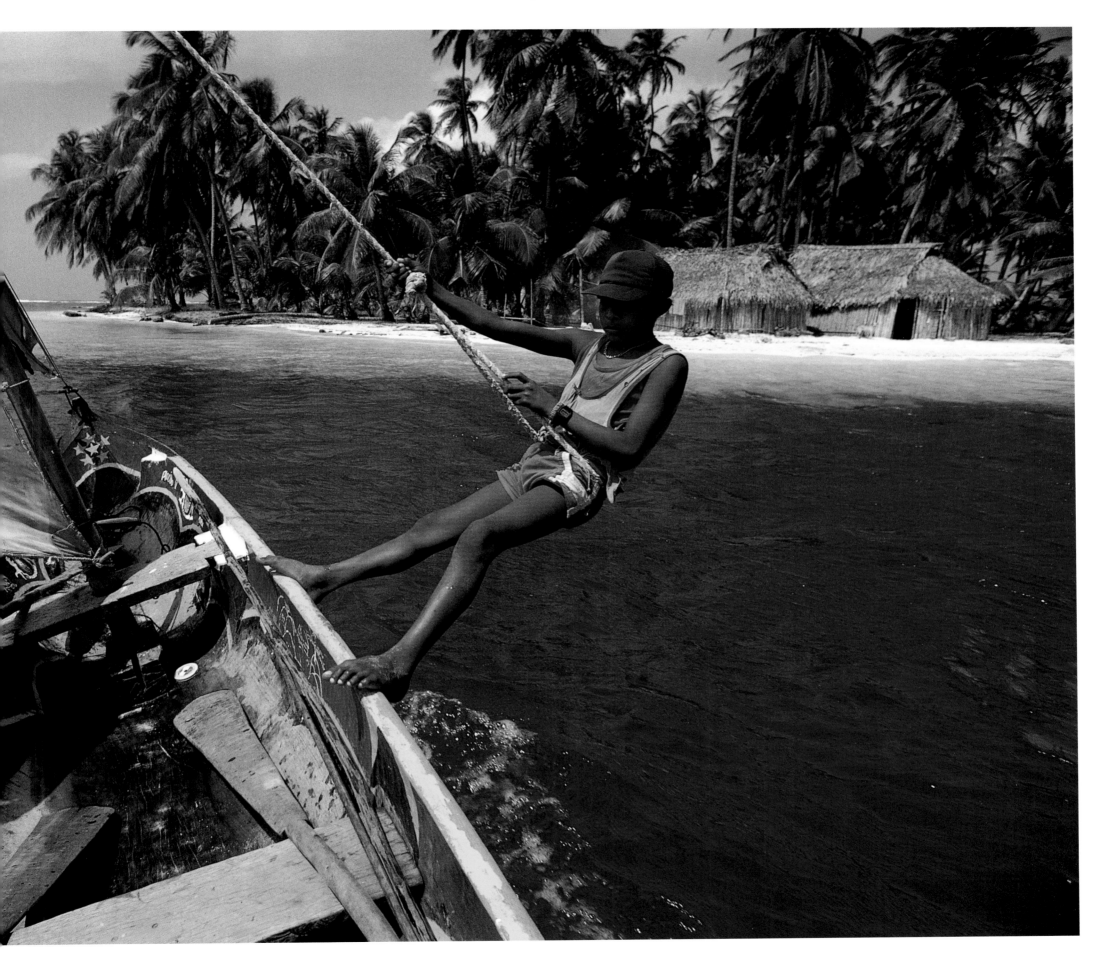

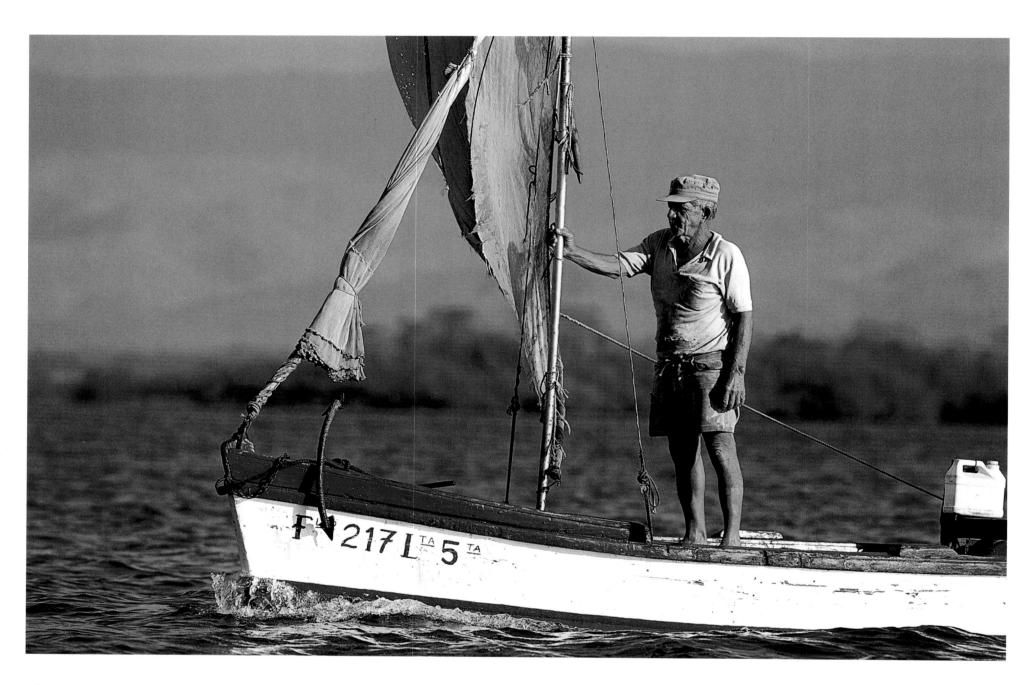

A Cuban fisherman in his sailboat on the fish-
ing grounds off Casilda's south coast.

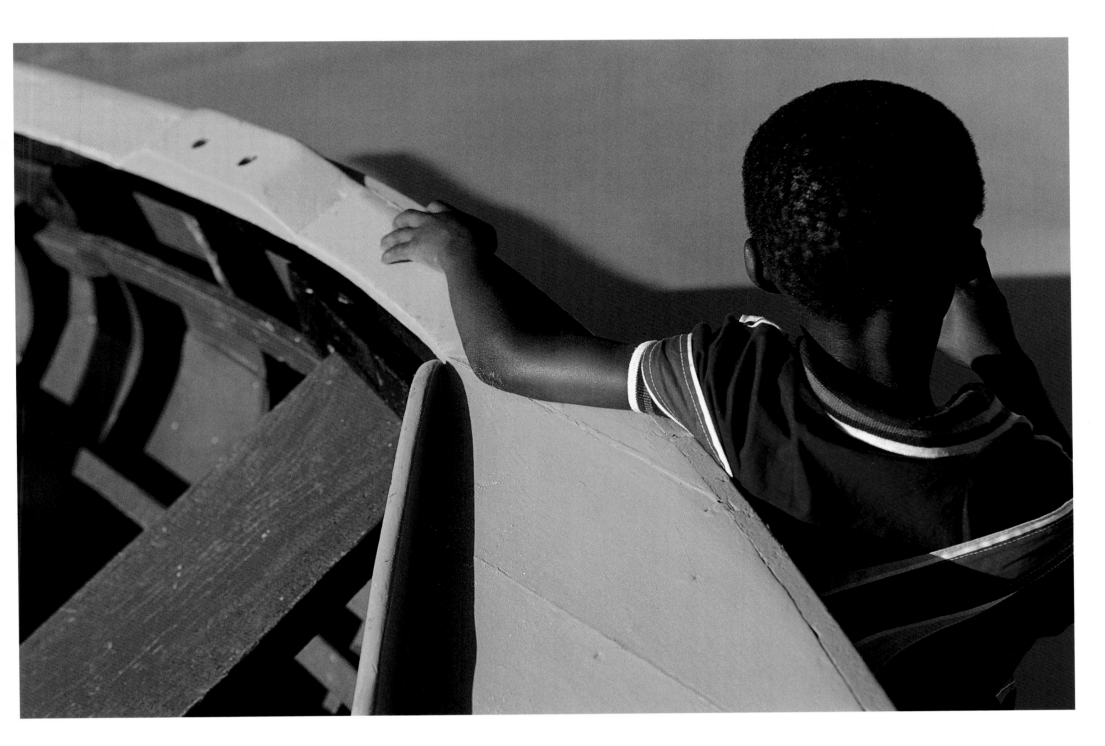

A local boy watches the workboat racing off Grande Anse Beach during the Grenada Sailing Festival.

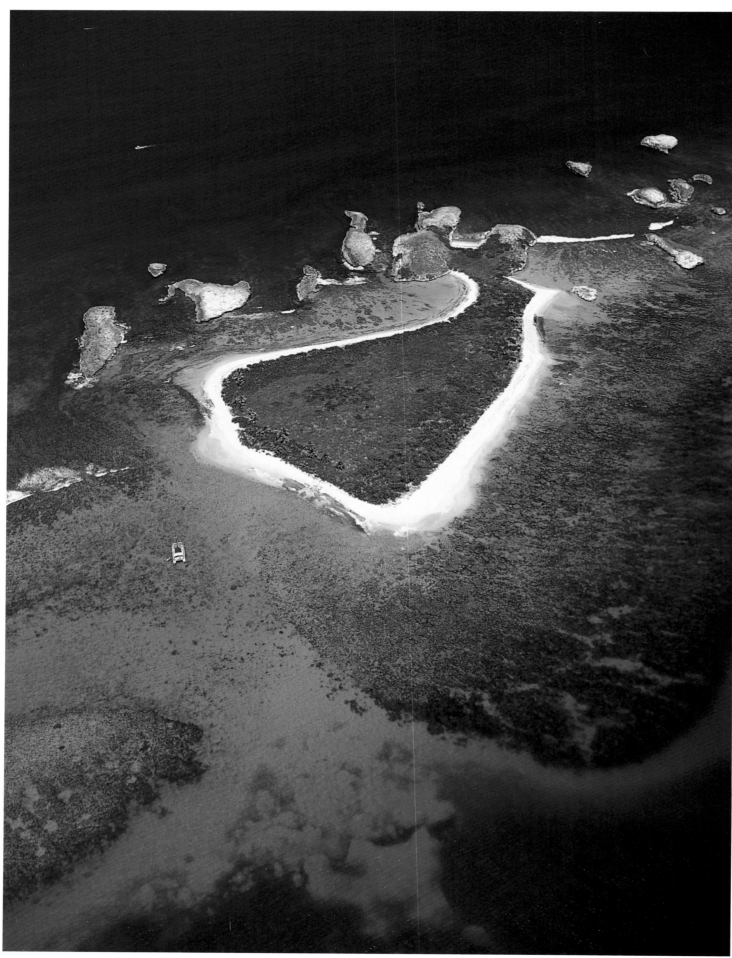

Anchored off Icacos, a small, uninhabited island off the eastern end of Puerto Rico in the Spanish Virgin Islands.

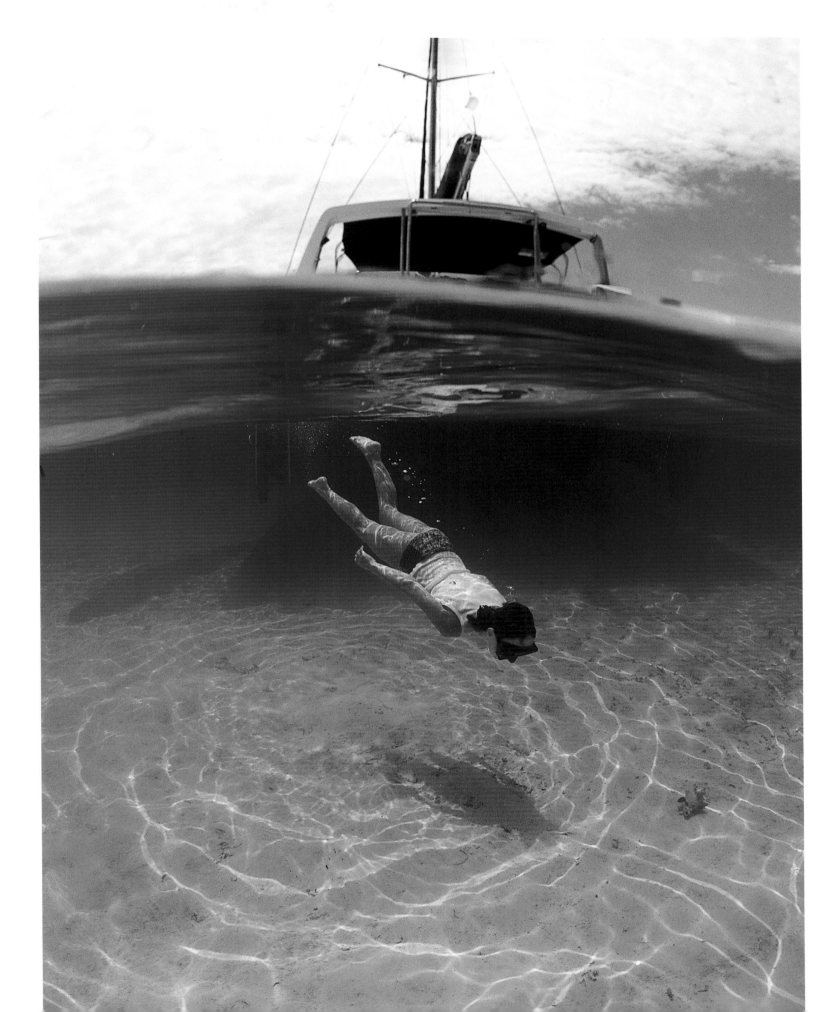

Read van der Wal dives down for a conch shell while cruising on a Moorings 38 catamaran in Belize.

OPPOSITE

The 140-foot ketch *Rebecca* looking fat and
happy from this helicopter's perspective
as she has the bit between her teeth somewhere
between Antigua and Guadeloupe in the
Caribbean.

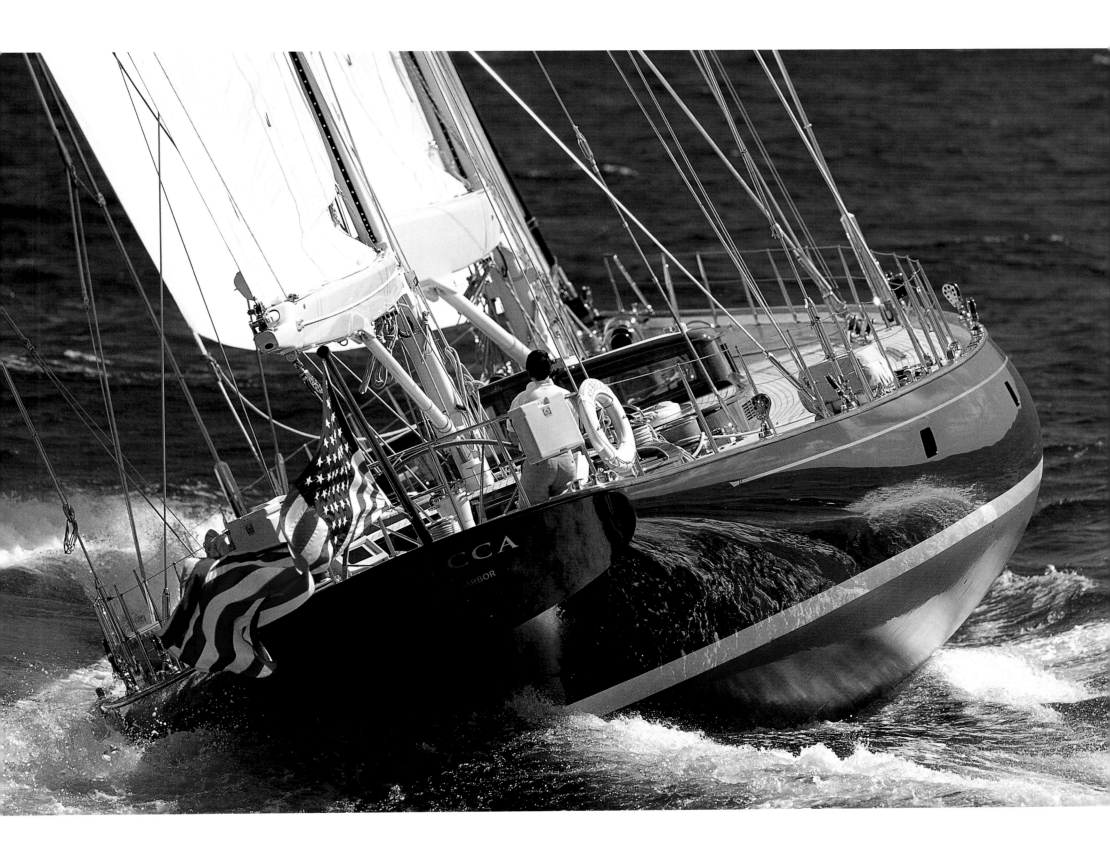

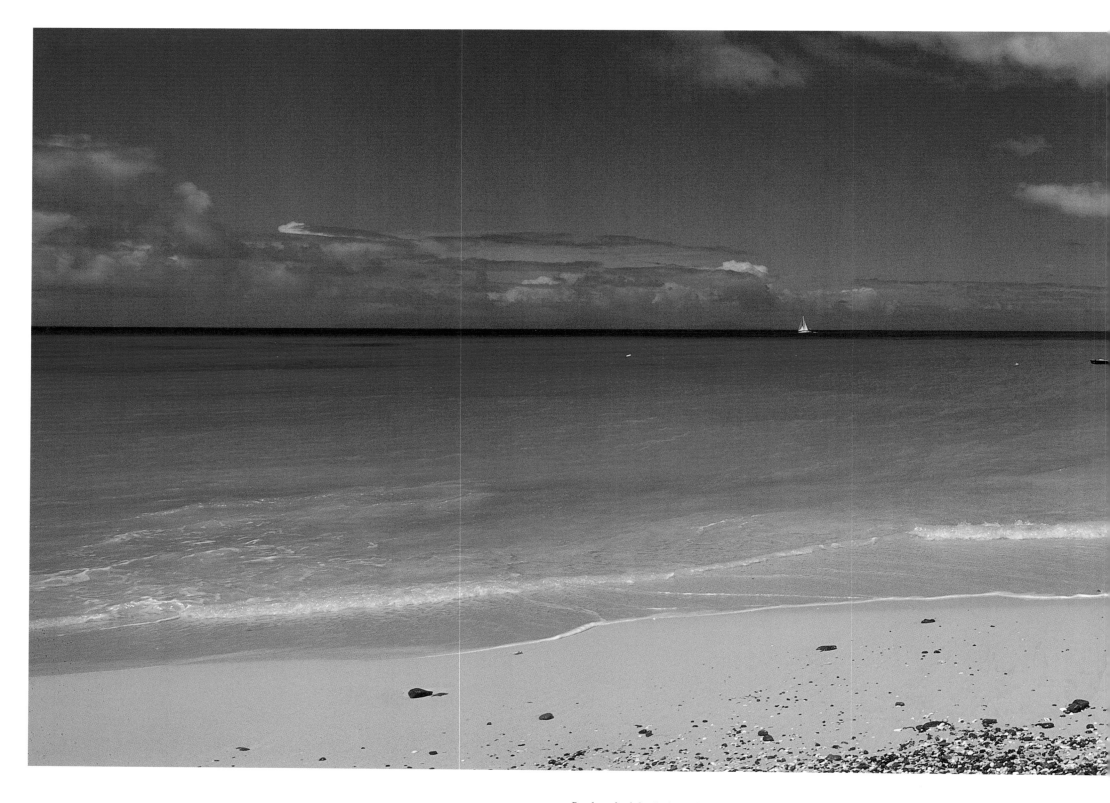

Ready to find the day's catch, two local fisher-
men load their boat on Crab Hill Beach, Antigua.

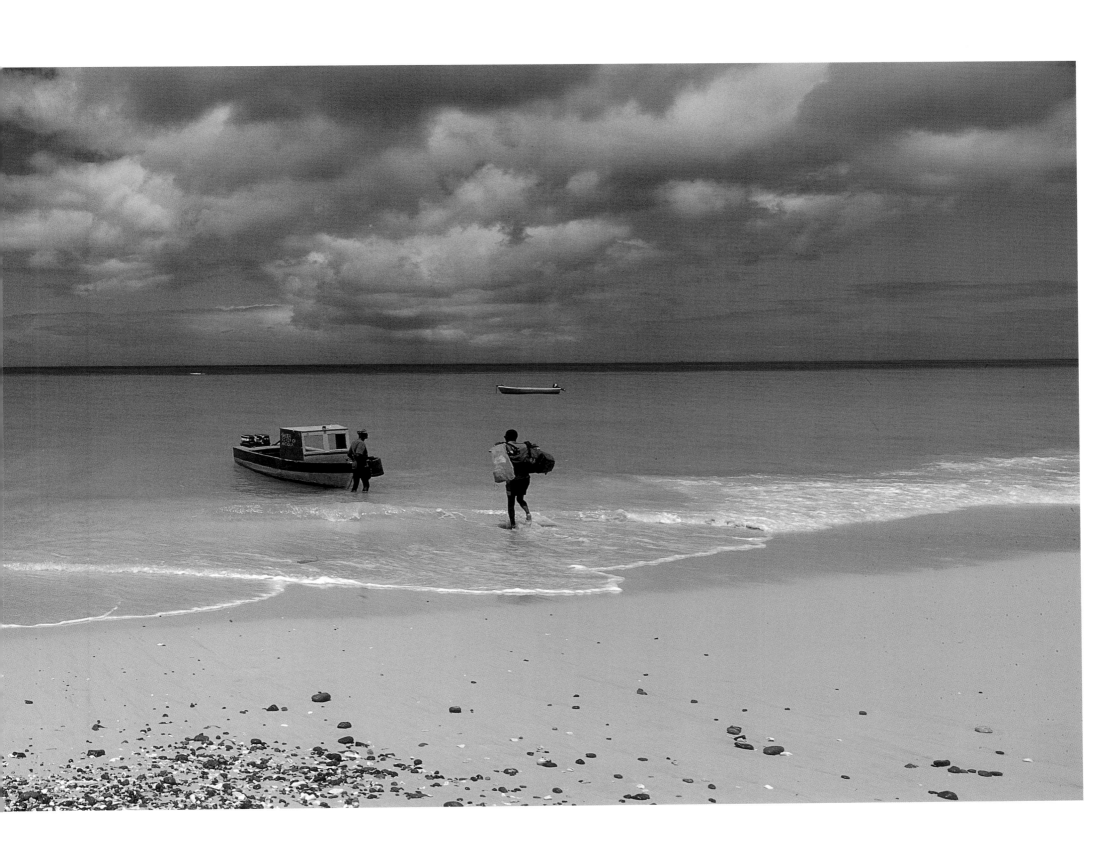

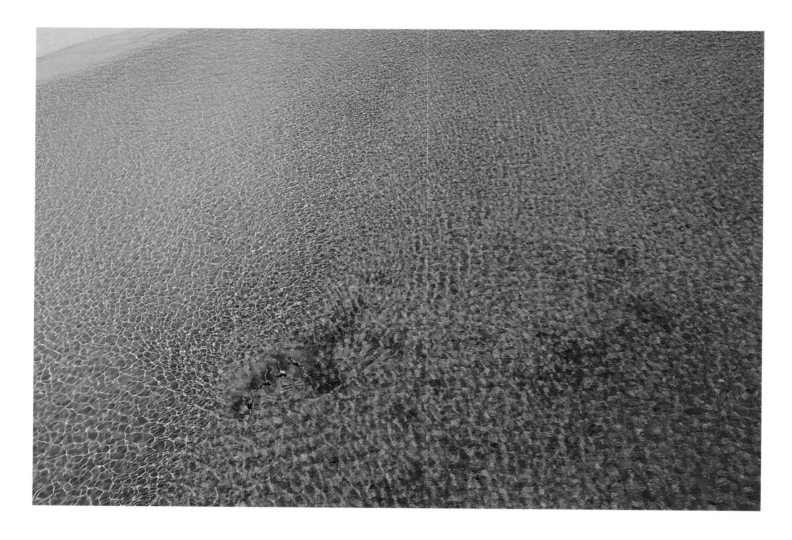

LEFT
Swimmers off *Shaman*'s bow in Vava'u, Tonga,
South Pacific.

OPPOSITE
Two divers leave an underwater cave in the
Vava'u group of islands.

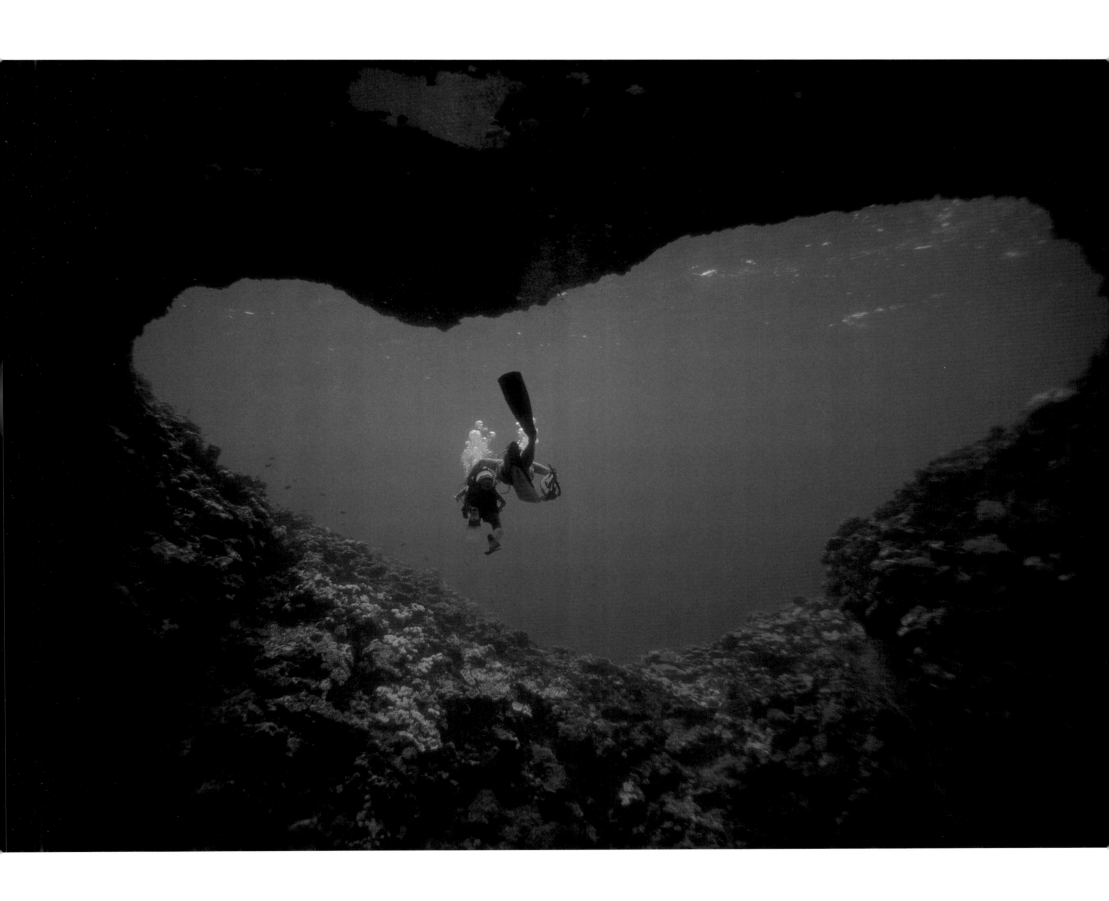

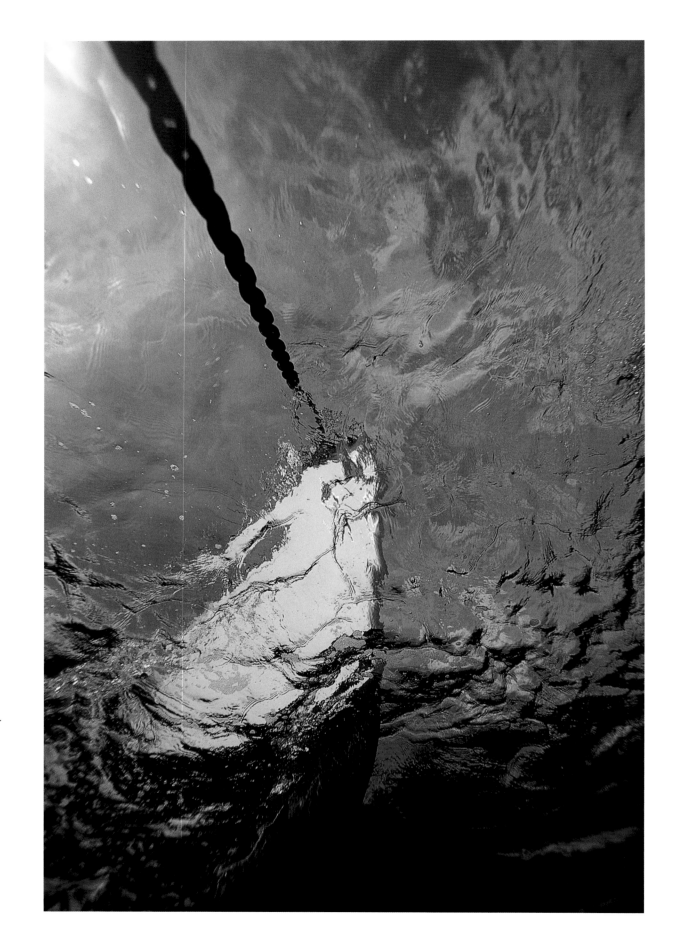

A fish's view from ten feet below the bow of *Shaman* at anchor in the clear water of Tonga.

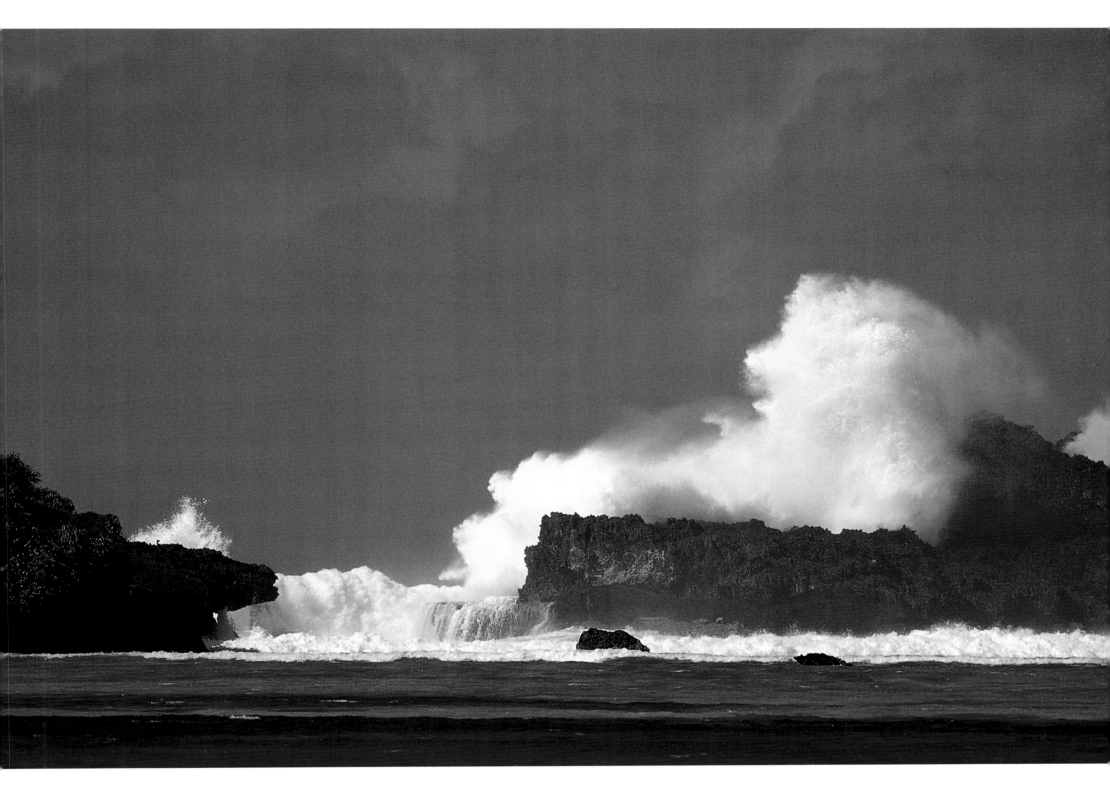

A large swell crashes onto the reef in the
South Pacific.

Shaman anchors close to shore in the Vava'u
group of islands for a great snorkeling spot and
an even better view from aloft.

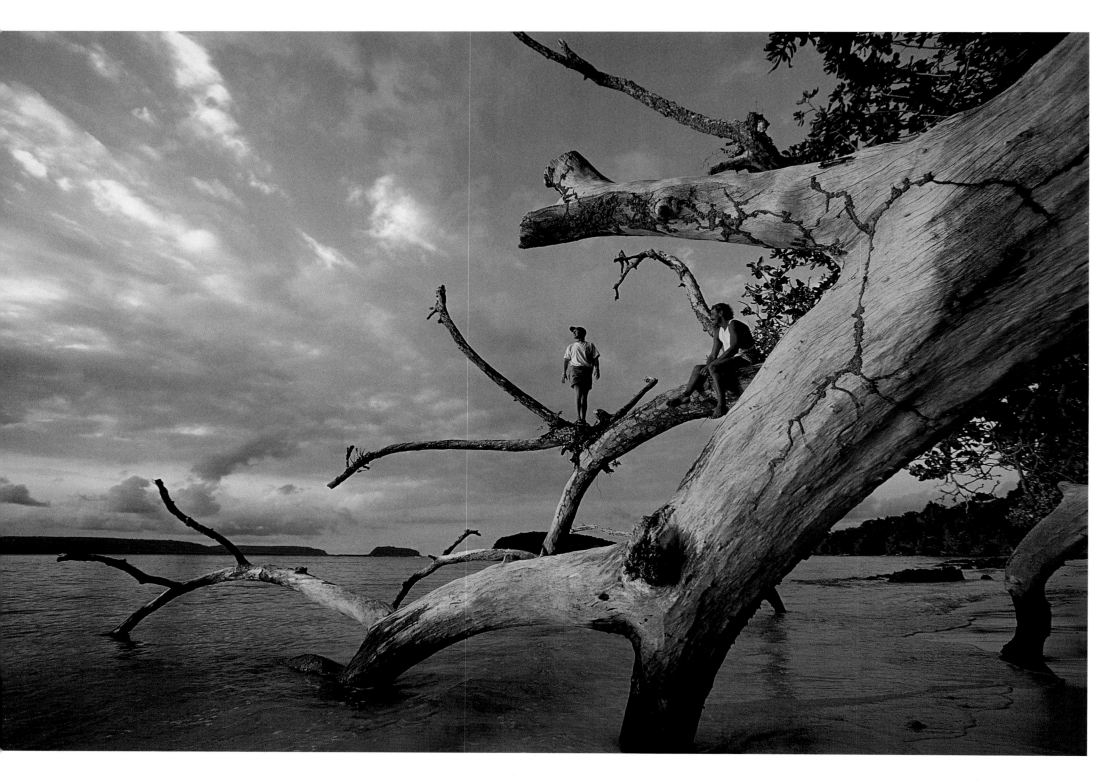

Watching the sunset into the South Pacific
from a dead tree on the island of Espiritu
Santo, Vanuatu.

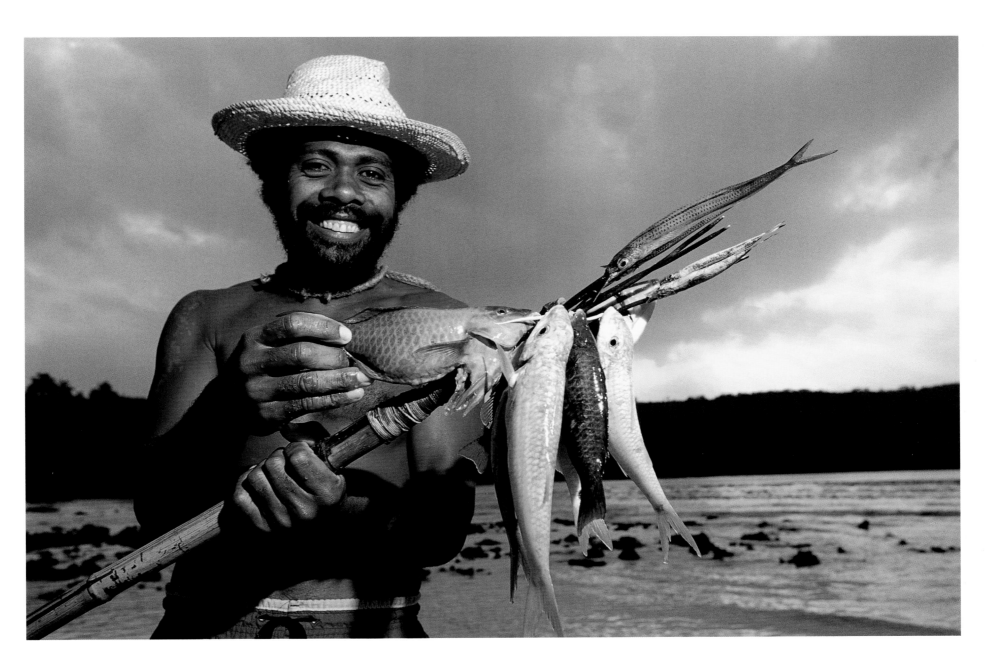

A local Vanuatu fisherman with the afternoon's catch of tropical fish.

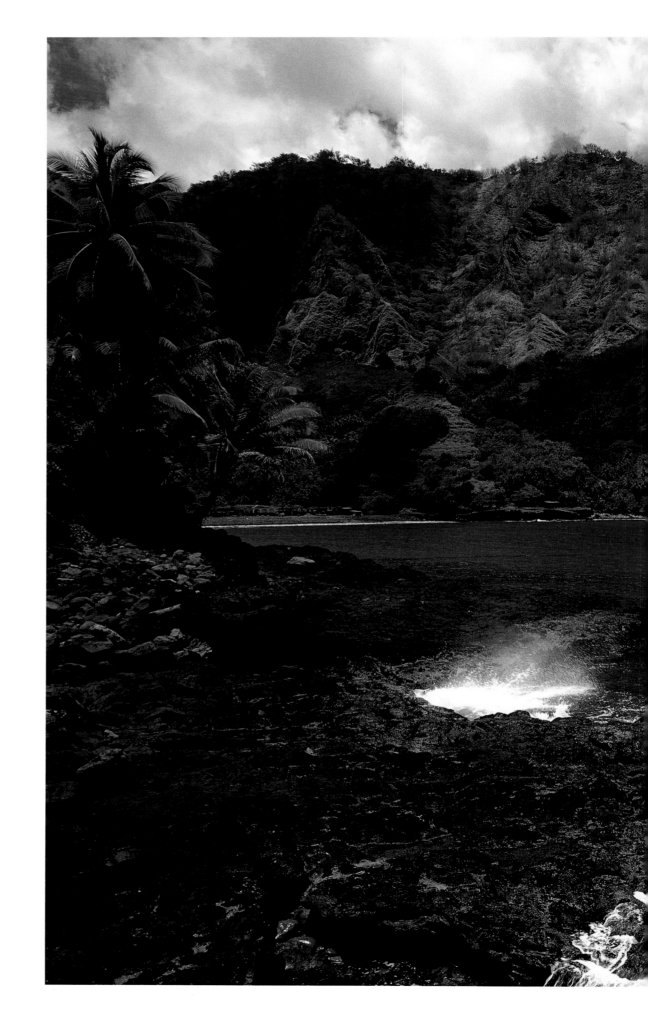

A pair of catamarans at anchor in the South Pacific paradise island group of the Marquesas, French Polynesia.

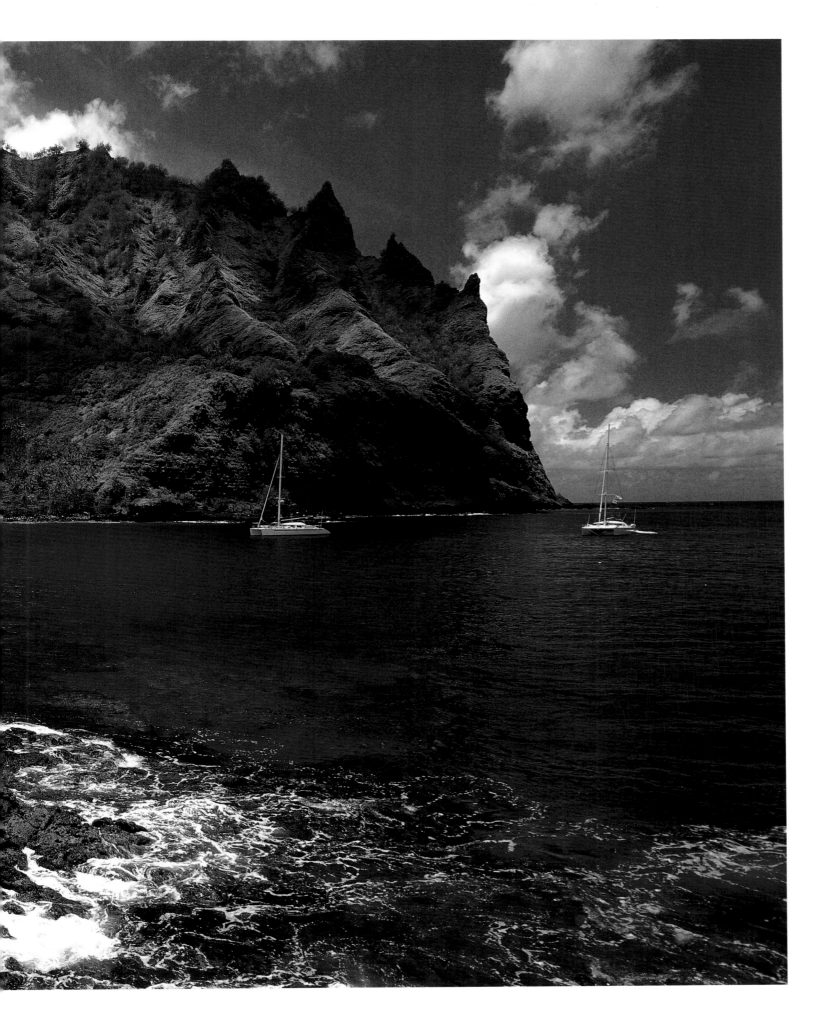

The sixty-foot catamaran *Hiti Nui* at anchor at
the Bay of Virgins in the Marquesas.

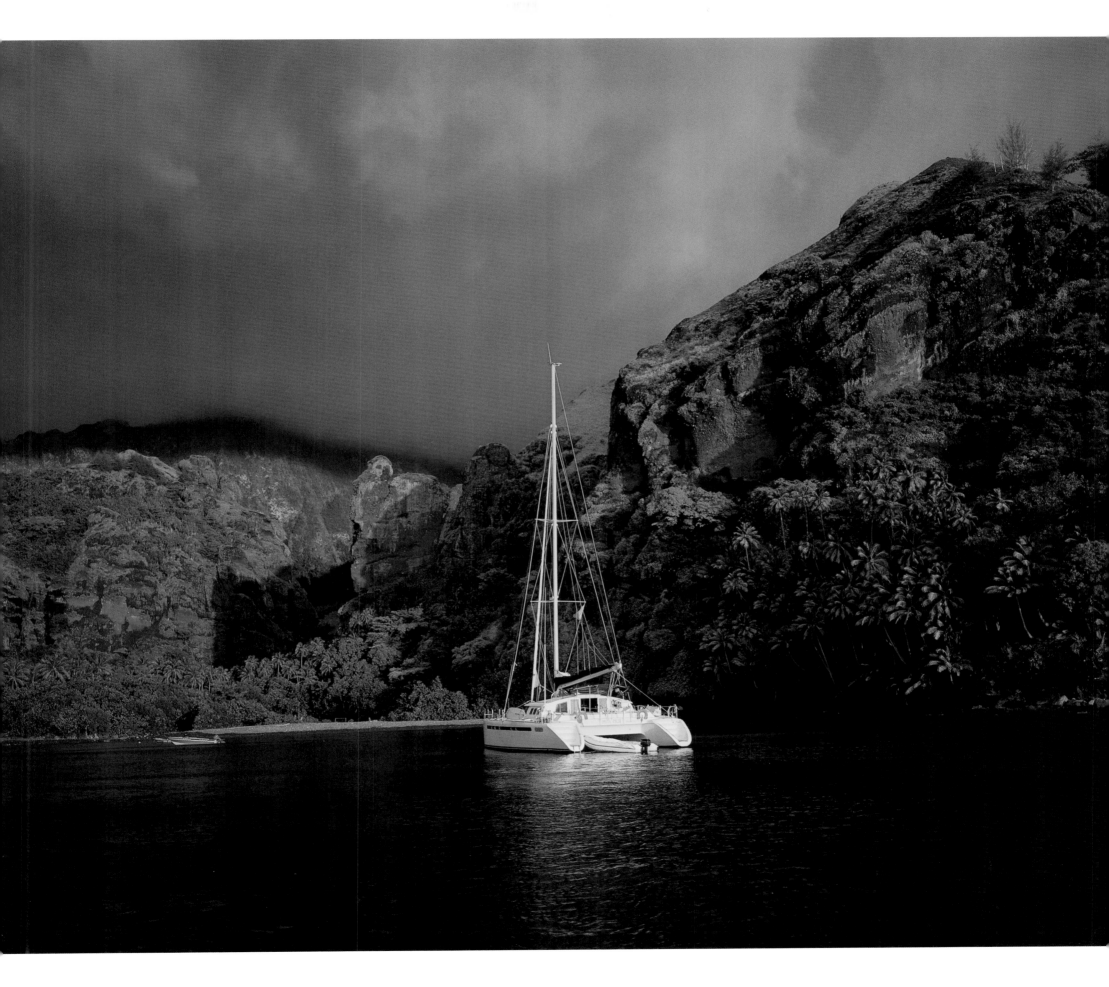

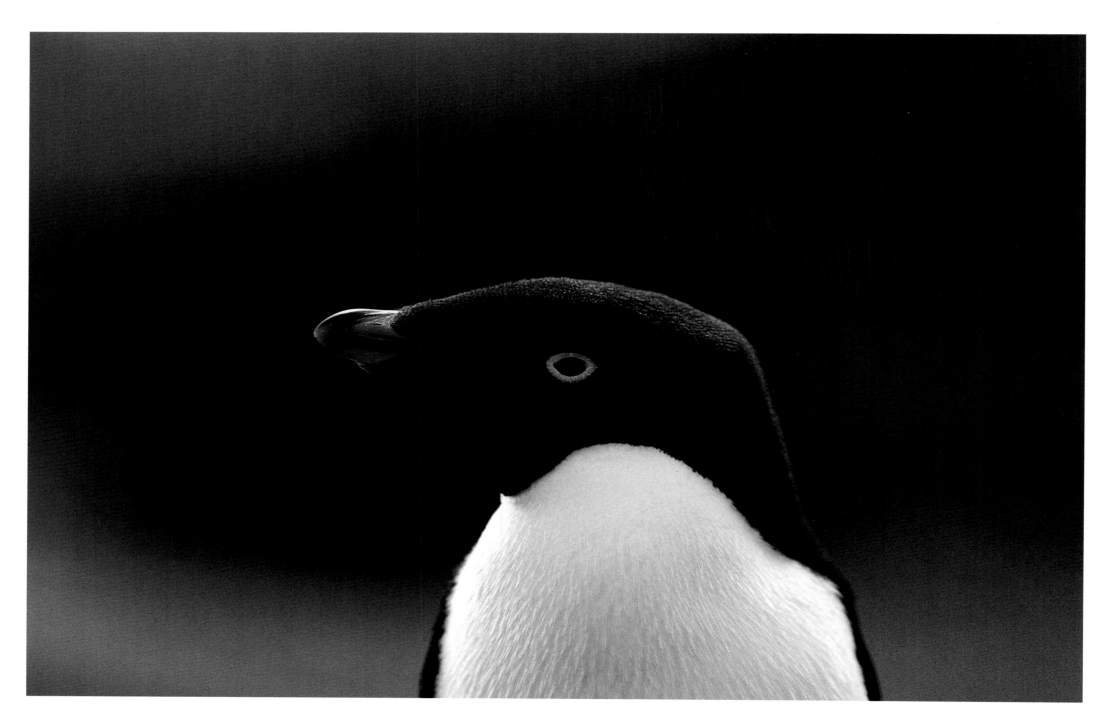

Adele penguin, Antarctica.

Exploring High Latitudes

High latitude: In other words, places where it is cold and few people go. High latitude cruising is done in the Northern and Southern hemispheres from about 60 degrees and higher to the point where the ice stops your progress. When traveling in these latitudes you need a very well prepared boat and a crew that can handle the rigors of strong wind, big seas, and treacherous ice. Most of the time supplies and help are at least several days away, so you have to be completely self-sufficient and very cautious. The rewards of cruising in these areas are unspoiled and breath-taking scenery, wildlife that is rarely seen by humans, and, best of all, the ability to go for weeks without seeing another boat, plane, or person.

Some of my most exciting memories have been of cruising at 80 degrees latitude, off Spitsbergen, well north of the main-land of Norway, where I spent time on the ninety-foot sloop *Shaman*. We had twenty-four hours a day of sunlight, about six hours of which was beautiful golden light that turned every scene into something magical. We hiked every day, with rifles to keep the hungry polar bears at bay. I carried my forty-pound pack of camera equipment and wore a good sturdy pair of hiking boots and windproof clothing to keep the bone-chilling arctic breeze out. As we explored this territory, we felt as if we were the first to set foot on these remote parts of the globe. There was little time for sleep, as there was so much to see, and the days literally never ended. With no sign of people and no footprints, we felt alone with the wildlife. The arctic summers are amazing but very

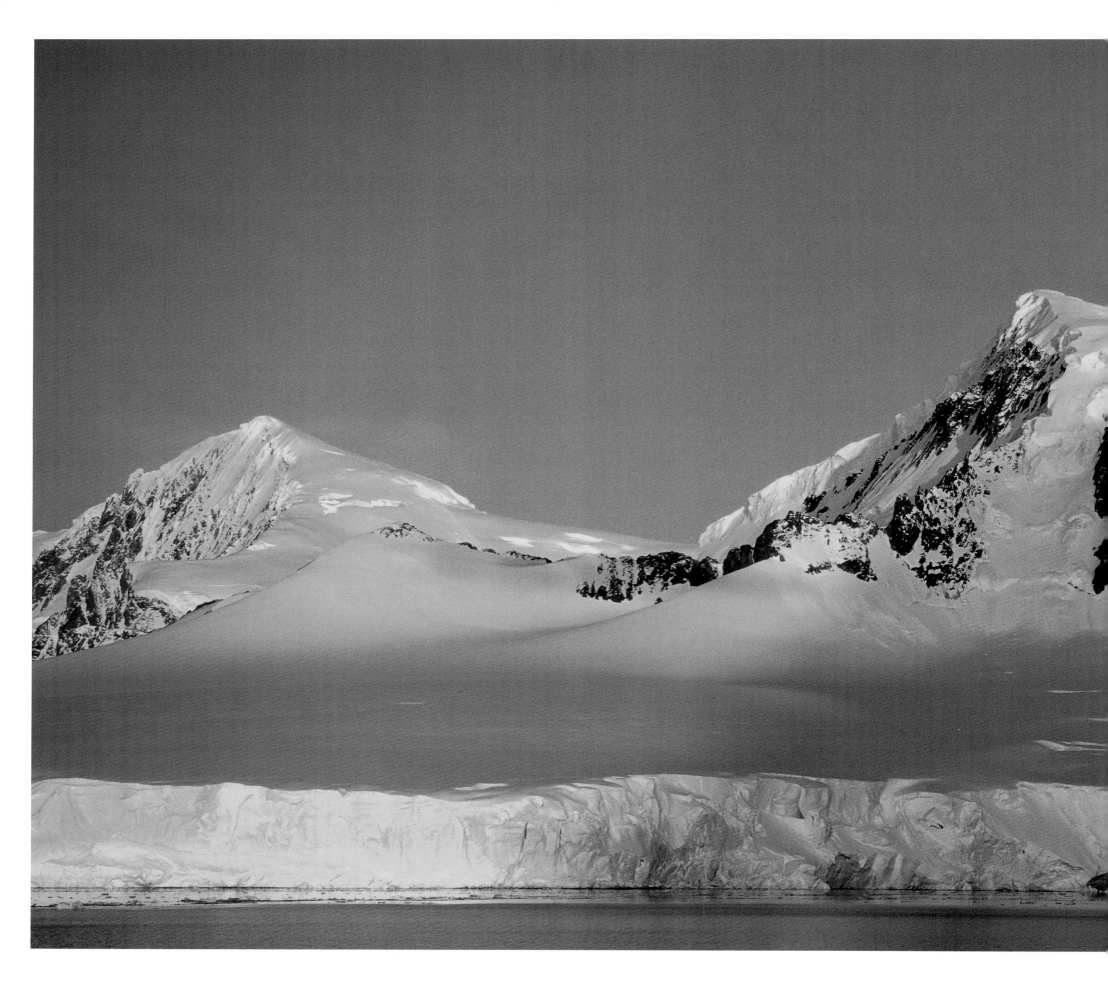

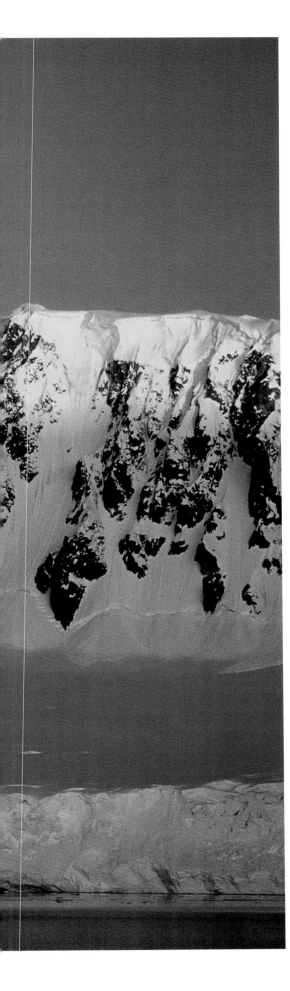

short and leave little time for the animals to gather food, build nests, mate, and hatch their young. When winter comes, Spitsbergen is without any daylight, and by then, the wildlife has migrated south to warmer climes.

At the other end of the world lie the desolate stretches of the Chilean waterway that leads to Tierra del Fuego, Cape Horn, and beyond to Antarctica. There, all you see is the Andean condor, glaciers, and wind that blows in excess of sixty knots regularly. Tucking up inside the fiords with multiple lines ashore and the katabatic winds screaming through the rigging is a good way to wait for the frequent deep weather depressions to pass and barrel off into the Southern Ocean. The joy in photographing these remote, rarely visited locations is in trying to best capture the spirit of the place. You can only hope that, upon your return, when you see the photographs you have taken, the feeling of the magic of the poles will revisit you.

Late light on the Straits of Le Maire mountains in Antarctica at midnight.

A few lone penguins on an iceberg in
Antarctica.

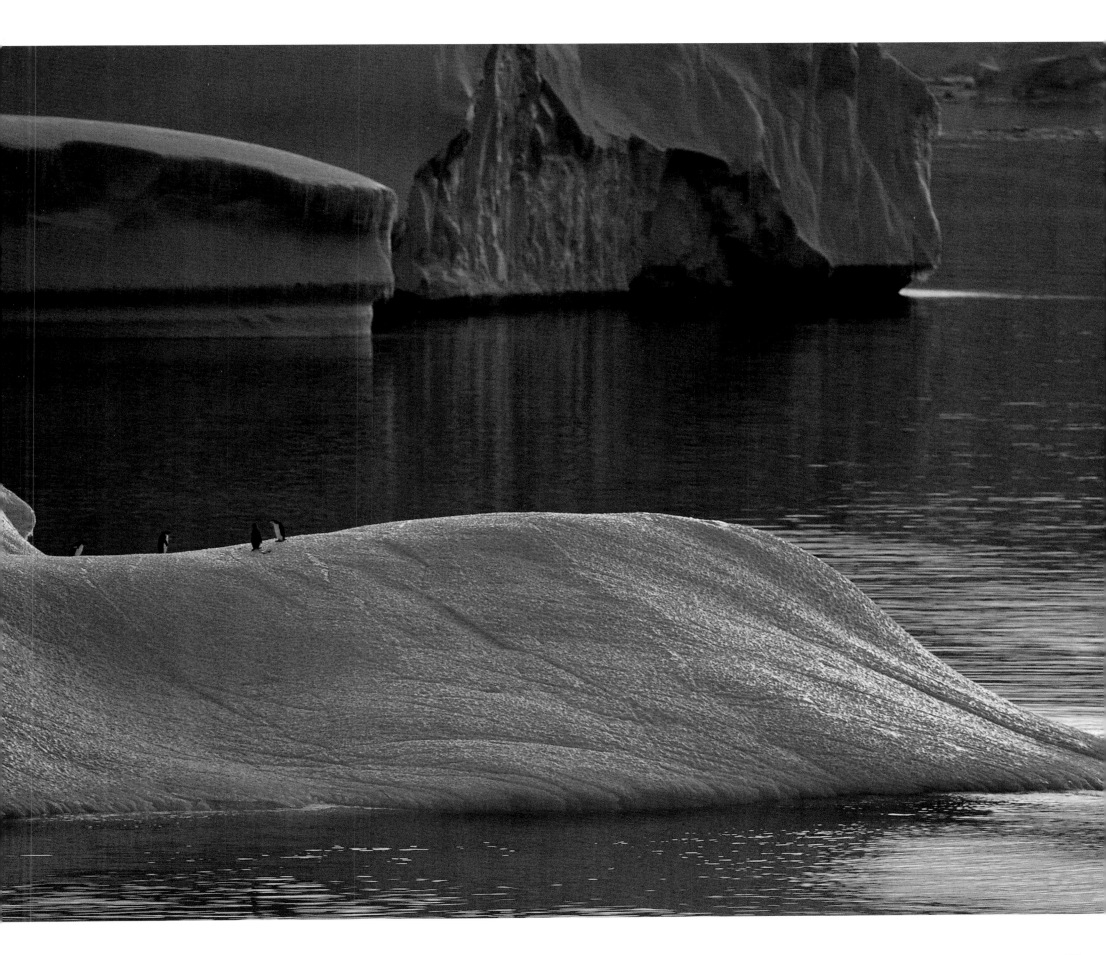

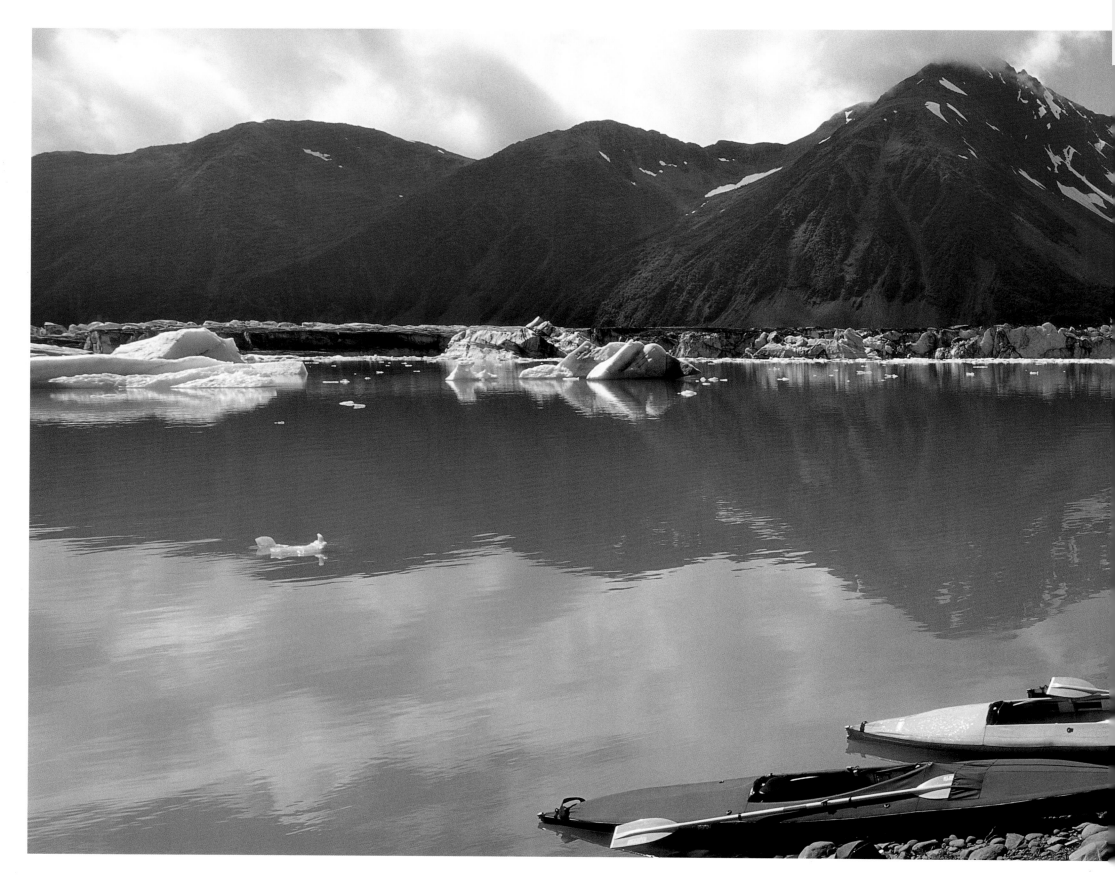

Three Klepper kayaks on the shore of the Kenai
Peninsula in Alaska.

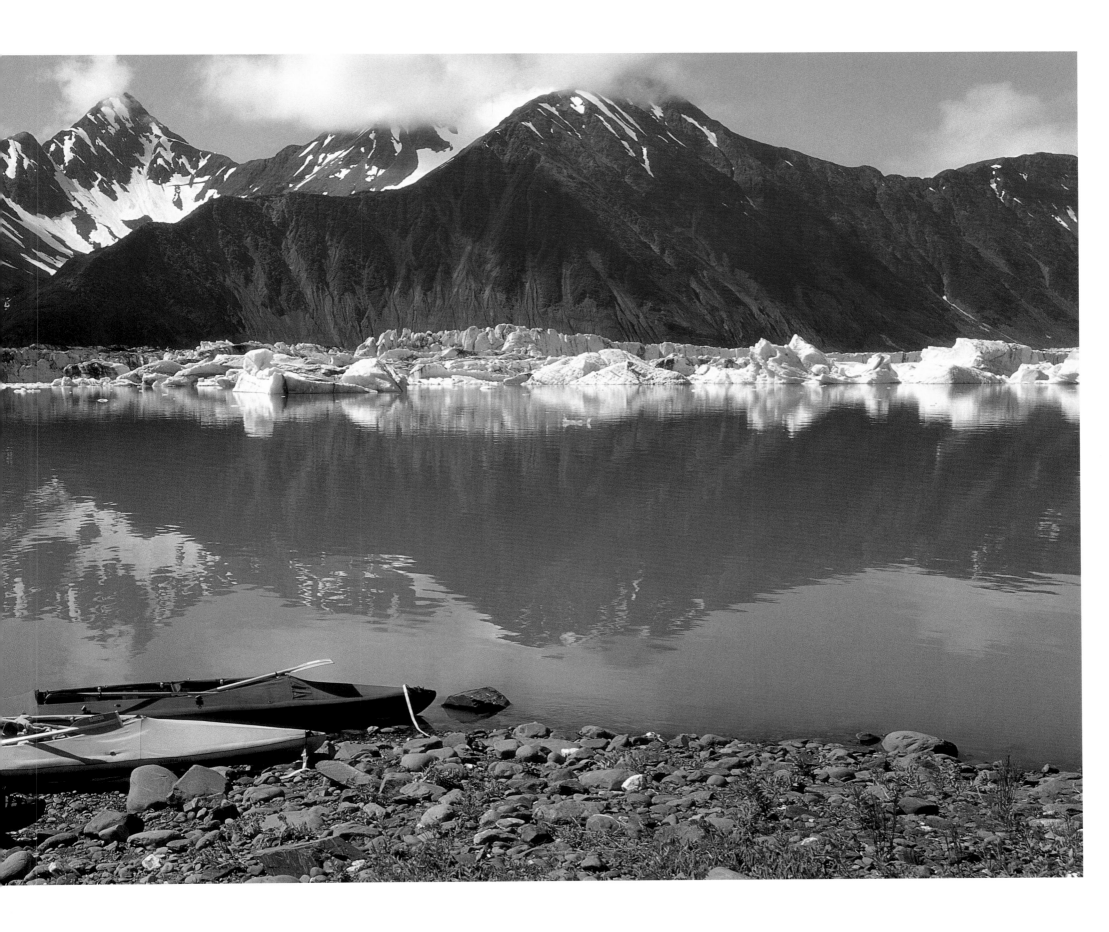

A whale sounds off Alaska's Kodiak Island.

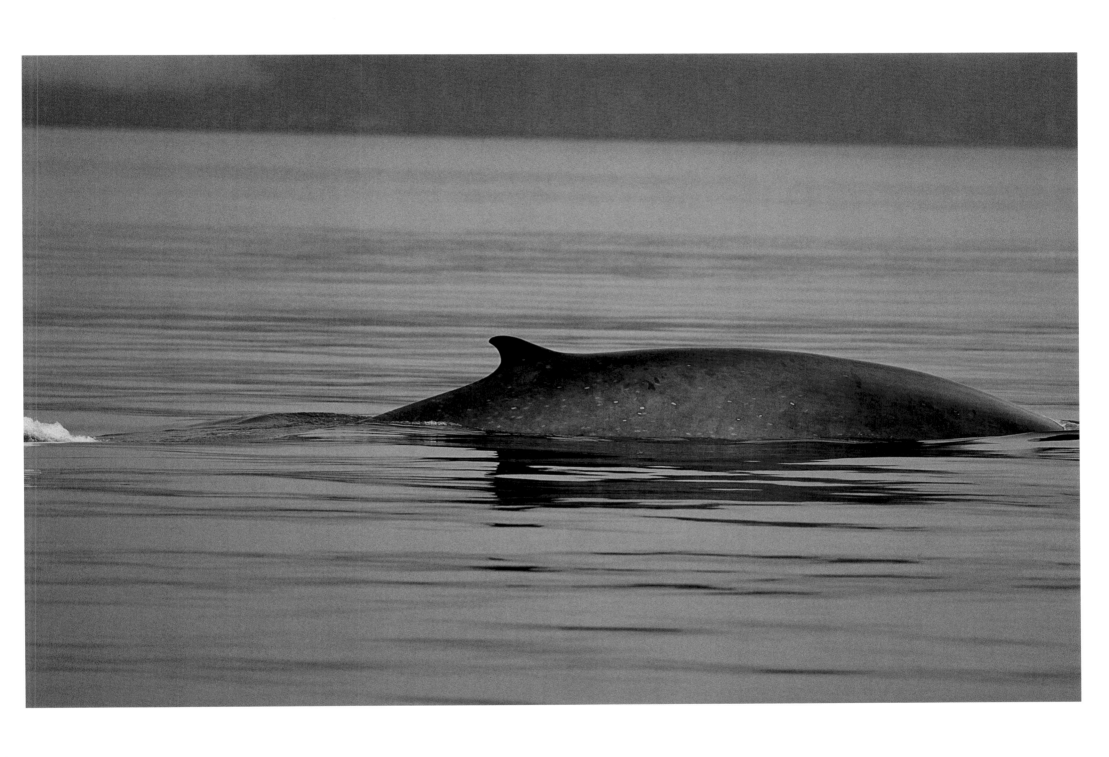

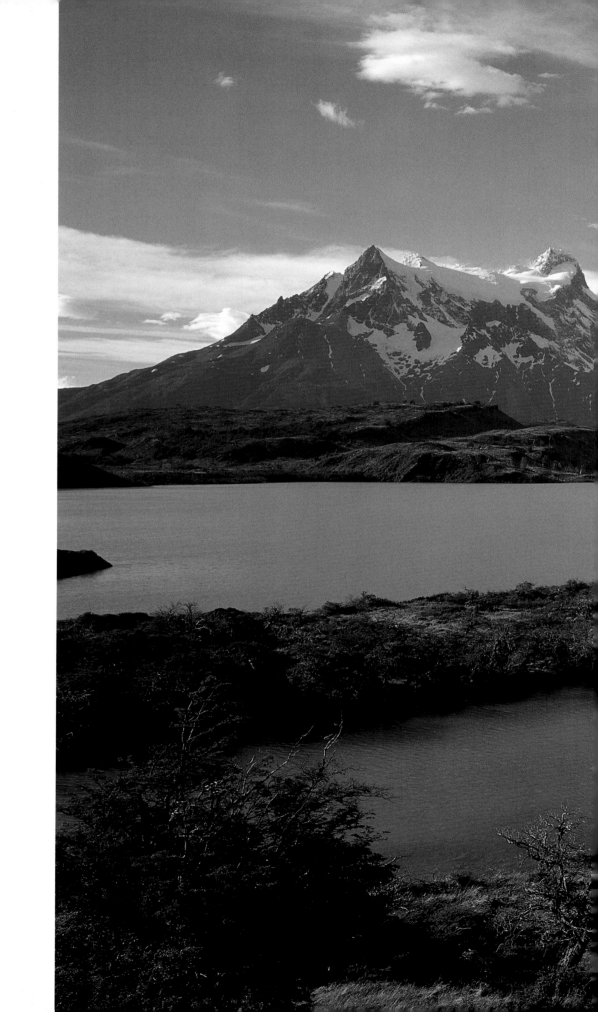

Torres del Paine National Park, Patagonia, Chile.

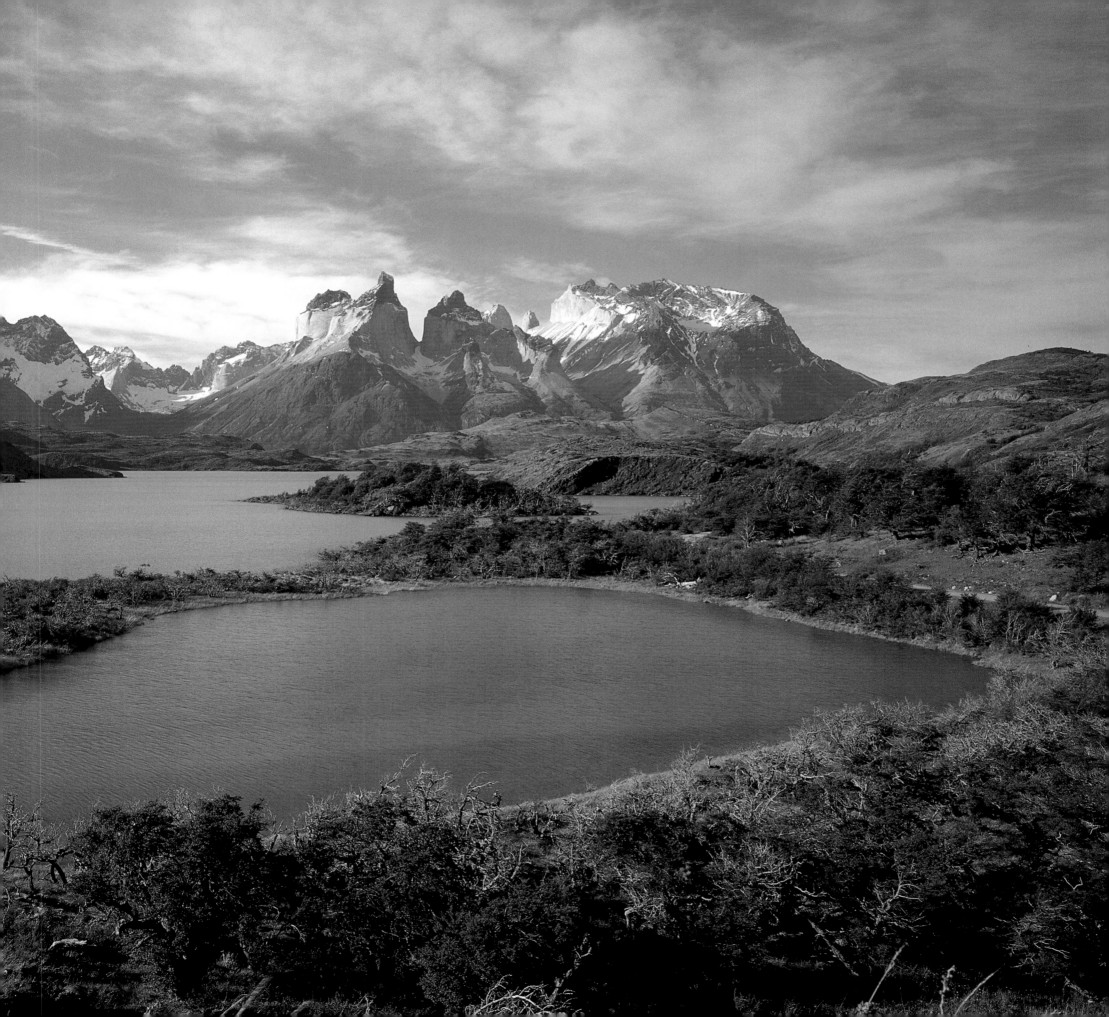

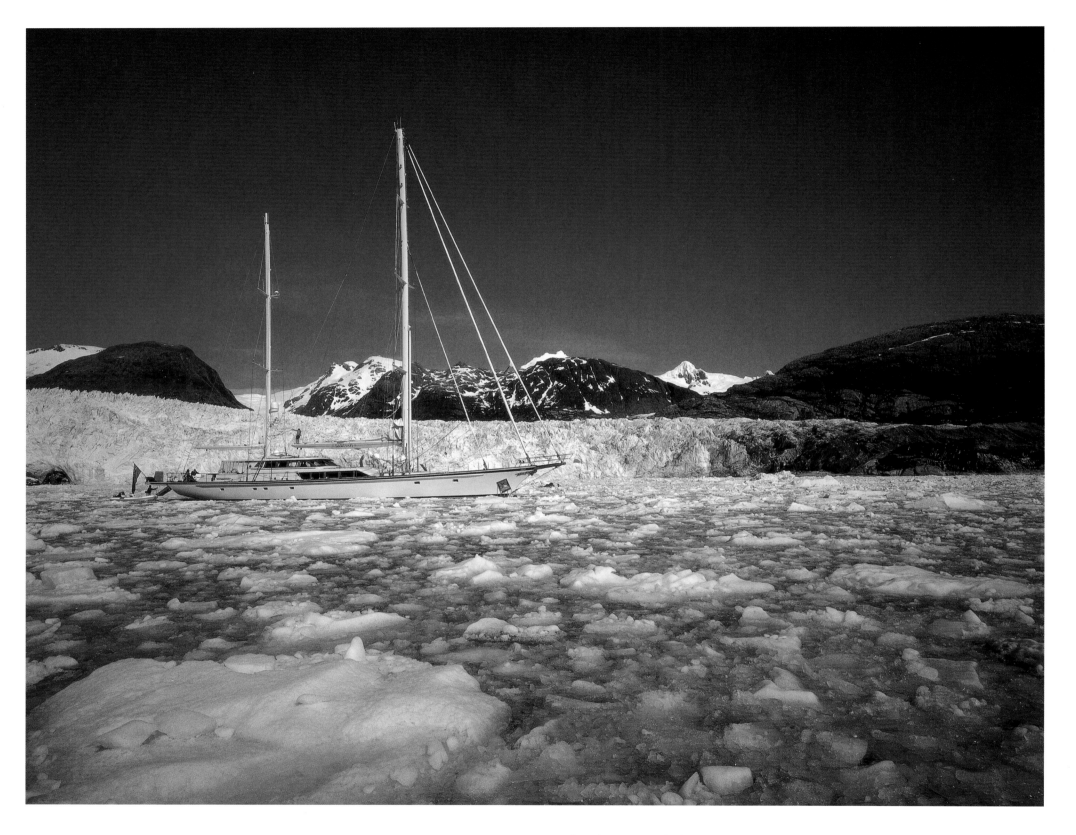

Sariyah trying to get back to the tender while exploring a glacier in Patagonia.

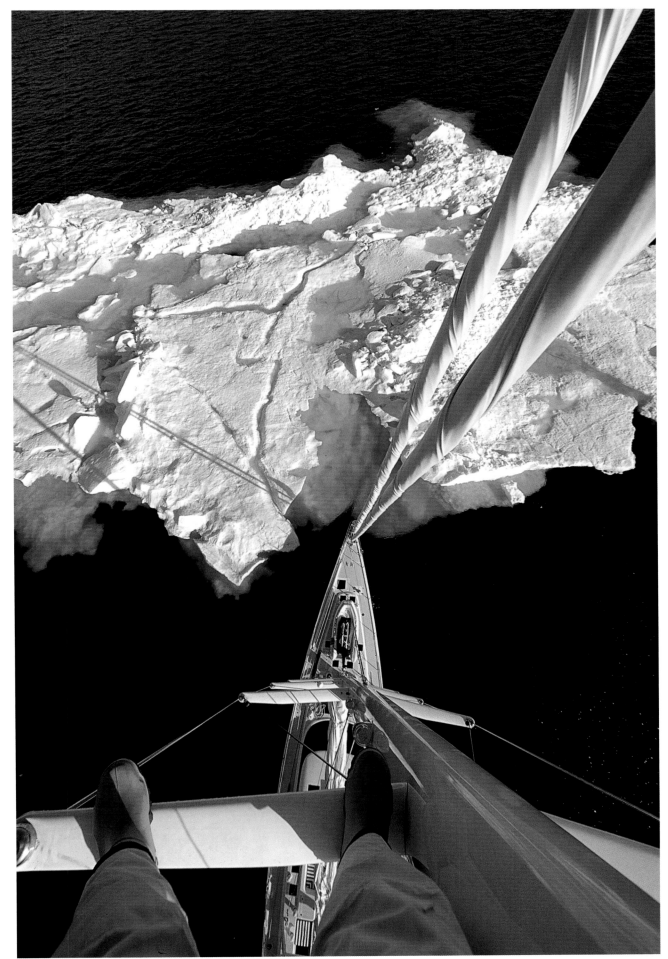

The mastman's-eye view from one hundred
feet aloft of an iceberg during the Spitsbergen
trip on *Shaman*.

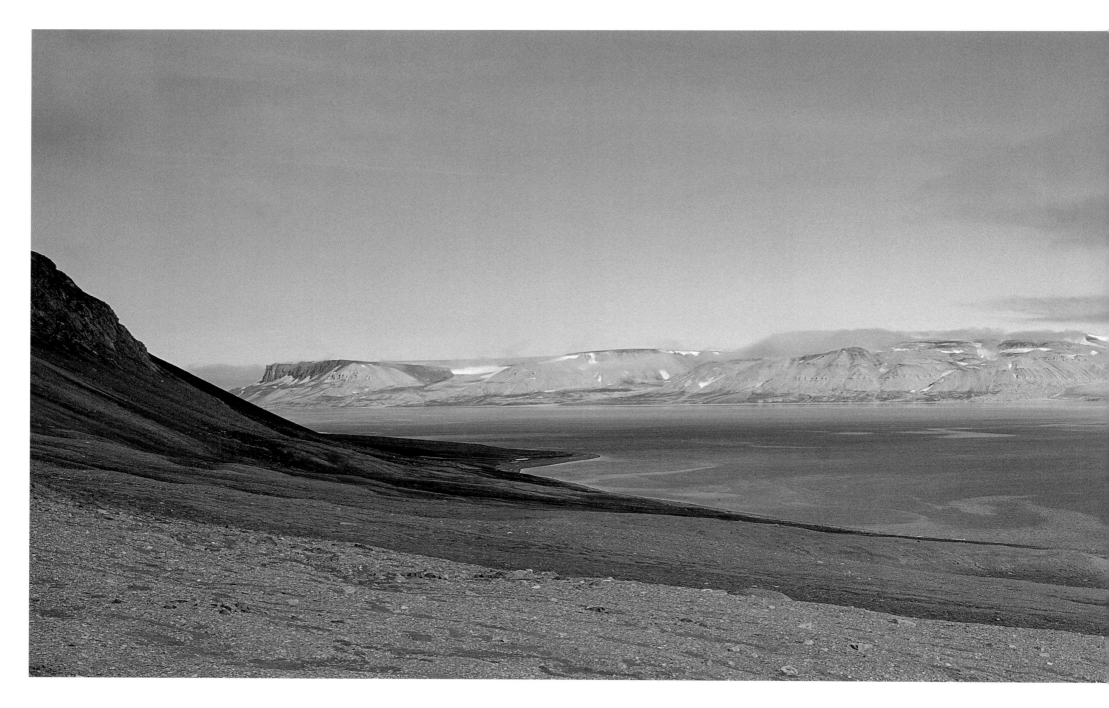

Shaman finds a peaceful anchorage in
Lomfjord, Hinlopen Strait, Spitsbergen.

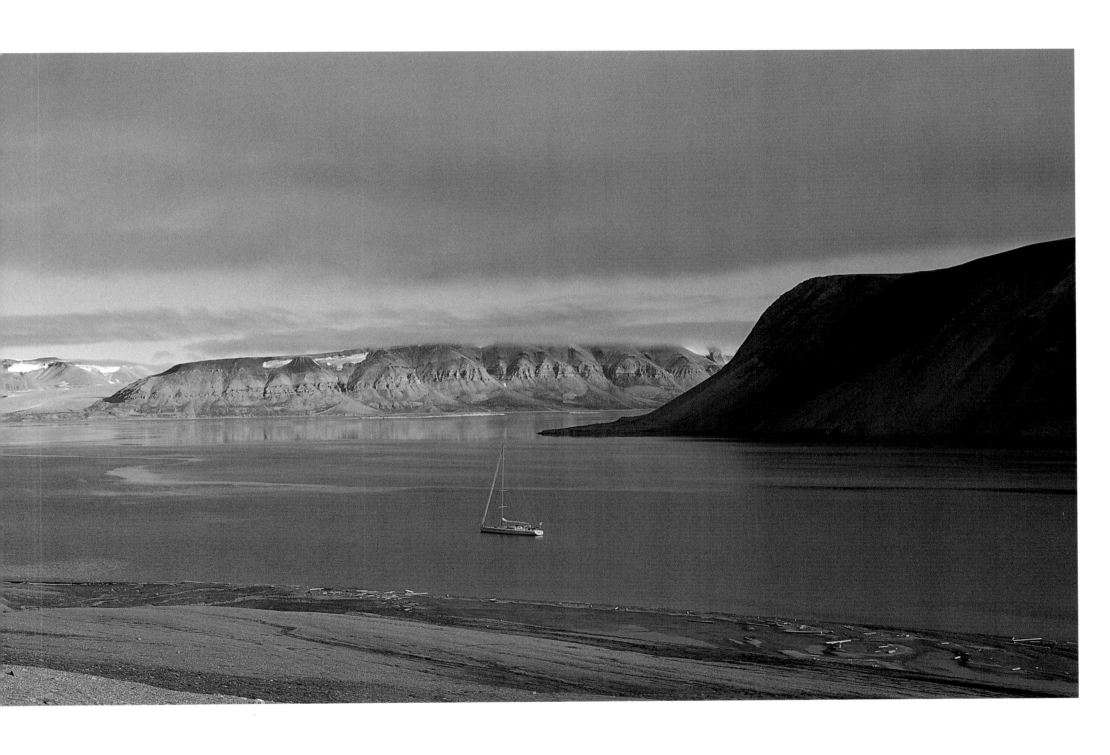

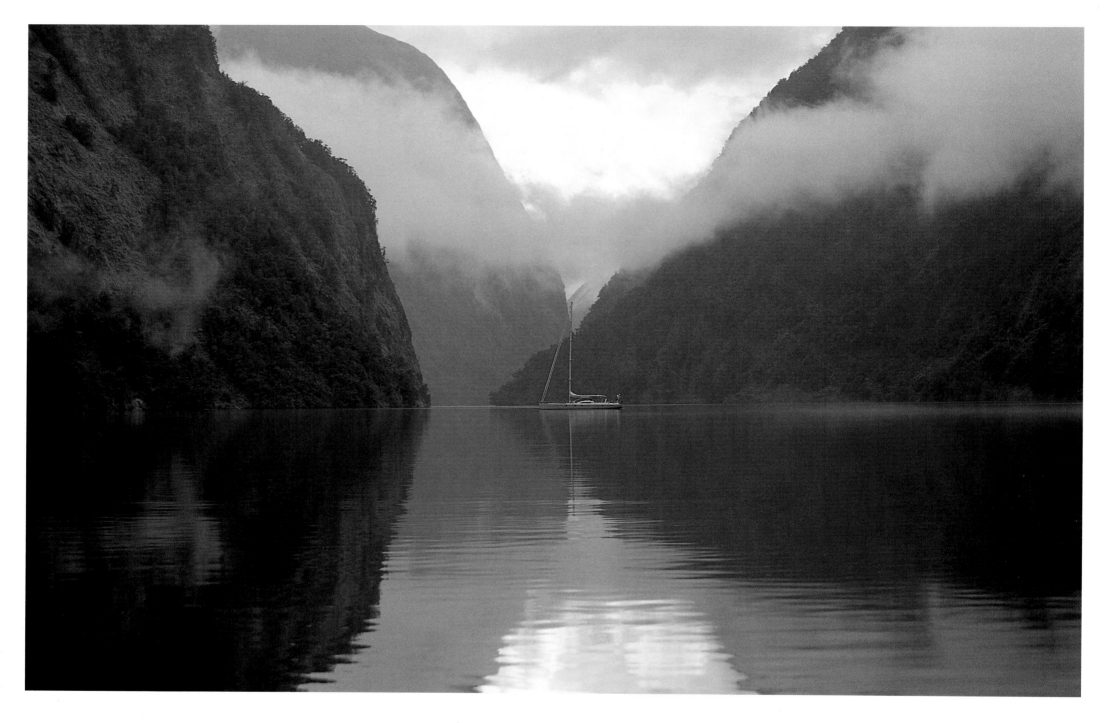

Shaman in the fiords of Doubtful Sound in
New Zealand's South Island.

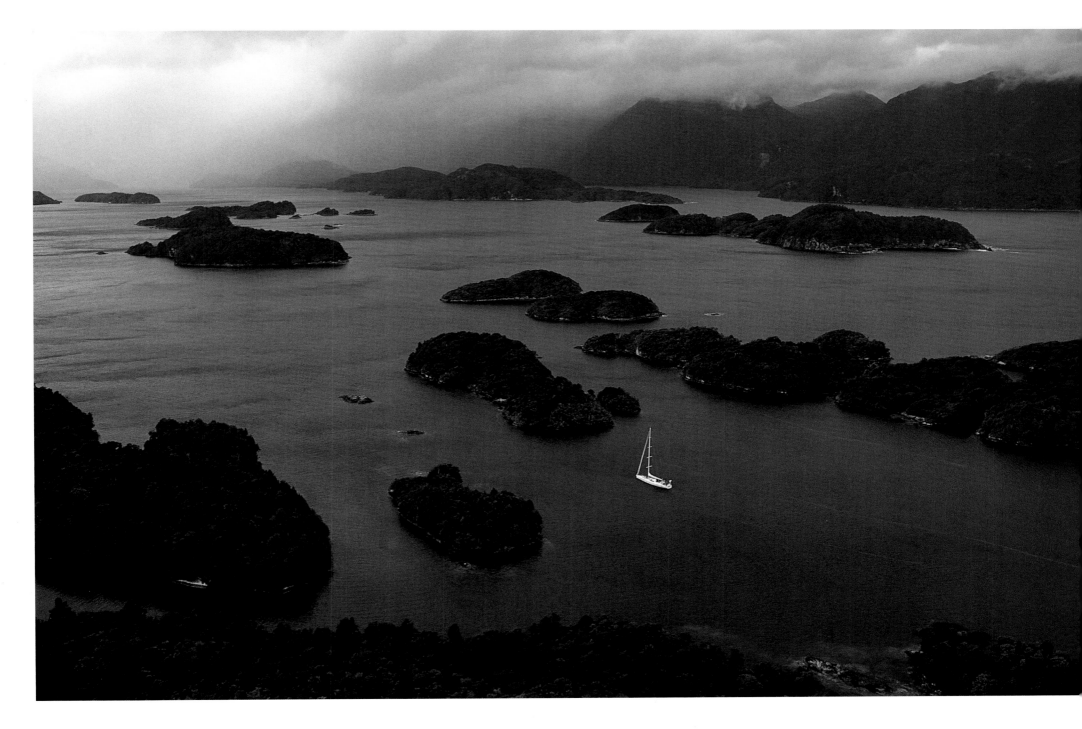

At anchor in Doubtful Sound.

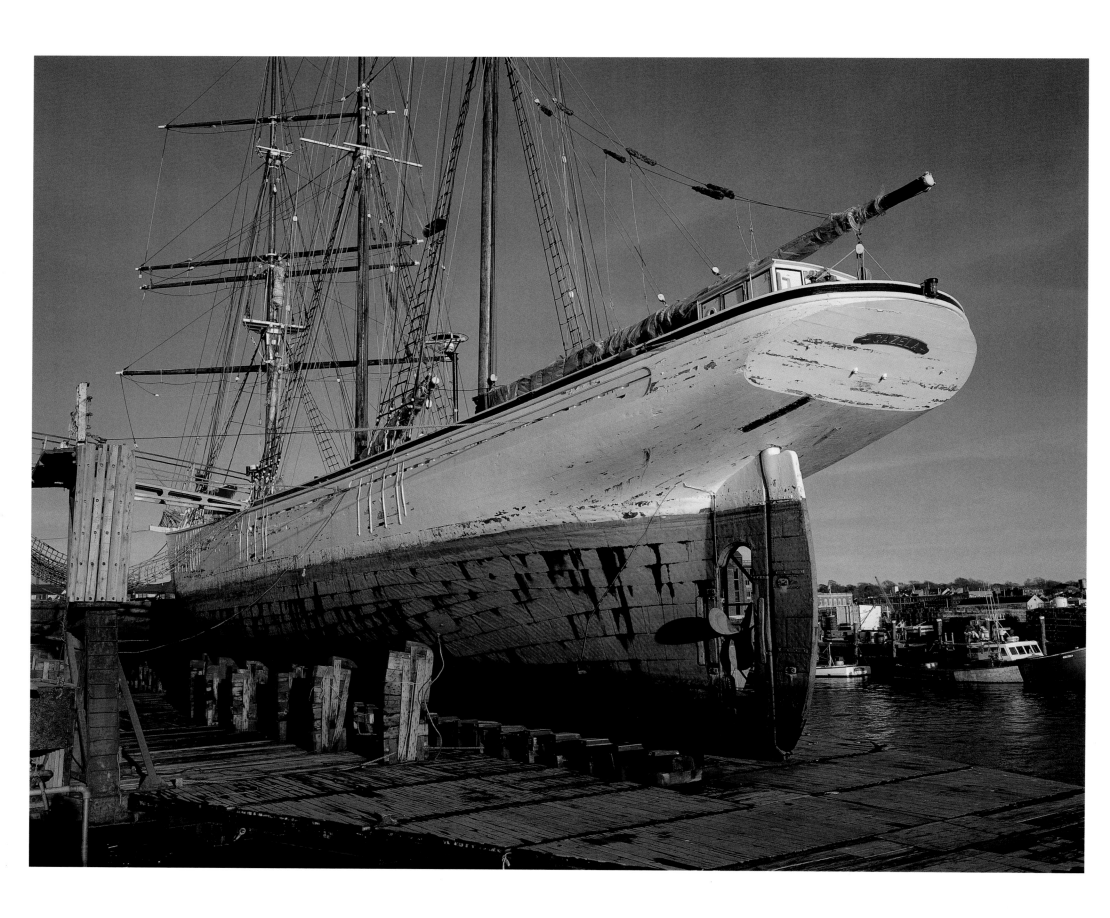

Cruising New England

I don't think there is a sailor anywhere who has not heard that some of the best cruising in the United States is in New England, from Penobscot Bay, Maine, to Nantucket and the other islands and as far south as Block Island in Rhode Island. When one thinks of these locations, fog and lobster pots jump to mind, but then the lighthouses, quaint fishing villages, and delicious seafood quickly take over and remind one why cruising in New England is so special.

Being based in Newport, Rhode Island, I feel lucky to live in this glorious area, which appeals to so many sailors, both local and transient, from all corners of the globe. To go from Newport to Cuttyhunk or Block Island takes me only an hour in good weather on my twenty-eight-foot chase boat, *Onnesignment,* and from those harbors the more distant spots, like Provincetown at the tip of Cape Cod, become short runs. This is where the beauty of cruising coastal New England lies; once you make it to your first harbor, another charming mooring or dock space is only a short hop up the coast, across a sound, or even around the corner.

The coastal route of southern Maine opens up to a photographer's world of dream locations. I shoot commercially for a handful of boat builders in Downeast Maine and I treasure these trips, as being there is like being nowhere else. If it is too foggy to shoot their new boats, I take off and explore the small boat-building shops that are littered along the coast. I poke around for a few hours to shoot the unusual little boats, which are being worked on by genuine yachtsmen and shipwrights. The boats that come out of these wooden sheds typically have the most

character and are hand-built by the shop owners themselves. To photograph craftsmen at work is fascinating, as is the typical crowded work shed overflowing with tools and molds. The photographs I take on these exploratory sojourns often tell a story and become the shots that are indeed treasured.

What ties together the harbors and boating towns in New England is not only the charm of the waterfront communities that welcome you, but also the characters who work there. The old salts represent the lifestyle that cruisers emulate for their relatively short trips through New England harbors, from the friendly guy who catches your lines and the local lobsterman found tidying his boat—ready to sell you today's catch and tonight's dinner on the spot—to the shopkeeper who divulges the source of the best clam cakes in town. Some of the most genuine people of the world are found right there along the coast, working and enjoying the waterfront, and sharing it with any cruisers who happen upon their shores.

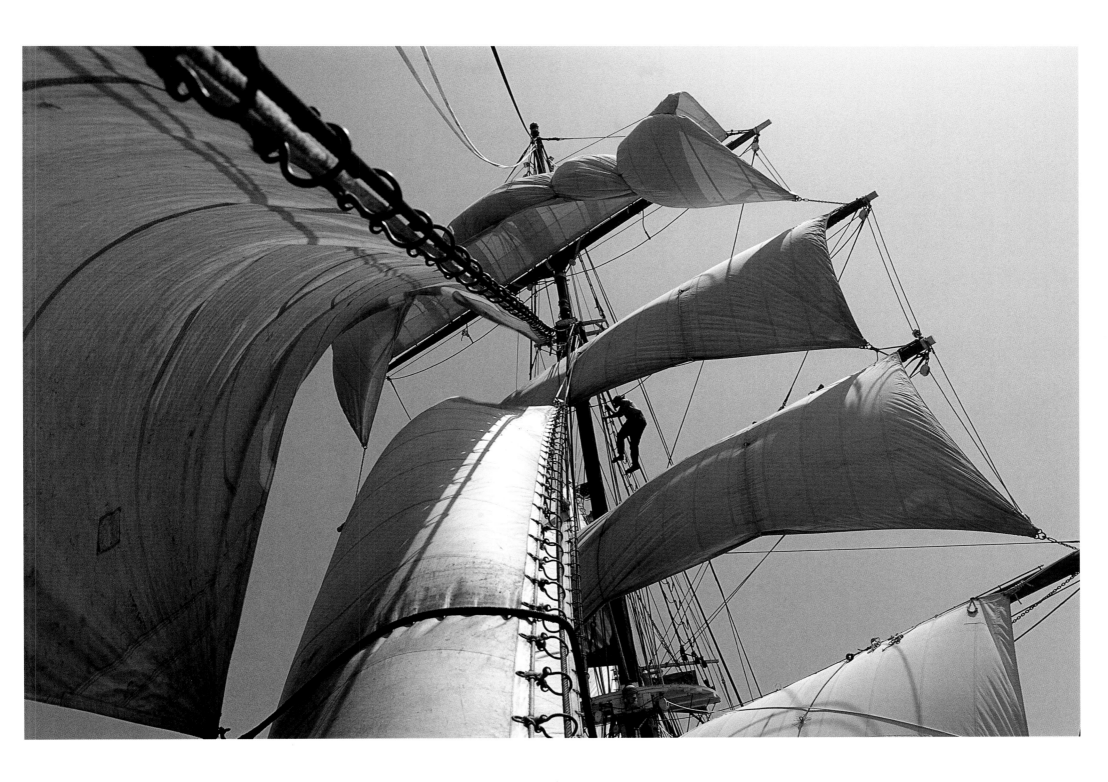

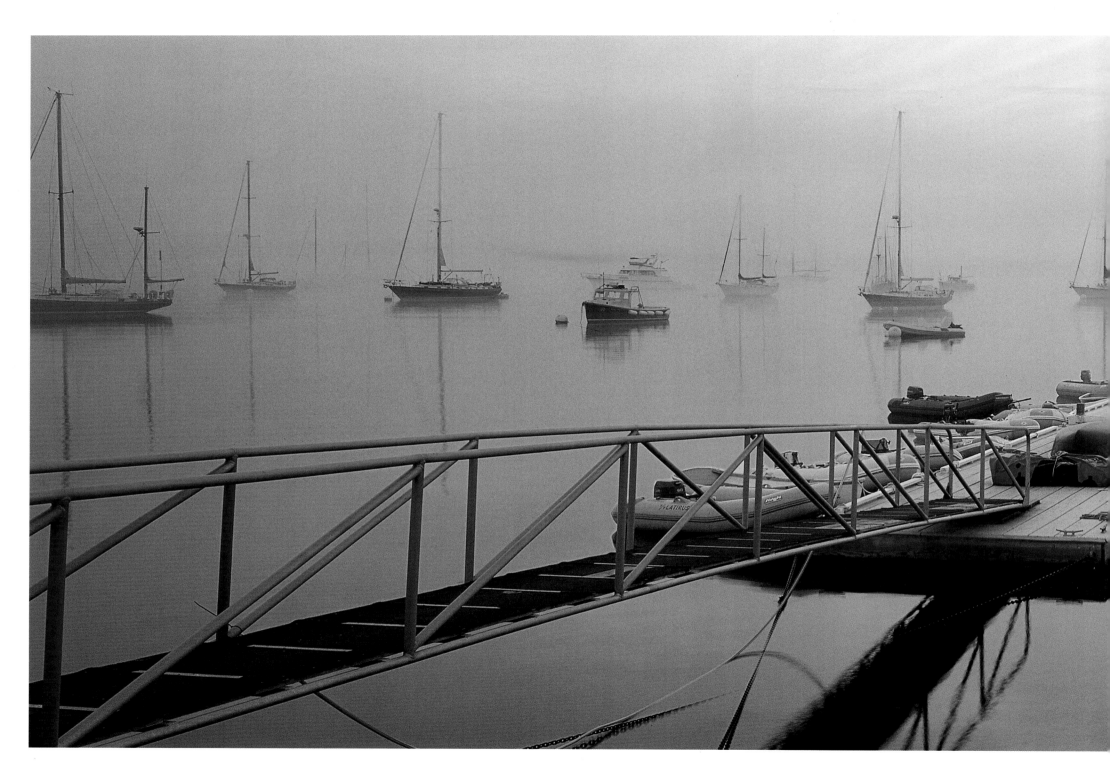

The Hinckley dinghy dock in Southwest
Harbor, Maine.

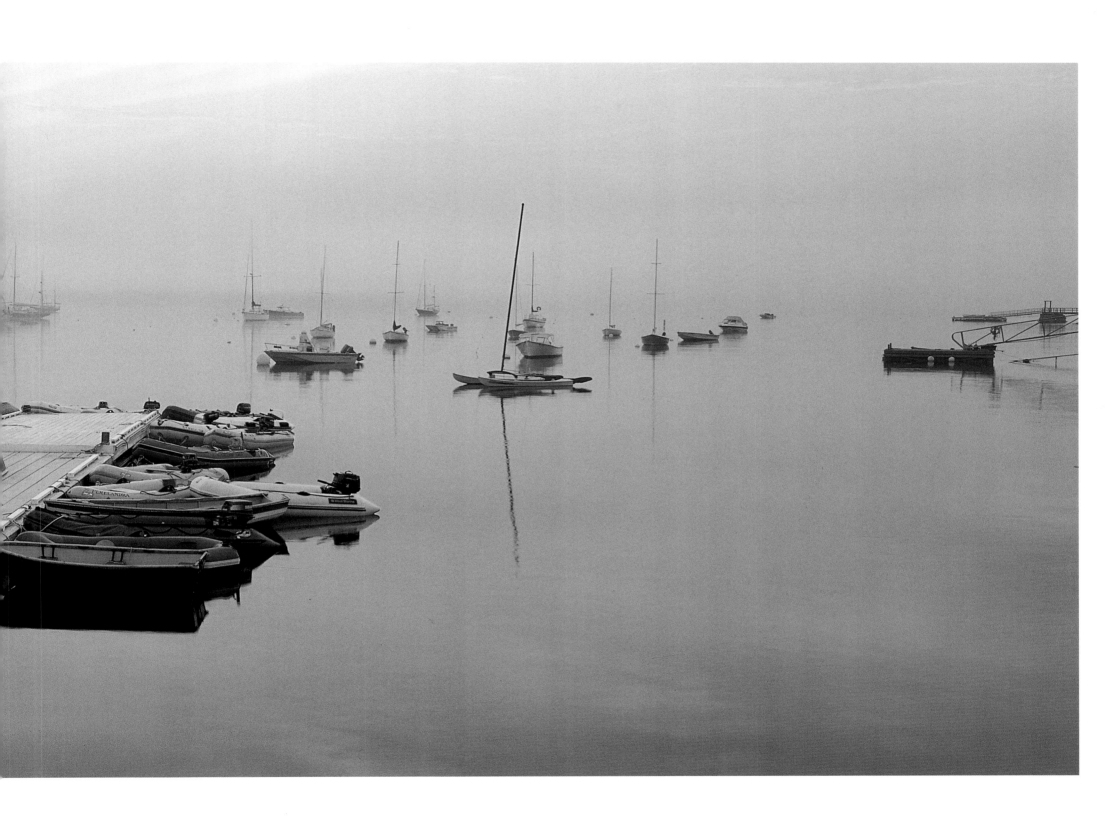

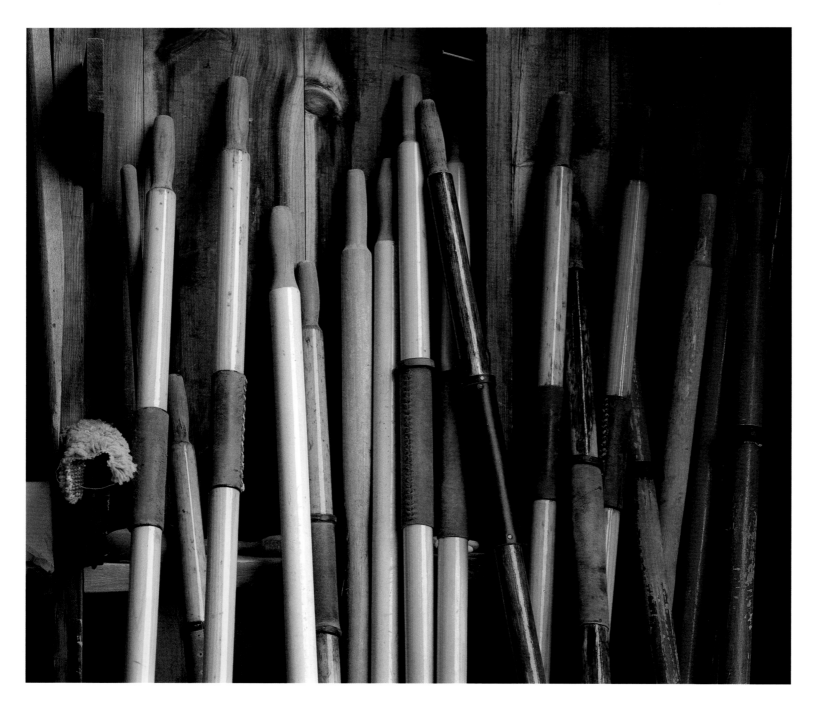

A stack of oars in winter storage.

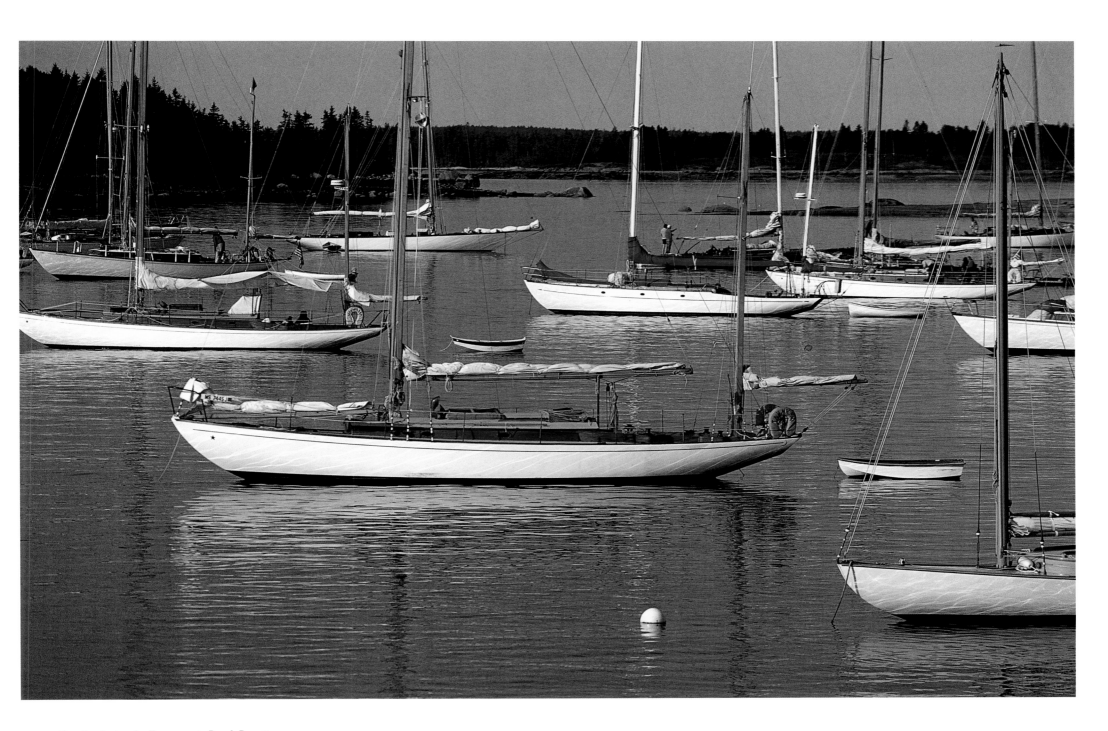

Sunrise during the Eggemoggin Reach Regatta
near Blue Hill, Maine.

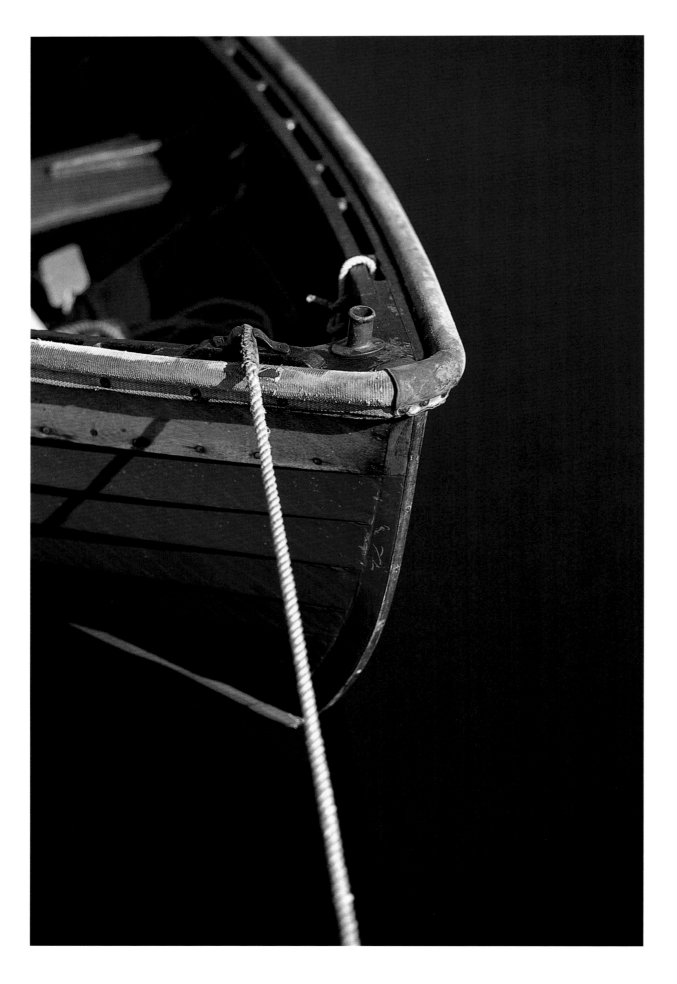

LEFT
Bow painter detail on wooden lapstrake dinghy.

OPPOSITE
Collecting seaweed in Southwest Harbor, Maine.

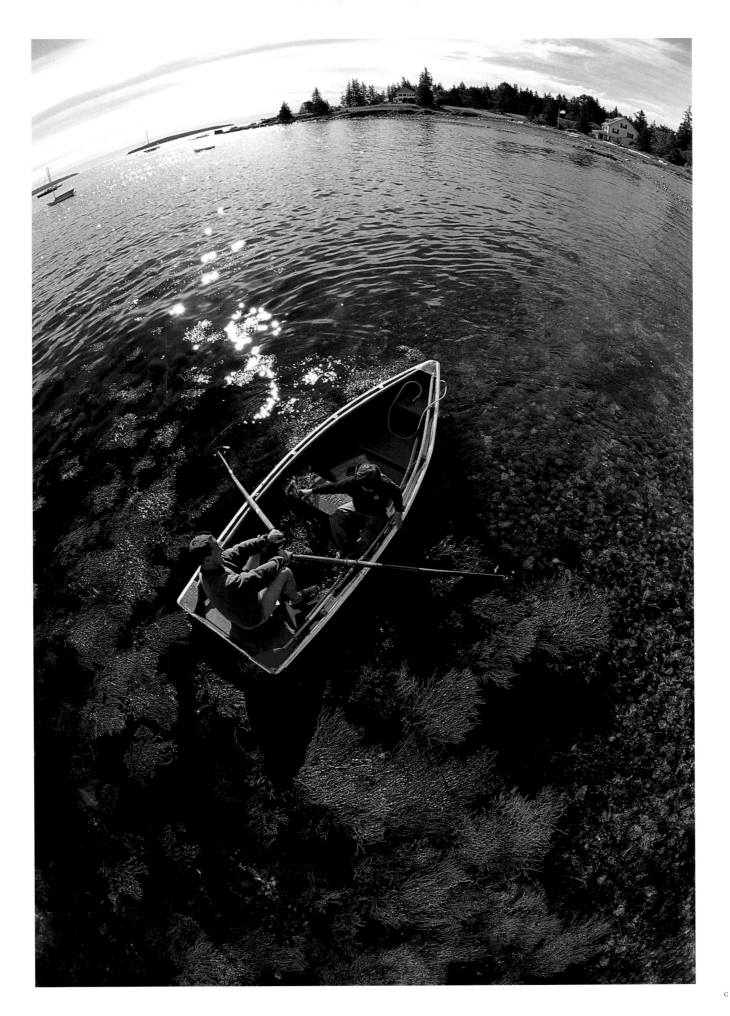

An aerial view of the Hinckley rendezvous in
Somes Sound, Mount Desert Island, Maine.

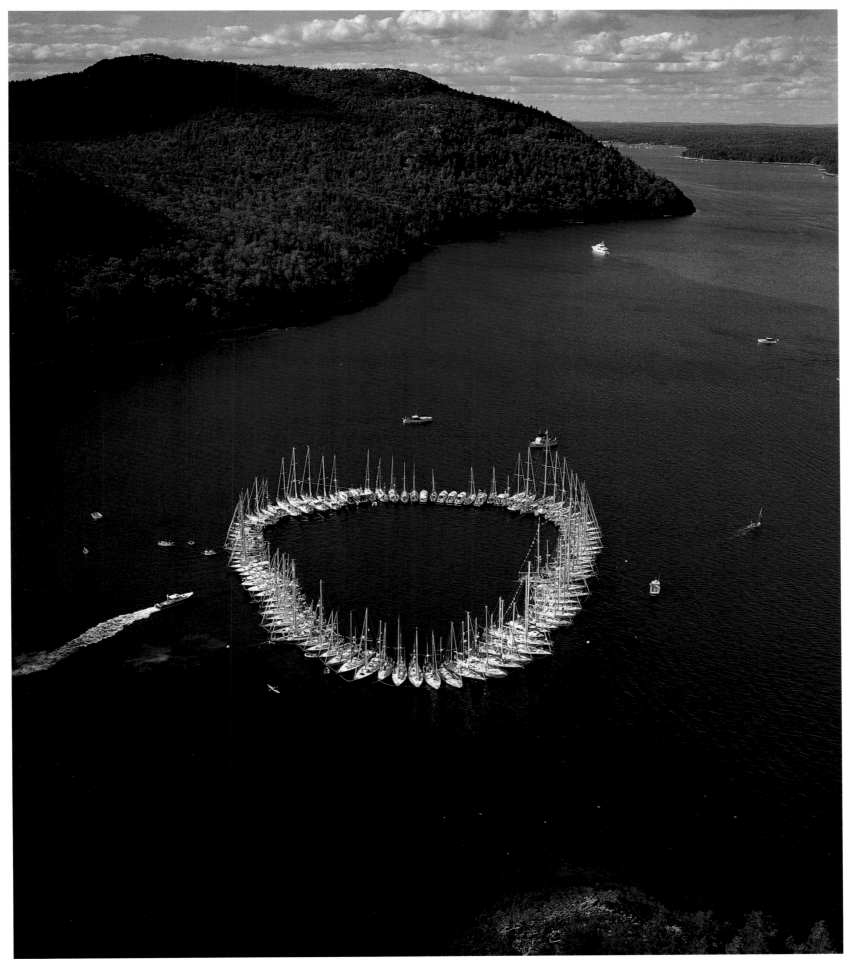

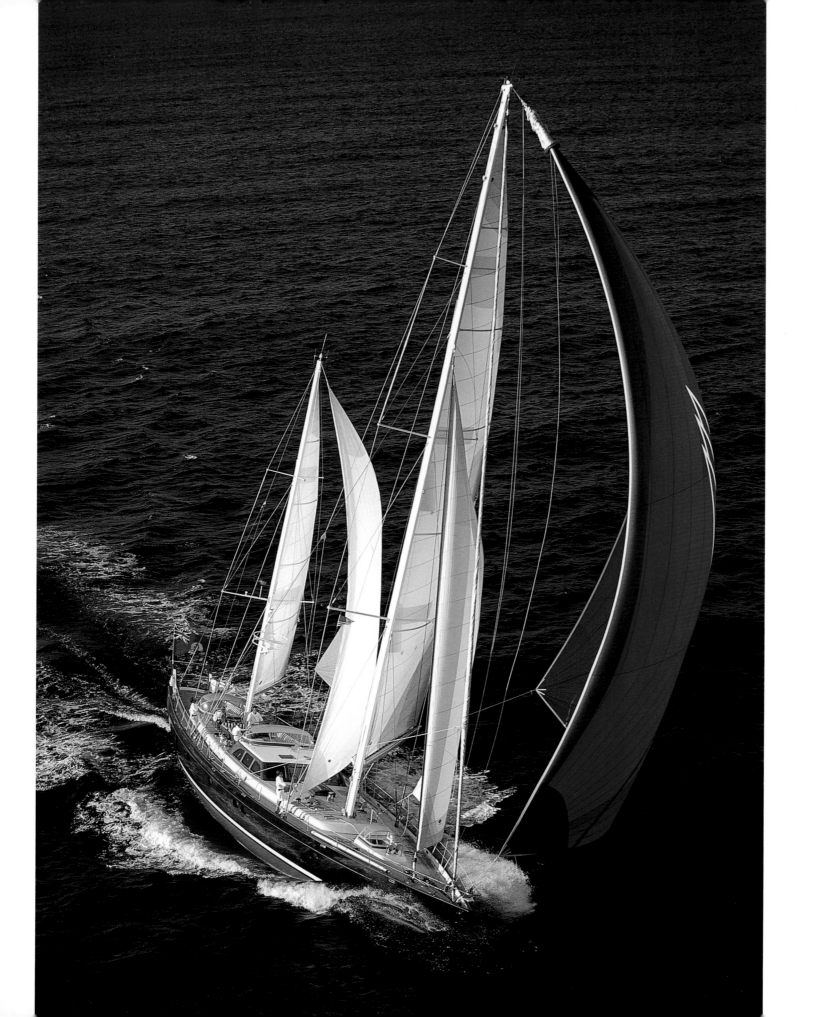

The eighty-foot ketch *Marguerite* reaches along with all the running canvas she owns.

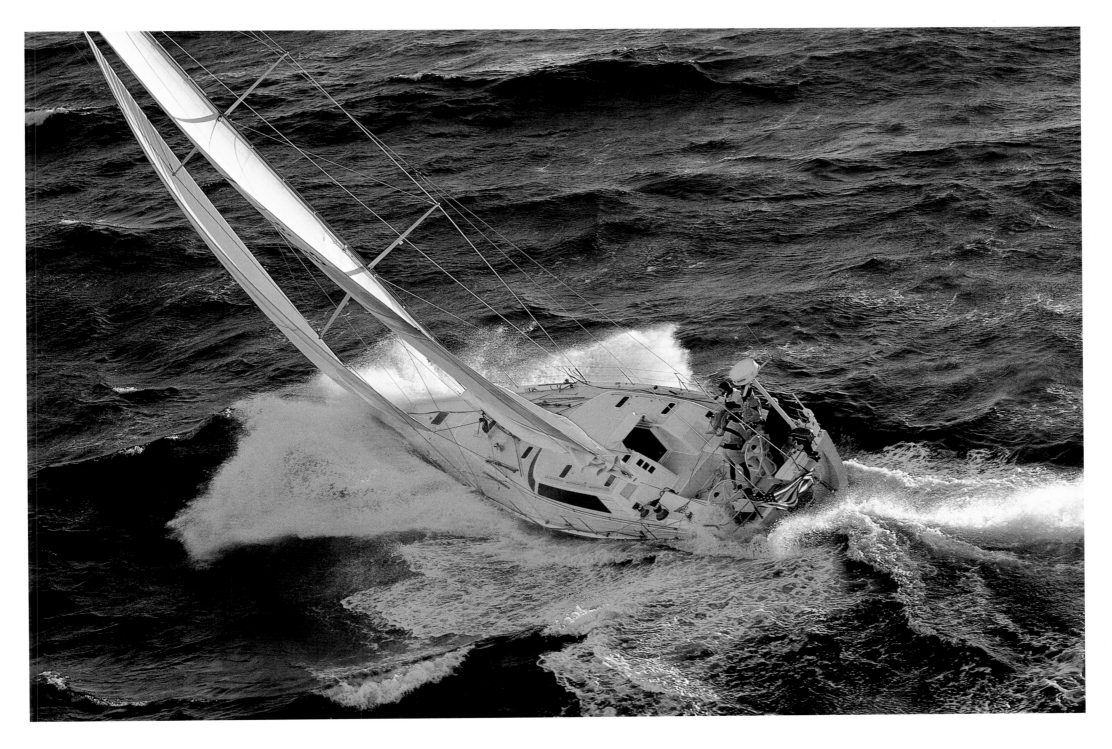

Brigadoon VII, a fifty-six-foot sloop from
Rhode Island, gets a taste of salty swell as she
pounds her way offshore toward Maryland.

The North Light on Rhode Island's Block
Island at sunrise.

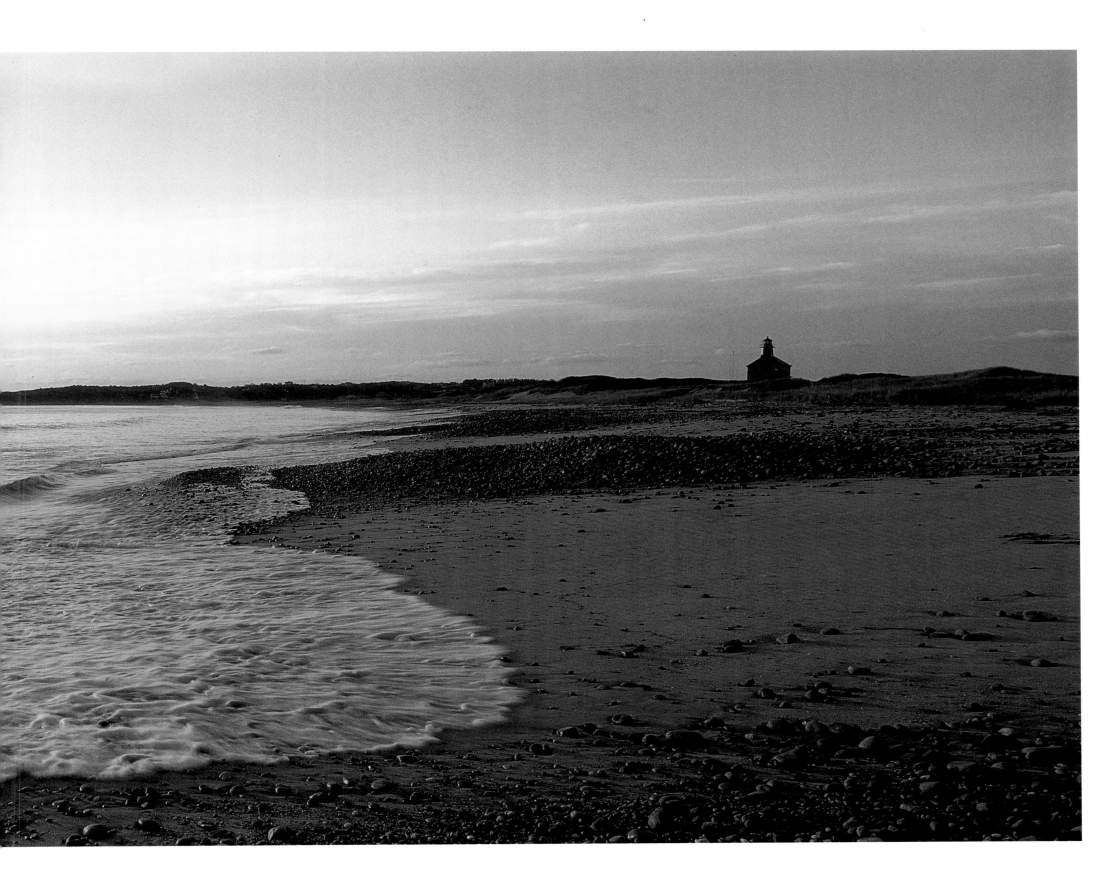

Three large sailboats on the dock at Bannister's Wharf, the heart and soul of Newport, Rhode Island.

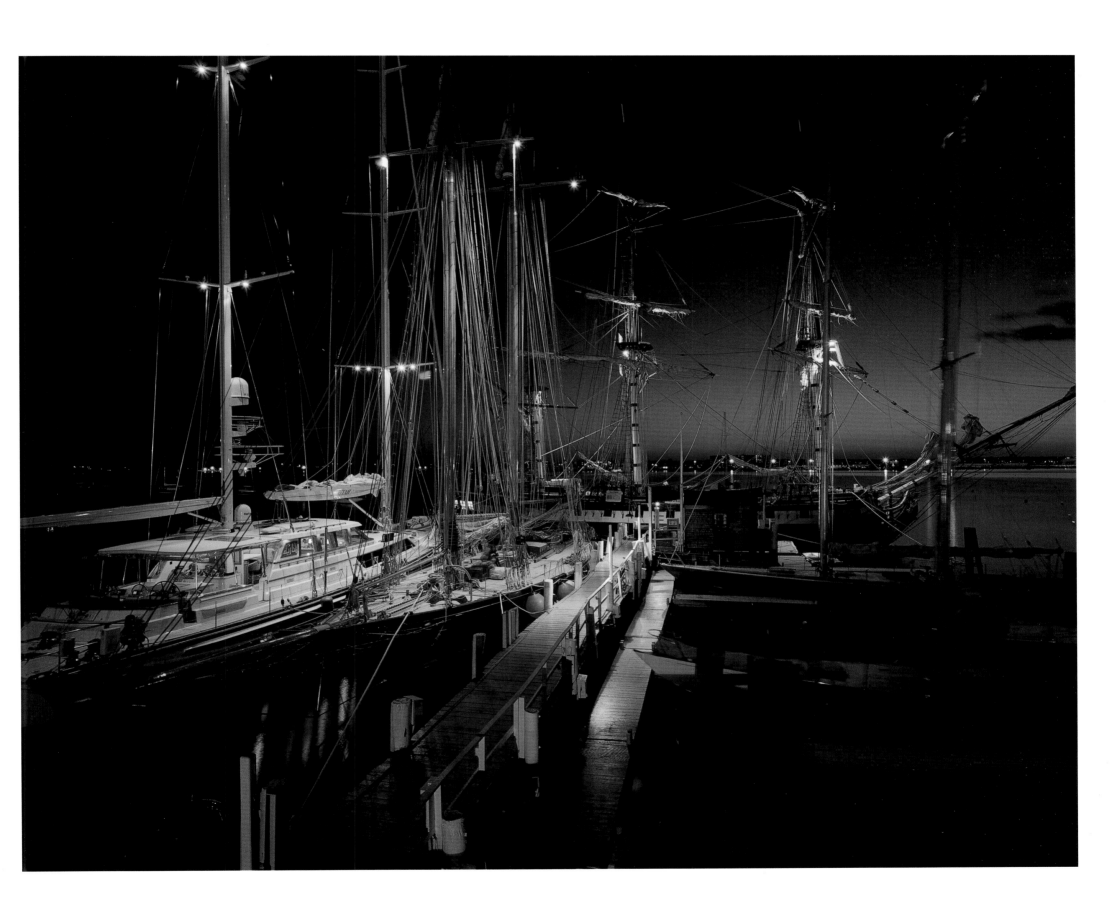

Acknowledgments

Thank you to all of those who have worked with me over the years and who have made it possible for me to put this collection of images together to create *Wind and Water*. A special thank-you to Kristin Browne, who has put her heart and soul into helping me get where I am today. She makes it possible for me to go off for weeks at a time so that I can concentrate on taking pictures while she runs the business back in Newport in the most professional way.

My gratitude goes to Conny van Rietschoten, the owner and skipper of *Flyer*, who gave me the opportunity to be a crew member on his Whitbread Round the World Race entry, which gave me my start in photography.

Thanks to Rob Johnson, owner of *Shaman*, a true adventurer who has taken me to some of the most beautiful and least traveled places on earth—places that most people have never even heard of. Our trips together make my work as a photographer so rewarding.

My appreciation also goes to Esmond Harmsworth, my literary agent, and Torrey Oberfest, my editor at Bulfinch, who took an idea, a bunch of slides, my scribbled captions and chapter openers, and patiently worked with me to make this book a reality.

And the biggest thank-you is to my wife, Tenley, and our kids, Read, Billy, and Adrian. They are my models, my helpers, and my supporters both at home and when I am far away taking pictures.

A TECHNICAL NOTE FROM THE AUTHOR

The majority of the photographs that appear in this book were taken with Canon EOS 1N and 1V cameras with the following Canon EF L series F2.8 lenses: 14mm, 15mm (non L), 17–35mm, 28–70mm, 70–200mm, 300mm, and 400mm. The underwater shots were taken with a Canon EOS A2 in a Delphinus U/W housing with 15 and 14mm lenses. The panoramic shots were taken with a Hasselblad XPan 35mm camera using 30mm, 45mm, and 90mm lenses. My earlier pictures on *Flyer* and the boy in the dugout canoe on page 111 were taken with an Olympus OM 1 camera on Kodachrome 64 film. All of the other images were shot on Fujichrome Velvia RVP 50 film, which I rated at 40 ASA. The camera bags, backpacks, and waterproof backpacks were all made by Lowepro. None of the images in this book were shot digitally.